FRENCH P

FOR ENGLISH LACES

D1273529

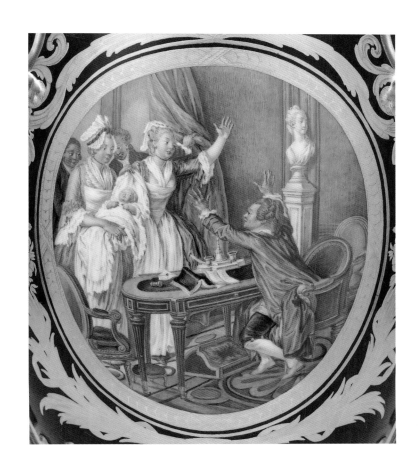

FRENCH PORCELAIN FOR ENGLISH PALACES

Sèvres from the Royal Collection

JOANNA GWILT

ROYAL COLLECTION PUBLICATIONS

First published 2009 by Royal Collection Enterprises Ltd
St James's Palace, London SW1A 1JR

© 2009 Royal Collection Enterprises Ltd
Text by Joanna Gwilt and reproductions of all items in the Royal Collection
© 2009 HM Queen Elizabeth II

All rights reserved. No part of this publication may be reproduced, stored in
a retrieval system or transmitted in any form or by any means, whether
electronic or mechanical, including photocopying, recording or otherwise,
without prior permission in writing from the publisher.

ISBN 978-1-905686-14-8

012856

British Library Cataloguing in Publication Data:
A catalogue record of this book is available from the British Library.

Production by Debbie Wayment
Designed by Mick Keates
Editorial and project management by Alison Thomas
Printed and bound by Studio Fasoli, Verona, Italy
Typeset in Sabon and Optima and printed on Hello silk

Mixed Sources
Product group from well-managed
forests and other controlled sources
www.fsc.org Cert no. SA-COC-002103
© 1996 Forest Stewardship Council
FSC

ILLUSTRATIONS
Front cover: One of a Pair of Mounted Vases and Covers (p. 108)
Page 1: Front reserve of Vase (p. 56)
Frontispiece: Oval Stand for Broth Basin (p. 170)
Back cover: Back reserve of centre vase of a *Garniture* of three Vases (p. 98)
Inside back cover: Back reserve of a flanking vase of a *Garniture* of three Vases (p. 36)

PICTURE CREDITS
Page 13 © Manufacture Nationale de Sèvres, Archives
Page 14 © Manufacture Nationale de Sèvres, Archives

CONTENTS

INTRODUCTION 7

VASES 16

TABLEWARE 124

CUPS AND SAUCERS 142

DÉJEUNERS, BROTH BASINS,
JUG AND BASIN 166

PLAQUES 176

SCULPTURE 182

RECOMMENDED READING 193

GLOSSARY 194

INDEX OF SÈVRES PAINTERS AND GILDERS 196

GENERAL INDEX 197

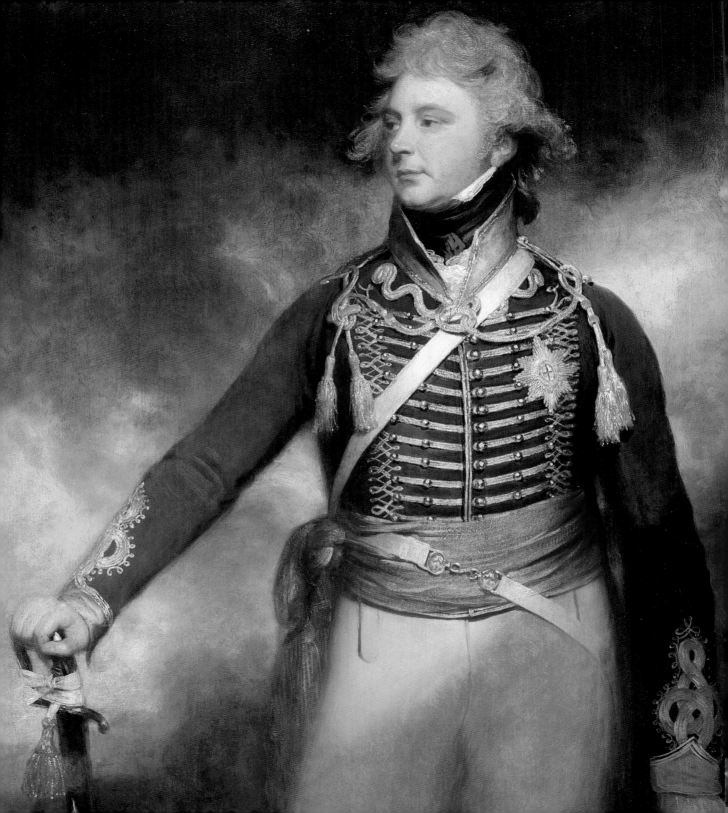

INTRODUCTION

This publication is based on the definitive catalogue by Sir Geoffrey de Bellaigue, *French Porcelain in the Collection of Her Majesty The Queen*, which throws new light on the history of collecting and on the production of porcelain in France, principally Sèvres, in the eighteenth and early nineteenth centuries.*

GEORGE IV'S COLLECTION OF SÈVRES PORCELAIN

The Sèvres porcelain in the Royal Collection is considered to be the finest assemblage in the world. Largely formed by George IV† between 1783 and 1830, the King's French porcelain epitomised his taste for the rare, the exotic and the extravagant; and it is rich in ornamental and flower vases as well as tablewares. The grandest pieces made at Sèvres formed glamorous accessories, enhancing the visual theatricality of George IV's state apartments at his London residence, Carlton House, where he held glittering receptions. In addition to these display pieces, he made extensive purchases of useful wares, such as cups and saucers, broth basins, *déjeuners* (tea sets) and complete services. To this day, they continue to be used for State Visits and ceremonial occasions.

George IV's enthusiasm for Sèvres porcelain was lifelong. In 1783, at the age of 21, he made his first purchase from the Sèvres manufactory and he continued to make acquisitions until his death in 1830. As late as 1829, as an invalid living the life of a recluse and given to fits of deep melancholy, he still eagerly bought further examples of eighteenth-century Sèvres at prices which were a record for the times. The French Revolution had brought on to the market a vast quantity of furniture, porcelain and other works of art, formerly the property of the French Crown and of

* For the reader interested in more detailed information, the catalogue number included at the end of each entry refers to the three-volume catalogue raisonné (published in 2009). The RCIN (Royal Collection Inventory Number) is also included. All measurements are given in centimetres.

† To avoid confusion the King is referred to throughout as George IV. He was born Prince of Wales in 1762, became Regent in 1811 and King in 1820, and died in 1830.

Opposite: Sir William Beechey (1753–1839), *George IV when Prince of Wales (1762–1830)*, 1803
RCIN 400511

France's erstwhile ruling classes. This enabled George IV to enhance further the splendour of his collections and the richness of his interiors.

In his choice of Sèvres, George IV preferred the boldly modelled and brightly coloured wares, rich in gilding. A certain flamboyance and bravura, in scale or decoration, characterises his collecting. His purchases formed part of his lavish and constantly changing schemes of interior decoration. They had to compete with and complement other rich furnishings – for the most part French – with which he filled the rooms at Carlton House. Grand *garnitures* of vases formed part of the fixed decoration of a room and were perceived as important elements in wall decoration, linking the chimney-piece or furniture on which they stood with the framed painting or tapestry above. Cups and saucers, *déjeuners* and broth basins, on the other hand, were treated as movable *bibelots*, transferred at a whim around or between rooms. While Sèvres porcelain lent itself to minute inspection – not least in its painted scenes – it also contributed greatly to the overall sparkling impact of the room displays.

Fated never to see Paris, George IV had to content himself with viewing it through the eyes of others. He surrounded himself with like-minded friends who were also collectors and patrons of the arts, including Lord Yarmouth, whose collection now forms part of the Wallace Collection. This loosely knit group of Sèvres enthusiasts acquired their porcelain through many of the same channels, using the same dealers in France and England. In some cases, items were secured directly from the Sèvres manufactory, but George IV relied mostly on purchases made on his behalf by close friends or trusted staff, such as his *maître d'hôtel*, Jean-Baptiste Watier, his Clerk of the Kitchen, Louis Weltje, or his confectioner, François Benois. Acting largely as scouts, they provided reports, despatched drawings of desirable objects, arranged for items to be sent on approval to Carlton House and also negotiated sales. Thus, for example, the *garniture* of three vases decorated with military encampment scenes (see p. 36) was acquired by Lord Yarmouth for George IV in 1817, and the pair of *vases à bandes*, painted with pastoral scenes after Boucher and Fragonard (see p. 70), was purchased on the King's behalf by Benois in 1820.

In the pre-Revolutionary period, many of the purchases of this coterie of Francophile collectors were made through the *marchand-mercier* (dealer-decorator) Dominique Daguerre, who numbered among his customers leading members of the French aristocracy, as well as the crowned heads of Germany, Russia, Italy and the Low Countries. In his dealings with George IV, Daguerre acted in two capacities: as porcelain supplier and as interior decorator, invited to supervise the furnishing of Carlton House in 1787.

In the early nineteenth century, George IV also engaged the services of English tradesmen to acquire some of his most important pieces of Sèvres porcelain. Among them was Robert Fogg,

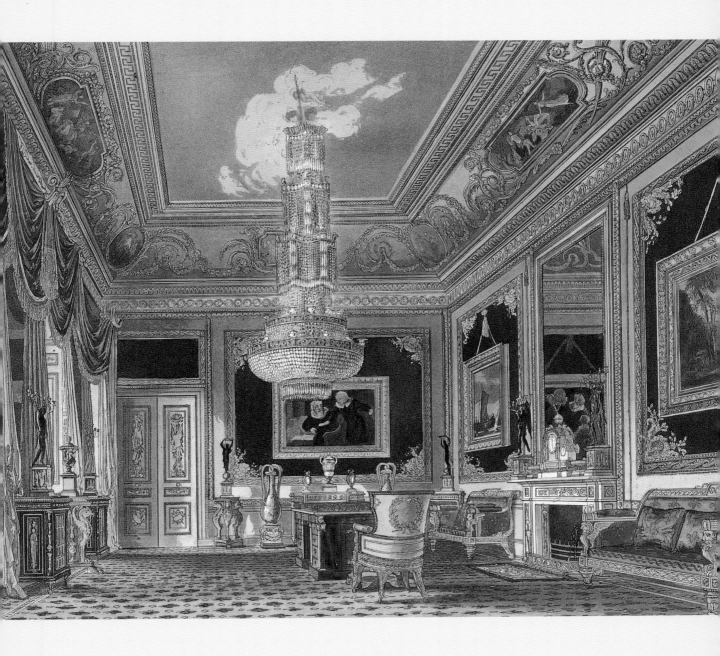

The Blue Velvet Room, Carlton House
Engraved by D. Havell after C. Wild, 1 October 1816

who was instrumental in many of the significant acquisitions, including the magnificent pair of vases mounted with finely chased and jewel-like gilt bronze formerly belonging to Louis XVI (see p. 108), and the dinner service specially commissioned by the French King for his personal use at Versailles (see p. 134) – the most costly and sumptuous service created at Sèvres in the eighteenth century. London auction houses also played a part in George IV's purchases, whether acting as auctioneers or intermediaries – for example, the Manchester service was acquired by private treaty from the Duchess of Manchester in 1802 through the London auctioneer Harry Phillips, who acted as intermediary (see p. 132). Notwithstanding a certain deterioration in quality evident in some of his later purchases, George IV made some spectacular acquisitions in the last year of his life, notably at Lord Gwydir's sale in May 1829, when he bid successfully for several vases, including the *vase royal* (see p. 66), which is one of the most imposing ornamental vases ever to have been made at Sèvres.

Apart from the dictates of interior decoration, fashion or simply preference, another factor which undoubtedly influenced George IV's collecting was his sense of history and his detailed knowledge of France under the Bourbons and earlier dynasties. This is illustrated by the collection of portrait heads in porcelain of the kings of France which he assembled, ranging from Louis XII to Louis XVIII. Few of them survive, but among them are two in biscuit porcelain of Louis XVI and Marie-Antoinette (see p. 184), and the *vase à médaillon du roi*, with biscuit portraits in low relief of a youthful Louis XV (see p. 60). In some instances, George IV's interest extended to the favourites of the sovereigns, notably Madame de Pompadour (1721–64) and Madame du Barry (1743–93), mistresses of Louis XV. An addition to his collection of Sèvres made under the *ancien régime* is a cup and saucer dated 1794, painted with a figure of Equality and Republican and Masonic emblems. It is among the most beautiful of the cups forming part of George IV's collection (see p. 160).

Another significant attraction for George IV was the opportunity to obtain souvenirs of the Emperor Napoleon. Of the rich harvest of pieces associated with Napoleon which he managed to acquire, the most prestigious memento was the Table of the Grand Commanders (see p. 178). On its arrival at Carlton House it was put on view for all to admire, in a place of honour in the bow of the Rose Satin Drawing Room. So highly did George IV regard this table, and such was its status in his eyes, that henceforth it became part of the ceremonial backdrop for all his state portraits by Sir Thomas Lawrence (see illustration on p. 180).

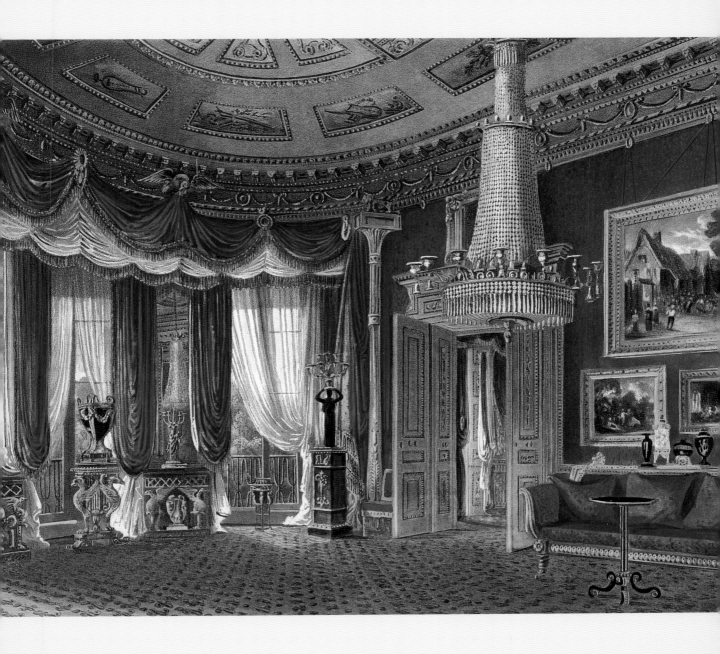

The Rose Satin Drawing Room, Carlton House
Engraved by D. Havell after C. Wild, December 1817

The Vincennes–Sèvres manufactory

Founded in 1740 by Jean-Henri-Louis Orry de Fulvy (1703–51), the Vincennes porcelain manufactory set out to develop a formula for hard-paste porcelain to rival that of the Orient and also that of Meissen, then the greatest porcelain manufactory in Europe. Under the supervision of Claude-Humbert Gérin, and with the assistance of the brothers Robert and Gilles Dubois, formerly of the Chantilly porcelain factory, the manufactory developed a superior soft-paste porcelain which was whiter and purer than any of its French rivals. Around the mid-eighteenth century, Sèvres had become the leading manufactory of porcelain in Europe, and its decorative exuberance and technical virtuosity remained unsurpassed.

China clay (kaolin), the essential ingredient of hard-paste porcelain, was not discovered on French soil until the 1760s, and 'true porcelain', as it was sometimes called, was not made at Sèvres until 1769. Therefore, wares of both soft-paste and hard-paste porcelain were made concurrently until 1804, when the production of soft-paste porcelain was abandoned. In aesthetic terms, soft paste is generally considered superior to hard paste, and even in the eighteenth century it was so regarded by many connoisseurs. However, in practical terms soft paste lacks the hardness and whiteness of true porcelain and is considerably more costly to produce because of the number of processes involved and the unstable nature of the porcelain in the kiln. It had a tendency to distort when turned on the wheel and when worked by the *repareurs* (repairers or modellers). In addition, thicker applications of gold were needed to compensate for its absorption in the lead glaze.

The complex process of manufacture involved many stages and specialist craftsmen. In order of production, these included the thrower or moulder, the *repareur*, the glaze painter, the ground artist, one or more painters for the principal decoration, the gilder and, finally, the burnisher. After each stage, except for the burnishing of the gold, the object would be fired. The first process was biscuit firing, followed by firing the glaze (often two or three times); then the painted decoration was fired, which may have been followed by a second firing for retouching. At this stage, the first application of gold was made. The final firing was after the second application of gold. At each stage, the processes involved were very labour-intensive; the painters and gilders would often work for months at a time on pieces of an especially detailed nature.

The Sèvres manufactory continues today and one of the great practical advantages it has over its rivals rests on the survival of so many of its records, which provide a wealth of information about design, sources for decoration and the different techniques applied in production. From its early years, the manufactory adopted as its mark the royal cipher – interlaced *LL*s – which was

The Sèvres manufactory in 1814, watercolour
Manufacture Nationale de Sèvres, Archives

inscribed on the underside of the pieces. In 1753 a system of dating was introduced to indicate the year a piece was decorated. A letter of the alphabet was usually placed within the factory mark, starting with *A* for 1753 and beginning again with double letters from 1778. The royal monogram was used as the official factory mark until July 1793, during the Revolution. (It was initially replaced with a new mark – *RF* – to indicate the factory's allegiance to the newly established French Republic.) In order to distinguish hard-paste from soft-paste porcelain, a crown was added above the interlaced *LL*s on the pieces in hard paste. It was usual for the artists to mark

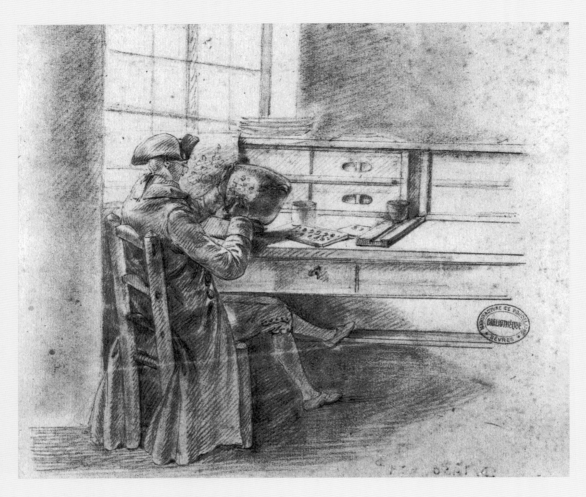

Anonymous drawing of a Sèvres painter, late eighteenth century
Manufacture Nationale de Sèvres, Archives

the wares for which they were responsible, often applying their marks above or below the factory mark. The gilders did the same, but generally only from about 1770. However, in practice there are sometimes no painters' or gilders' marks, so an attribution to a particular artist can only be made on stylistic grounds based on similarities to other marked pieces.

It was usual practice for the throwers, moulders and *repareurs*, who fashioned the paste prior to firing and decoration, to mark their work. Their marks, incised in the paste, consist of initials,

numbers and hieroglyphs. However, once covered by the glaze, a number of these are difficult to decipher. Like those of the painters and gilders, it is likely that the marks were used to monitor the quality and quantity of their work. Even though we know little of the significance of most of the incised marks, they are of interest because, unlike painted marks, they cannot be counterfeited and they provide positive proof that the paste is, at the very least, of Vincennes or Sèvres porcelain.

Under the patronage of Madame de Pompadour, the official mistress of Louis XV, the manufactory began to break away from the influence of German- and Oriental-inspired wares. The 1750s saw a series of events that transformed the fortunes of the manufactory. New designers and administrators were appointed, among them Jean-Jacques Bachelier (1724–1806), who, in 1751, was made responsible for the creation of decorative schemes. New forms of vases and services were designed by the goldsmith Jean-Claude Duplessis (c.1690–1774; artistic director of models 1745/8–74), who was responsible for the creation of entirely original French productions with bold colours and rich gilding. In 1756 the manufactory was transferred to more suitable premises at Sèvres, to the west of Paris, and three years later the King finally assumed financial responsibility for the manufactory. Until the Revolution the manufactory belonged to the French Crown, and subsequently it became the property of the French State, under which it continues to operate today.

Perhaps the greatest achievement of the Sèvres manufactory was its ornamental vases and flower vases, which were produced in keeping with prevailing fashions, in a variety of forms and sizes. In the eighteenth century, the end-of-year sales of Sèvres porcelain held in the King's private apartments at Versailles brought French aristocratic and fashionable collectors flocking to acquire the latest designs from the royal manufactory in order to decorate the luxuriously appointed interiors of their *hôtels* and *châteaux*.

It was in the quality of its painting that the Sèvres manufactory was believed to surpass all others. Judging from the number of pieces in George IV's collection – the most striking characteristic of which is their elaborately painted decoration, featuring scenes, trophies, still lifes, floral and other decoration – it is very probable that the King would have whole-heartedly endorsed the importance of fine painting. The richness of its coloured grounds and the superb quality and opulence of its gilded decoration gave Sèvres porcelain a special appeal to patrons throughout Europe, and in particular in England, as George IV's magnificent collection amply demonstrates.

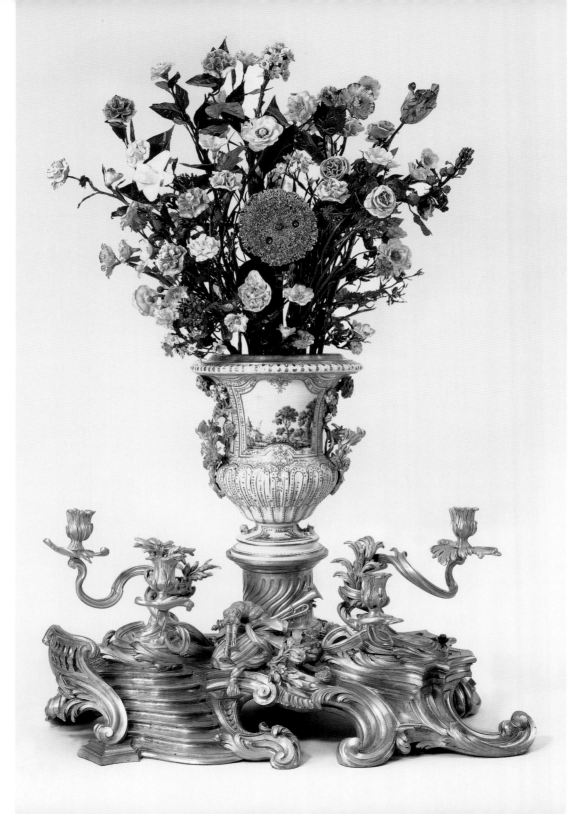

'THE SUNFLOWER CLOCK'
c.1752
(vase Le Boitteux)

The ensemble is essentially a curiosity. Resting on an elaborately scrolled, asymmetrical terrace in gilt bronze, the Vincennes vase, with painted scenes recalling those of early Meissen porcelain, is filled with a bouquet of flowers on green-lacquered brass wire. In the centre of the arrangement is a gilt bronze clock dial disguised as the seeding centre of a sunflower.

The original piece was enhanced in the early nineteenth century. The additions include the gilt bronze snake handles, the twin-branch candelabra, the drum supporting the vase and an assortment of later porcelain flowers of German and English origin. Of particular interest is the jewelling on the vase, which in places can be seen to overlay the original Vincennes painted insects and moths.

Notwithstanding these enrichments, the assemblage retains much of its former glory and remains an astonishing creation, to which potters at Vincennes, bronze manufacturers and a clock-maker all contributed.

Vincennes soft-paste porcelain, green-lacquered brass wire (for the stems), gilt bronze mounts

Measurements:
Overall height, 105.4;
width, 66.7; depth, 54.0
Vase height, 30.0; diameter, 13.9

Marks:
Vase: painted in blue: interlaced *LLs* enclosing a dot
Backplate: engraved by the clock-maker Benoist Gérard

Strike spring: signed by the spring manufacturer S. Missier (February 1752)

Provenance:
Acquired by George IV; bought in Paris, November 1819, almost certainly by François Benois, for 5,500 francs.
At time of purchase, thought to have once belonged to Madame de Pompadour, mistress of Louis XV of France.
RCIN 30240
Cat. no. 1

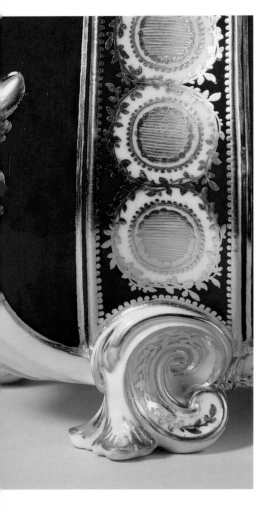

FLOWER VASE
c.1765–8
(*caisse* or *cuvette Courteille*) 1st size

The *cuvette Courteille*, designed to hold both fresh and porcelain flowers, was so named after the King's representative at the Sèvres manufactory, Dominique-Jacques de Courteille, who held the post of *commissaire du roi* from 1751 until his death in 1767.

Marine scenes were popular decorative subjects during the 1760s. In this instance, six sailors are shifting cargo on a quayside. A distinctive feature of the vase is the elaborately tooled treble gilt frame enclosing the scene. An important distinction between gold band decoration of the 1750s and that of the 1760s and 1770s is in the treatment of the surface decoration. The latter was tooled and burnished to form geometric patterns, skilfully rendered to enhance the visual splendour of the vase.

Soft-paste Sèvres porcelain, dark blue ground (*beau bleu*)

Measurements:
Height, 18.7; width, 30.3; depth, 15.8

Marks:
Painted in blue: interlaced *LL*s

Provenance:
Recorded in 1826 in the Dining Room, Basement Storey of Carlton House.
RCIN 36088
Cat. no. 2

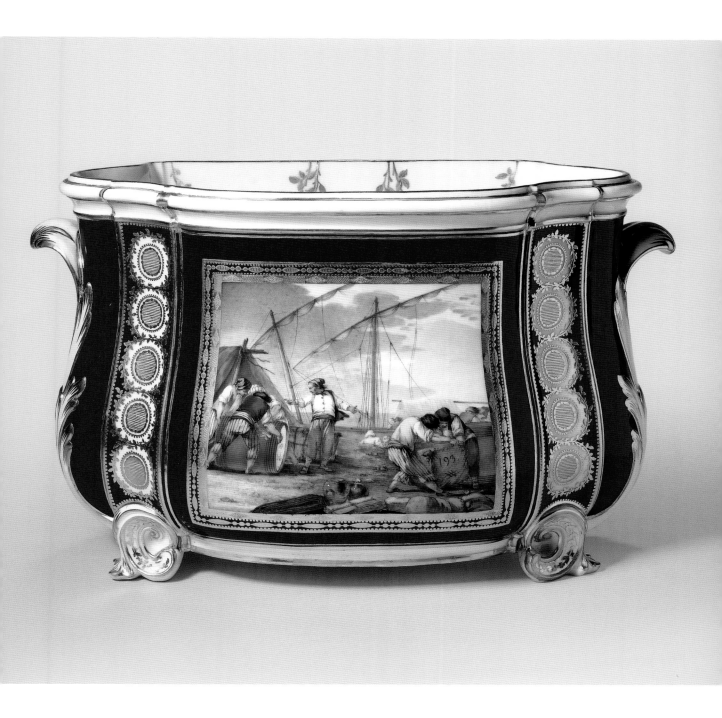

FLOWER VASE
1760
(*cuvette à tombeau*) 2nd size

The distinctive pale blue ground, sometimes known as *petit verd*, used at Sèvres for a comparatively short time between 1759/60 and 1763, is lighter in tone than the more widely produced *bleu céleste* (turquoise blue). The two colours were often not differentiated in the Sèvres records, as only subtle differences in tone separate them. The reserve on the vase depicts a traditional Teniers scene, with five peasants drinking outside an inn. The same scene can be found on the *cuvette Mahon* (see p. 29).

One of the earliest and most important champions of the Sèvres manufactory was Madame de Pompadour, who was known to have had a marked taste for the *petit verd* ground and assembled a number of striking pieces of extravagant shape and ornament decorated with this unusual colour.

Soft-paste Sèvres porcelain, pale blue ground (*petit verd*)

Measurements:
Height, 18.6; width, 24.5; depth, 14.7

Marks:
Painted in blue: interlaced *LL*s enclosing the date-letter *H* for 1760, with (above) *M* (in script), the mark of the figure painter Jean-Louis Morin and (below) three dots aligned, the mark of the flower painter Jean-Baptiste Tandart *l'aîné*.

Provenance:
Acquired by George IV, possibly at the sale held by Harry Phillips (No. 473), 20 March 1805.
RCIN 36082
Cat. no. 7

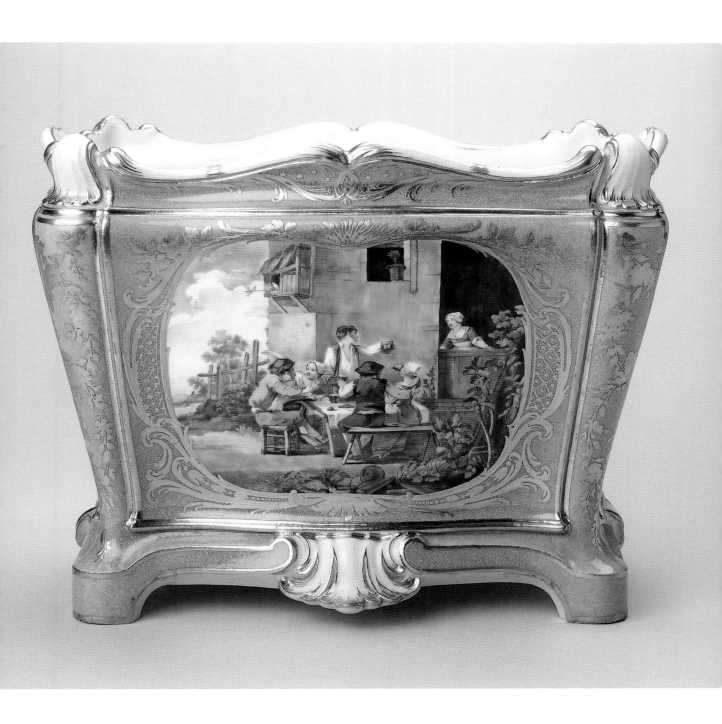

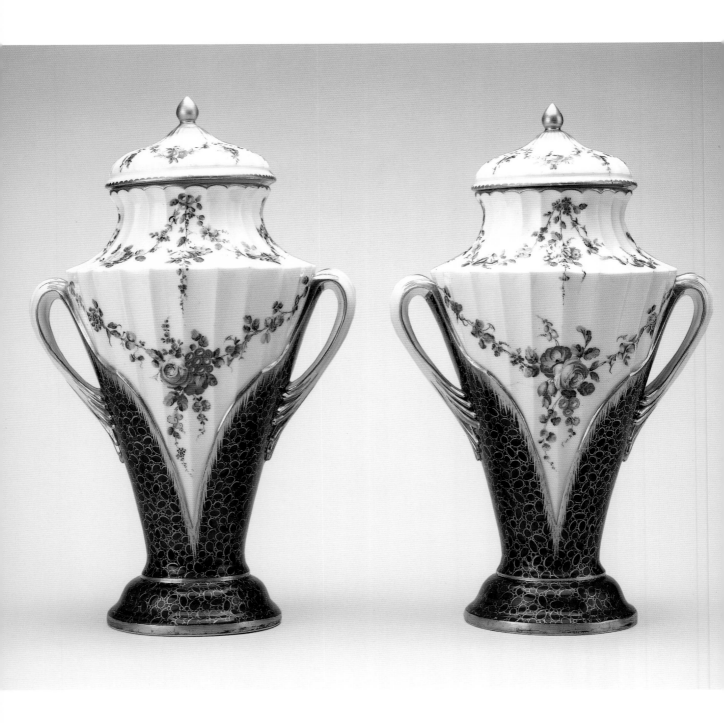

Pair of *Pot-pourri* Vases
*c.*1755–7
(*vase cannelé* or *vase à corset*) ?1st size

The delicate and fanciful design of this vase, characteristic of
production at Vincennes in the early years, dates from 1754.
Jean-Claude Duplessis, who was one of the most influential
artistic directors of models at Vincennes and Sèvres during the
years 1745–74, was probably responsible for its design.

 Circular in plan, the vase is partly fluted and decorated on
the lower section with a *bleu lapis* ground, overlaid by gold
caillouté decoration, a popular design motif employed at Sèvres
during the 1750s and 1760s. The appeal of these vases seems
not to have lasted, being overtaken by the fashion for vases in
the severe neo-classical style in the 1760s and 1770s.

Soft-paste Vincennes porcelain,
dark blue ground (*bleu lapis*)

Measurements:
Heights, 33.0; widths, 19.6;
depths, 15.0

Marks:
Painted on both, in underglaze blue:
interlaced *LL*s with two dots by rim

Provenance:
Presumably acquired by George IV
RCIN 36117.1–2
Cat. no. 11

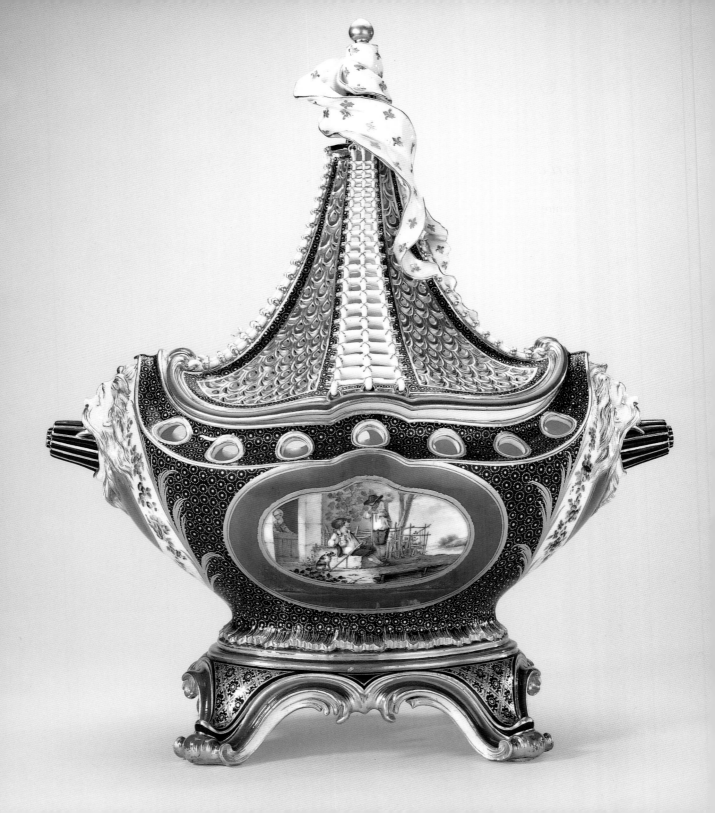

POT-POURRI VASE AND COVER

1758/9

(*pot-pourri à vaisseau* or *pot-pourri en navire*)

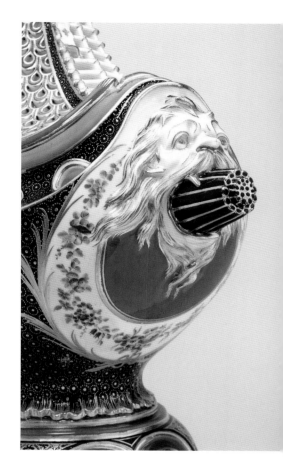

For many admirers of Sèvres porcelain, the *pot-pourri à vaisseau* represents the height of sophistication and a remarkable combination of the technical mastery of the *repareurs* and the skill of the painters and gilders.

The vase, the largest of the three models of this shape produced at Sèvres, is decorated with two ground colours, green and dark blue. The front reserve depicts a genre scene taken from an unknown source, inspired by David Teniers the Younger (1610–90). The ends of the vase are in the form of a bowsprit, projecting from the jaws of a marine head, and at the masthead is a fluttering white pennant, patterned with fleurs-de-lis. The vase was purchased in 1759 at the end-of-year sale at Versailles by Madame de Pompadour for 960 *livres*. Madame de Pompadour is known to have owned three examples of this model; these formed important components of her sumptuously appointed apartments.

Soft-paste Sèvres porcelain, dark blue ground (*bleu lapis*)

Measurements:
Height, 45.2; width, 37.8; depth, 19.3

Marks:
Painted in blue: interlaced *LL*s enclosing the date-letter *F* for 1758/9

Provenance:
Acquired by George IV
RCIN 2360
Cat. no. 12

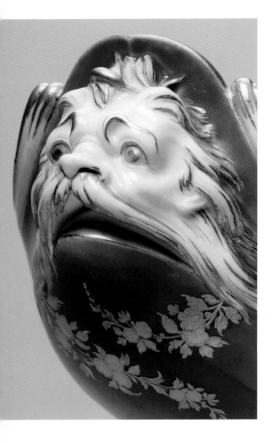

FLOWER VASE
1757/8
(*cuvette à masques*)

The gondola-shaped vase, decorated with an apple-green ground, broadly resembles the boat-shaped vase (see p. 24). Missing from the jaws, however, are the bowsprits. Despite the visual appeal of the *cuvette à masques*, comparatively few were made; production seems to have been limited to the years 1755–62.

One of the distinctive features of the decoration is the elaborately tooled, imaginative gilding encircling the two reserves. The vignette-like representation of a stag being pursued through a forest glade by hounds and mounted huntsmen is framed by elaborate gold floral trails and trellis panels supporting birds. The painter Mutel (active 1754–9, 1765, 1771–4), who was responsible for the hunting scene, was a former decorator of fans and later specialised in landscape painting at Sèvres. The strong cool colours, in tones of olive green, brown and wispy blue-grey, are typical of his hand.

Soft-paste Sèvres porcelain,
gilt bronze pads

Measurements:
Overall height, 24.2; width, 33.9;
depth, 17.8

Marks:
Painted in blue: interlaced *LL*s enclosing
the date-letter *E* for 1757/8, and a pair of
calipers, the mark of the painter Mutel.

Provenance:
Acquired by George IV
RCIN 36071
Cat. no. 13

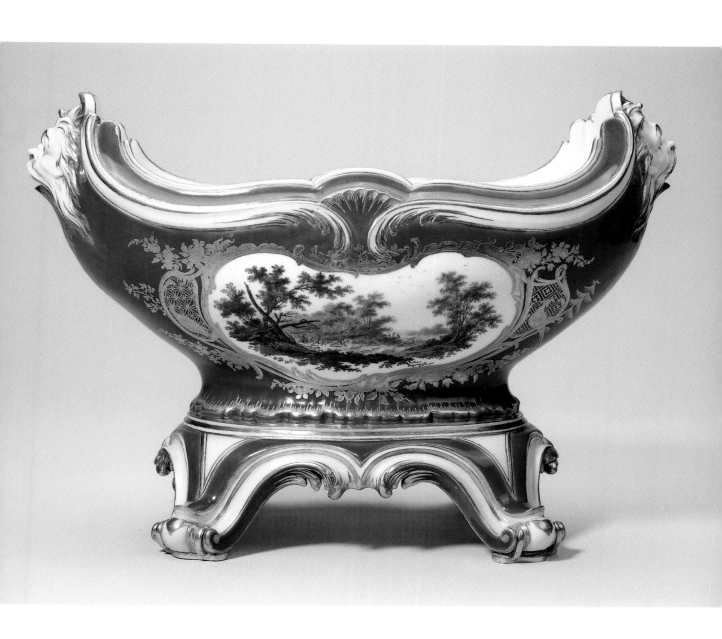

FLOWER VASE

c.1760
(*caisse à la Mahon* or *cuvette Mahon*) 2nd size

Named to commemorate the seizure by the French of the British-held town of Mahon on the island of Menorca in May 1756, at the start of the Seven Years War between France and England (1756–63), this *cuvette Mahon* is one of the finest examples produced. The painted scene depicting peasants drinking – one of whom stands brandishing an empty pitcher in the direction of a serving wench – may be inspired by a detail taken from *La Quatrième Fête Flamande*, engraved by Philippe Le Bas (1707–83) after David Teniers the Younger.

A striking feature of the vase is its *bombé* form, decorated with a predominant *bleu lapis* ground, overlaid with gold trellis, *caillouté* patterns and green bands. On the reverse side, the ornate swirling foliate roundel illustrates the opulence of the rococo style.

Soft-paste Sèvres porcelain, dark blue ground (*bleu lapis*), gilt bronze pads

Measurements:
Overall height (incl. gilt bronze pads), 17.3; width, 27.2; depth, 15.4

Marks:
No painted marks

Provenance:
Acquired by George IV
RCIN 36073
Cat. no. 17

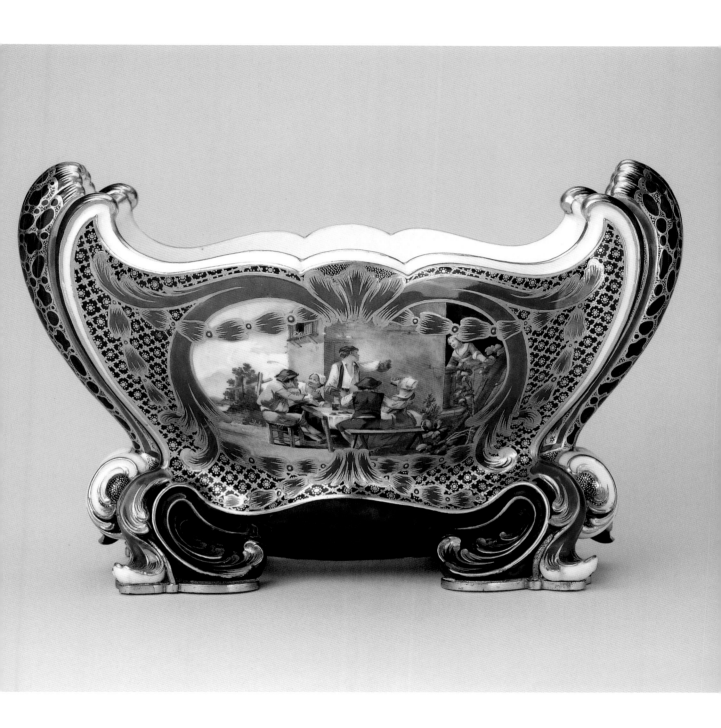

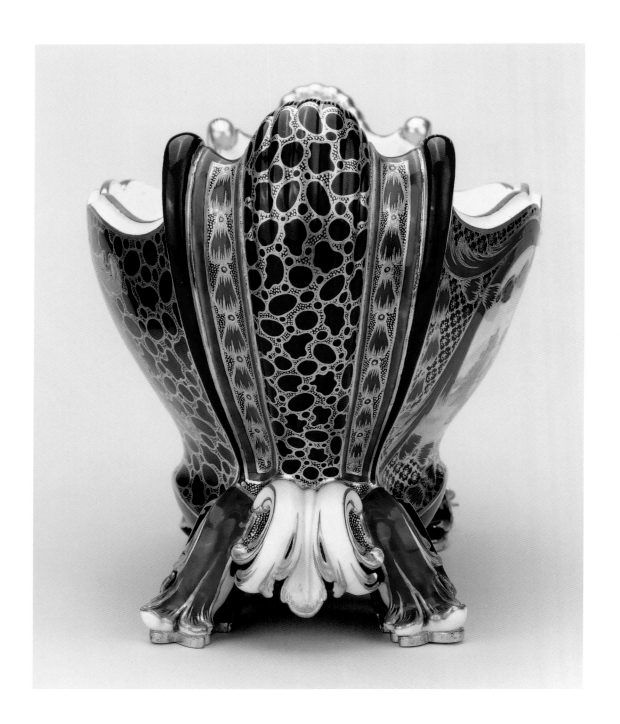

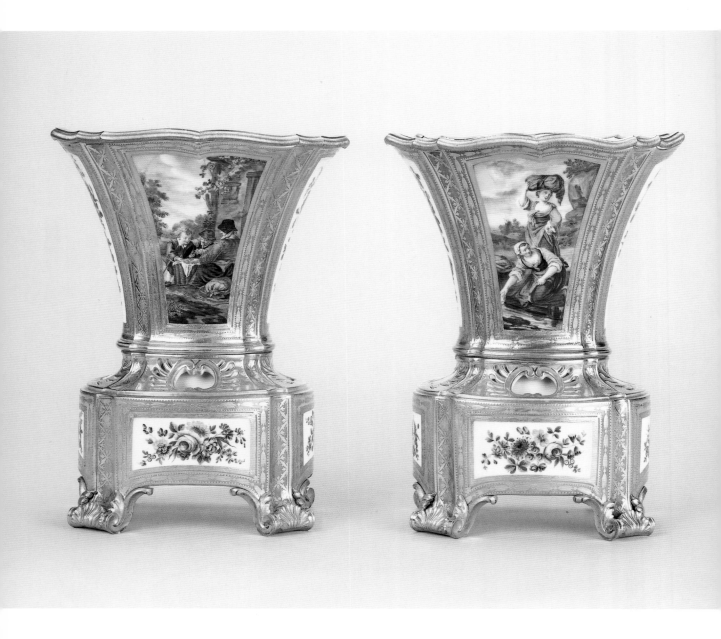

PAIR OF FLOWER VASES
(IN TWO PARTS)
*c.*1759–61
(*vase hollandois nouvelle forme* or *vase hollandois nouveau ovale*) 3rd size

The *vases hollandois* were among the most popular shapes created by the Vincennes–Sèvres manufactory. One of two new versions created in 1757/8, this *vase hollandois nouveau ovale* was produced in five sizes and was occasionally fitted with porcelain flowers.

Painted with a *petit verd* ground, the vases are each decorated with a scene. One depicts two eager children grabbing at sweetmeats which a woman is presenting on an upturned basket, and the other shows two washerwomen by a stream. The scenes reproduce details taken from the painting *Rendez-vous de Chasse* by the Flemish artist Carel van Falens (1683–1733). Together with its pair, *Halte de Chasseurs*, they formed his *morceau de réception* at the Académie Royale de Peinture in 1726. The scenes painted on the vases are the same way round as in the paintings and the palette is also very similar, which suggests that the Sèvres artists were using as models either the original oil painting or faithful copies, rather than an engraving. The gilt bronze mounts are possibly later English additions.

Soft-paste Sèvres porcelain, pale blue ground (*petit verd*), gilt bronze mounts

Marks:
No painted marks

Measurements:
Overall heights (incl. mounts), 24.1; widths, 17.3 and 17.6; depths, 14.5 and 14.7

Provenance:
Purchased in Paris for George IV by François Benois at a cost of £80. RCIN 4963.1–2
Cat. no. 21

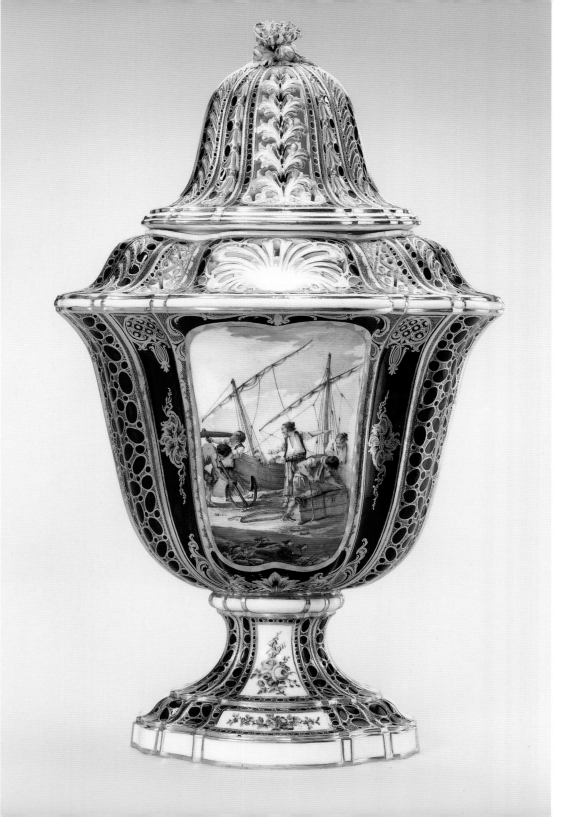

Pot-pourri Vase and Cover

c.1761
(*vase Boileau rectifié*)

The sinuous lines and convex and concave curves make this an ambitious design for Sèvres. The complexity of its shape may account for its rarity – only five examples of this type are known.

The model was named after Jacques-René Boileau de Picardie, Director of the Sèvres manufactory (1751–72), and the earliest example dates from 1757/8. The original model was not intended for use as a *pot-pourri* vase. A modified and richer design was produced in 1762, incorporating an elaborate pattern of pierced decoration on the neck and cover. The only two examples of this later design are both in the Royal Collection.

The decoration of the vase is particularly accomplished. The *bleu lapis caillouté* ground is complemented by a marine scene on the front and flowers on the reverse, attributed to Jean-Louis Morin (active 1754–87). Of particular beauty is the richly tooled and burnished gilding in the full Louis XV style, which accords perfectly with the majestic form of the vase and cover.

Soft-paste Sèvres porcelain, dark blue pebbled ground (*bleu lapis caillouté*)

Measurements:
Height, 46.4; width, 28.0; depth, 23.1

Marks:
Painted in blue: interlaced *LL*s

Provenance:
Acquired by George IV
RCIN 2299
Cat. no. 22

GARNITURE OF THREE VASES

1764

(vase à bâtons rompus) 1st size;
(vase ferré) 1st size

The military encampment scene was a popular decorative theme on similarly shaped Sèvres vases during the 1760s. The scenes depicted here are particularly fine examples of Jean-Louis Morin's painting, executed when he was at the height of his powers. The reserves on the pair of flanking *vases ferrés* represent, on the left, the provision of drink and, on the right, of food, while the centre vase depicts a brawl outside a sutler's tent.

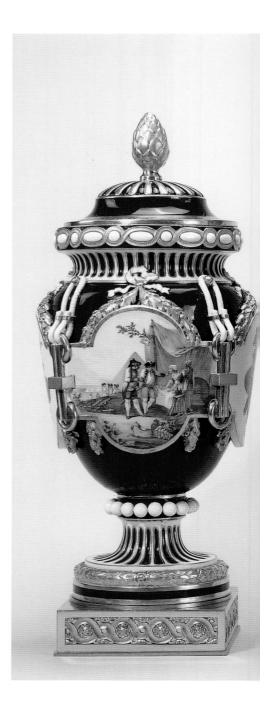

Soft-paste Sèvres porcelain, dark blue ground *(bleu nouveau)*, gilt bronze plinths

Measurements:
Flanking vases:
Overall heights, 47.5 and 48.0;
heights (excl. plinth), 42.9 and 43.3;
widths, 18.9; depths, 19.2 and 19.4
Centre vase:
Overall height, 53.0;
height (excl. plinth), 46.3;
width, 29.8; depth, 19.7

Marks:
Flanking vases: painted in blue: interlaced *LL*s enclosing the date-letter *L* for 1764, with (to the left) *M*, the mark

of the figure painter Jean-Louis Morin. Centre vase: painted in blue: interlaced *LL*s enclosing the date-letter *L* for 1764

Provenance:
Purchased by Lord Yarmouth on behalf of George IV in 1817.
RCINs 2289.1–2 and 2290
Cat. nos 27 and 40

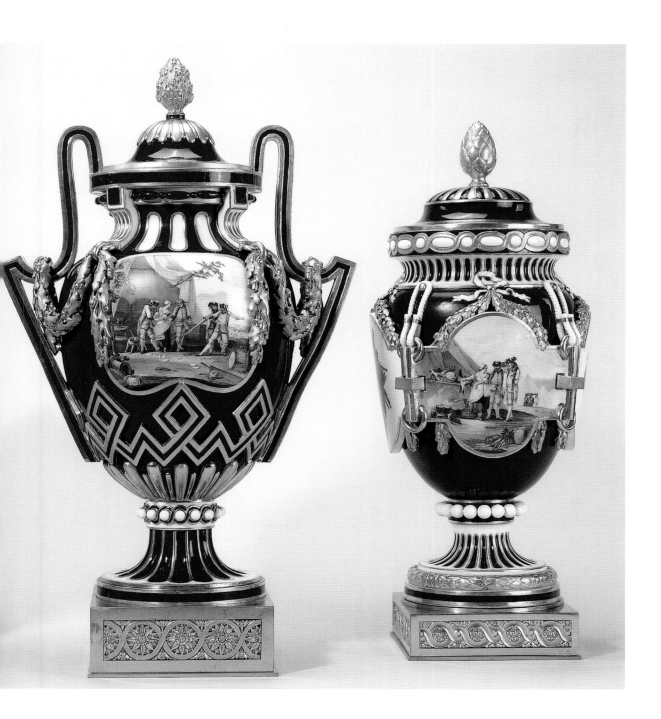

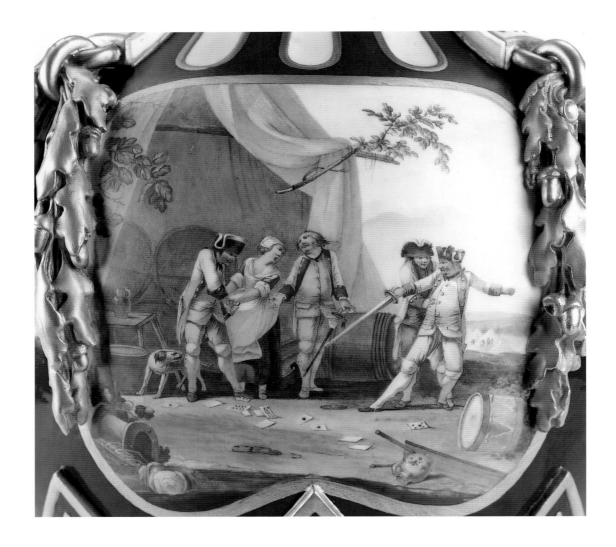

The possibility that Morin had first-hand knowledge of camp life when his father was an army surgeon may well account for the convincing look to these scenes and the apparent authenticity of some of the colours of the uniforms. The six trophies on the back and sides of the *vases ferrés* are based on the compositions of Jean-Charles Delafosse (1734–89), as engraved by Pierre-François Tardieu (1711–71).

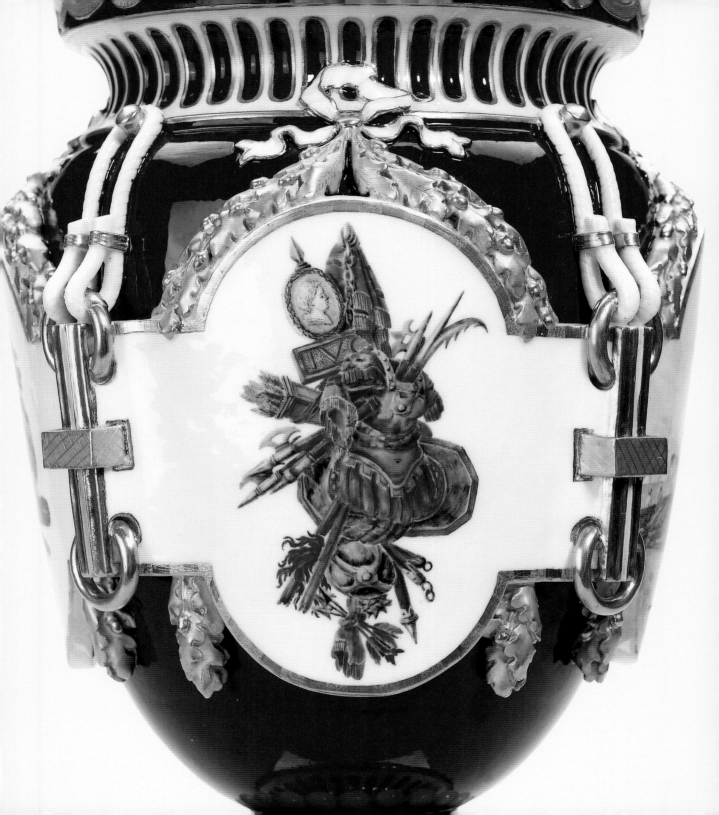

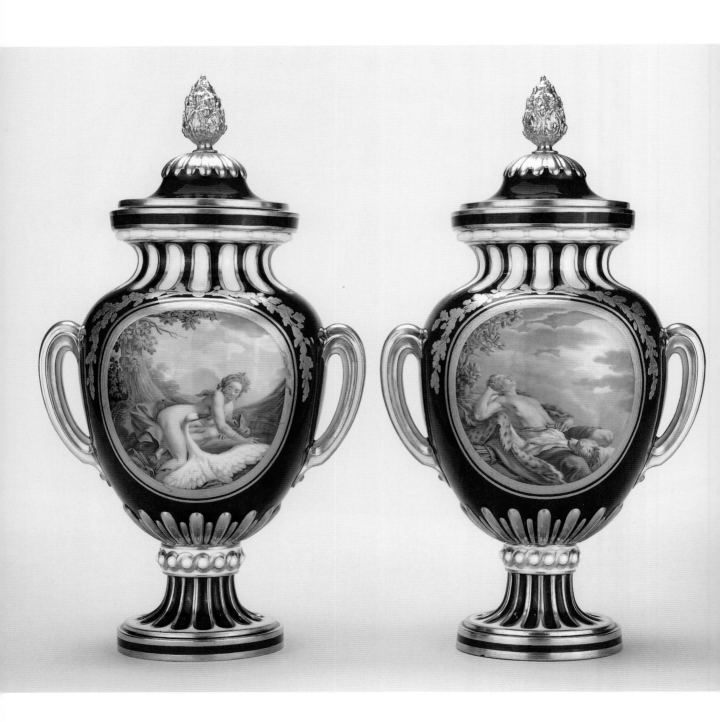

Pair of Vases and Covers

1772

(*vase à bâtons rompus*) 2nd size

The oval reserves are painted on the front with mythological scenes of Leda and Endymion, and on the reverse sides with bunches of fruit and flowers suspended on a ribbon.

Leda, who is about to be seduced by Zeus in the guise of a swan, reclines on turquoise blue drapery. In a moon-lit scene, Endymion, whose beauty so enraptured Silene (the moon) that she condemned him to eternal sleep so that she could kiss him, lies on an animal skin, watched over by his hound. Both scenes are copied from engravings by Nicolas de Launay (1739–92) after the painter Jean-Baptiste-Marie Pierre (*c*.1713–89).

Soft-paste Sèvres porcelain, dark blue ground (*bleu nouveau*)

Measurements:
Heights, 39.5 and 39.8; widths, 21.5 and 21.6; depths, 16.2 and 16.3

Marks:
Painted in blue: interlaced *LL*s enclosing the date-letter *T* for 1772, with (below) *K*, the mark of the painter Charles-Nicolas Dodin.

Provenance:
Acquired by George IV in 1813 from the dealer Robert Fogg, as part of a three-piece *garniture* with the *vase Angora* (see p. 74).
RCIN 36103.1–2
Cat. no. 41

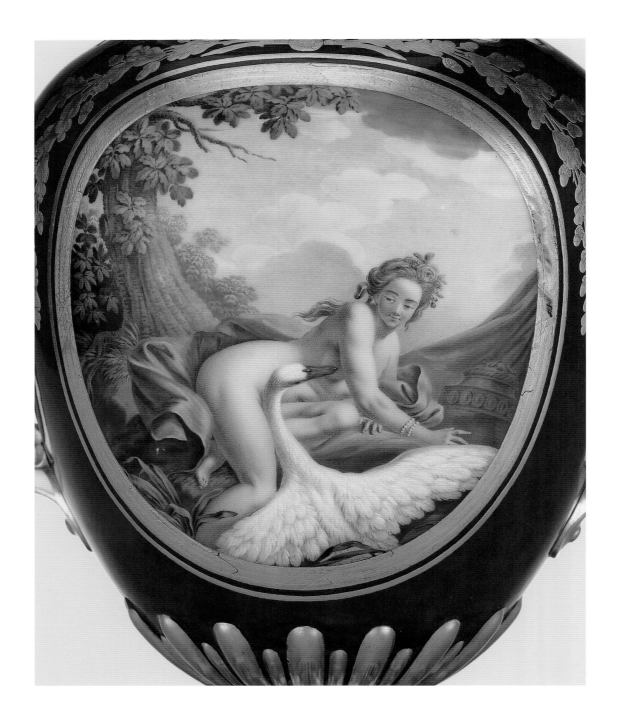

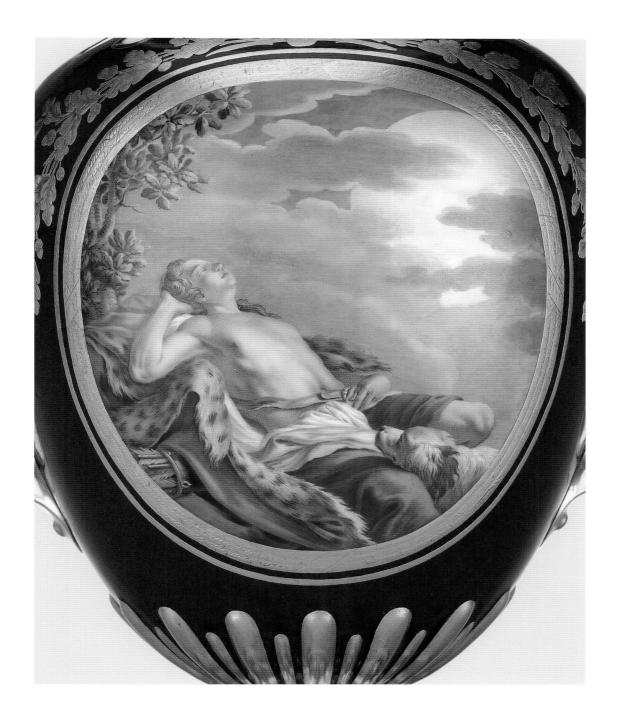

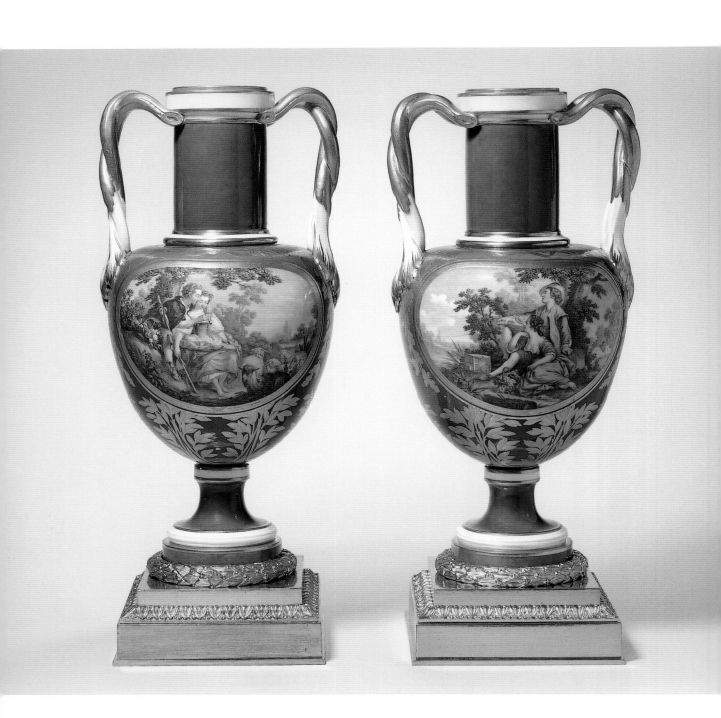

PAIR OF VASES
1768
(*vase Bachelier à anses tortillées*)

The two pastoral scenes on the front of the vases, confidently attributed to the Sèvres painter Charles-Nicolas Dodin (active 1754–1803), are copied from engravings after François Boucher (1703–70), *La Pipée* by Gilles Demarteau (1722–76) and *L'agréable Leçon* by René Gaillard (1719–90). On the reverse sides, complementary elements of bucolic pastimes are incorporated into the trophies. The finely tooled gilded sections, which were intended to enhance the richness of decoration and the sparkling effect of reflected candlelight, are skilfully crafted on the six upright myrtle sprays of the lower section and the broken zigzag line on the gold band around the back reserve. Formerly in the collection of Queen Charlotte, the vases were acquired by her son, George IV.

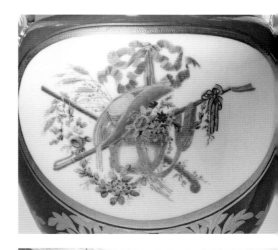

Soft-paste Sèvres porcelain, gilt bronze plinths

Measurements:
Overall heights, 36.5;
heights (excl. base), 31.0;
widths, 15.8; depths, 14.5

Marks:
On one vase only: painted in mauve: interlaced *LL*s enclosing the date-letter *P* for 1768

Provenance:
Purchased in 1819 by George IV from the estate of his mother, Queen Charlotte.
RCIN 31035.1–2
Cat. no. 46

Two Vases and Covers
*c.*1770

Though the vases differ only in minor details, they are not considered a pair. Interesting comparisons illustrate the manufactory's adept use of templates for gilded and painted

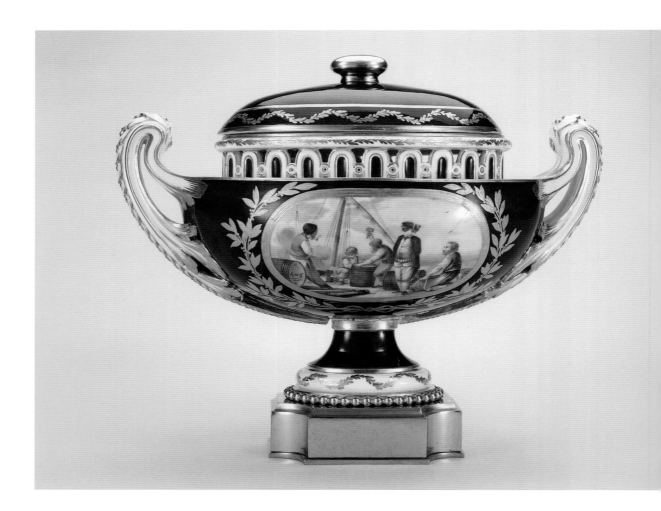

decoration and the minor modifications of shape. For example, the neck of the vase on the left is pierced to enable it to be used for pot-pourri, and the treatment of the flat shoulders of the vase on the right is decorated with the *bleu nouveau* ground, overlaid with a delicate gilded trelliswork and leaf trail.

The marine scene, a popular subject at Sèvres in the 1760s and 1770s, was not confined to vases. The scene on these vases

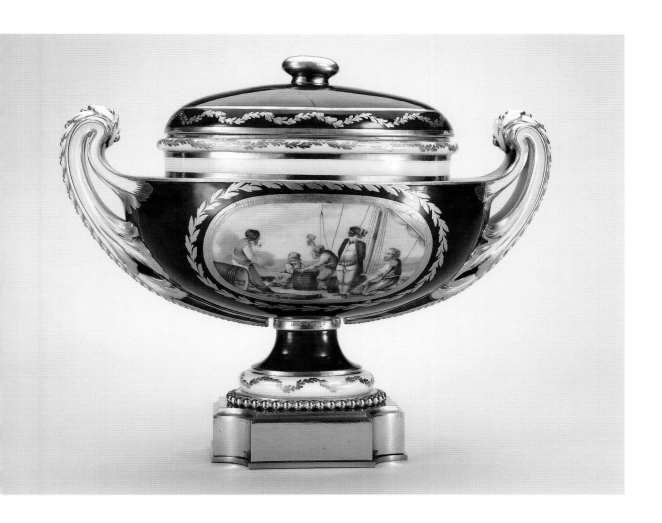

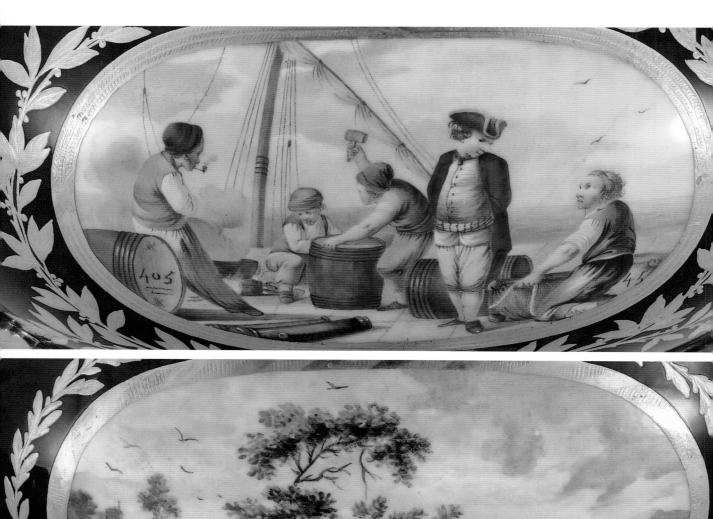

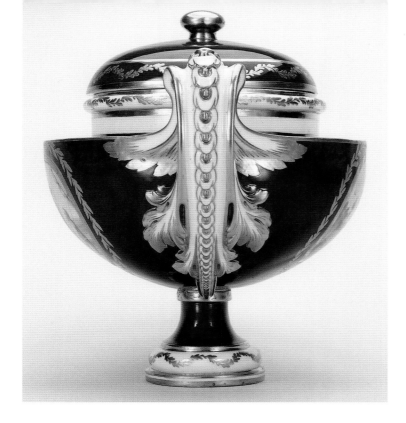

is known to have been reproduced on seven other ornamental and useful wares, possibly all painted by Jean-Louis Morin.

As the colours of the clothes worn by the sailors on these pieces are broadly similar, this would suggest that they were copied from a common colour template. The landscapes on the reverse sides may be the work of Jean Bouchet (active 1757–93).

Soft-paste Sèvres porcelain, dark blue ground (*bleu nouveau*), gilt bronze plinths

Measurements:
Overall heights, 24.8;
heights (excl. plinth), 21.3 and 21.5;
widths, 29.3; depths, 17.6 and 17.8

Marks:
Painted on both, in blue: interlaced *LL*s

Provenance:
Acquired by George IV from the widow of Quintin Craufurd in May 1820.
RCINs 2279 and 2280
Cat. nos 50 and 51

PAIR OF VASES AND COVERS

1767

(*vase à panneaux* or *vase à perles*) 1st size

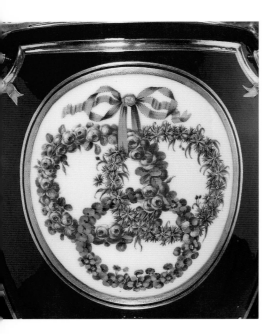

The *vase à panneaux* became a popular model of the late 1760s and 1770s. First created in 1766, it was reproduced in five variant shapes, each in three sizes. As was not uncommon in the eighteenth century, it was known in the manufactory by two names. The term *à panneaux* may refer to the panels on the body and neck, and *à perles* to the bosses on the handles, rim and cover.

The quayside scenes, which can confidently be attributed to Jean-Louis Morin, are known on a total of 11 other vases. The intertwined wreaths of roses, cornflowers and speedwell on the backs are attributed to Jean-Baptiste Tandart *l'aîné* (active 1754–1803).

An unusual feature of this pair is that the covers do not match. The cover of the vase on the left should belong to a *vase lézard* and was almost certainly a later substitution, made before the vases were acquired by George IV.

Soft-paste Sèvres porcelain, dark blue ground (*bleu nouveau*), gilt bronze plinths

Measurements:
Overall heights, 52.0;
heights (excl. plinth), 48.0;
widths, 26.3 and 26.7;
depths, 20.9 and 21.1

Marks:
Painted in blue: interlaced *LL*s
On one vase only: interlaced *LL*s
enclosing the date-letter *O* for 1767

Provenance:
Acquired by George IV
RCIN 2281.1–2
Cat. no. 52

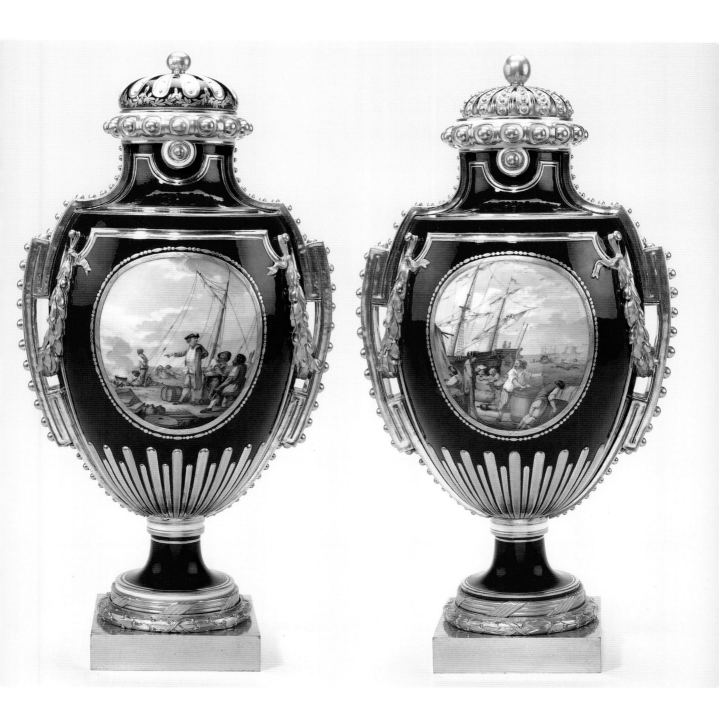

PAIR OF VASES AND COVERS
c.1766–c.1770
(*vase à panneaux* or *vase à perles*) 3rd size

This pair of vases is of the smallest size of *vases à panneaux*. The richness and quality of their gilding and finely executed painted decoration make these vases particularly handsome examples of the manufactory's production in the early neo-classical idiom.

The style of painting suggests that the two vases were painted by Morin in the late 1760s or early 1770s. The pattern of large gold pastilles, which may have been known in the eighteenth century as *mouches d'or* or *pois d'or*, found particular favour in the 1770s. Nine other vases in the Royal Collection are decorated in this way.

Of particular note are the detailed and superbly painted marine trophies on the backs of the vases. They include paddles, lobster pots, fishing nets, anchors, baskets, strings of pearls and reeds. The most likely candidate for the painting of the trophies is either Louis-Gabriel Chulot (active 1755–1800) or Charles Buteux *l'aîné père* (active 1756–82).

Soft-paste Sèvres porcelain, dark blue ground (*bleu nouveau*)

Measurements:
Heights, 30.5; widths, 17.5 and 17.6; depths, 13.8 and 13.9

Marks:
On left-hand vase: painted in blue: interlaced *LL*s next to a lower-case *m*, the mark of the painter Jean-Louis Morin and *9*, possibly the mark of the painter and gilder Charles-Nicolas Buteux *fils aîné*.

Painted in dark blue: *N*. (unidentified mark).
On right-hand vase: painted in mauvish brown: interlaced *LL*s enclosing an (?)*r*, the date-letter for 1770, beside a lower-case *m* for Morin.

Provenance:
Acquired by George IV
RCIN 2302.1–2
Cat. no. 53

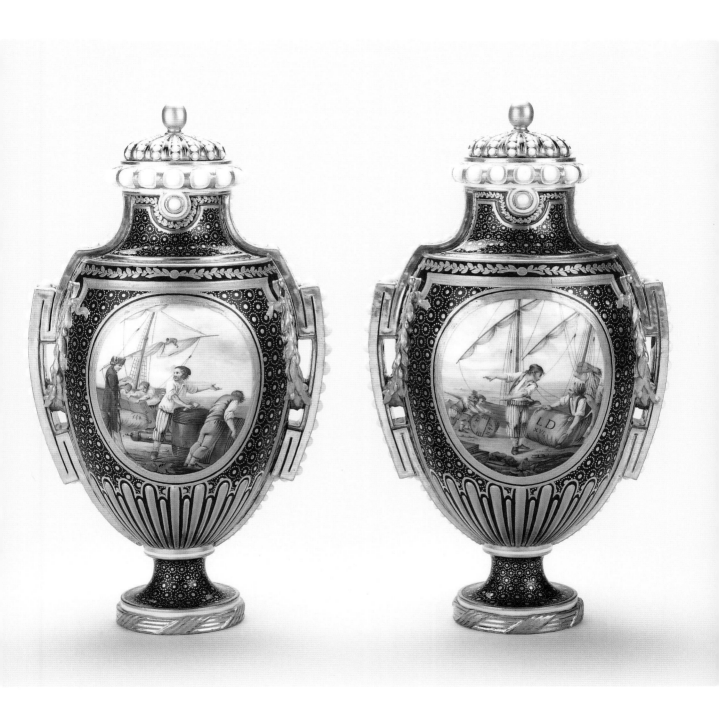

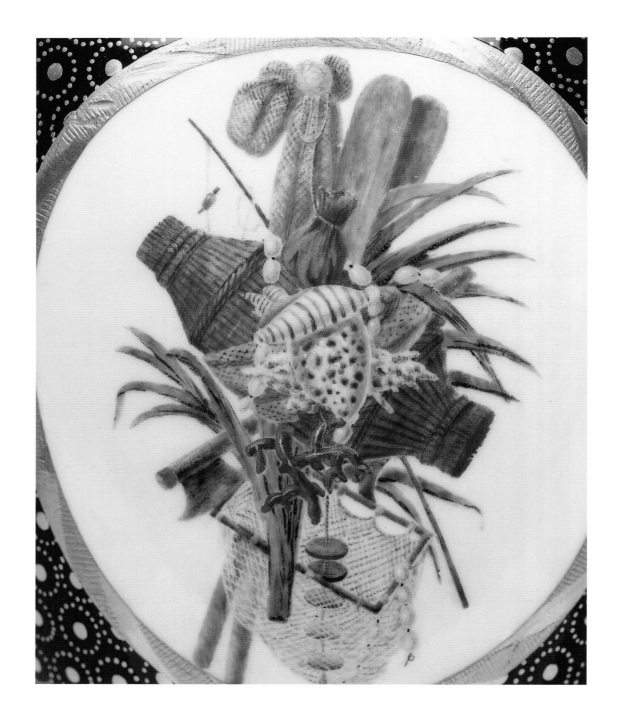

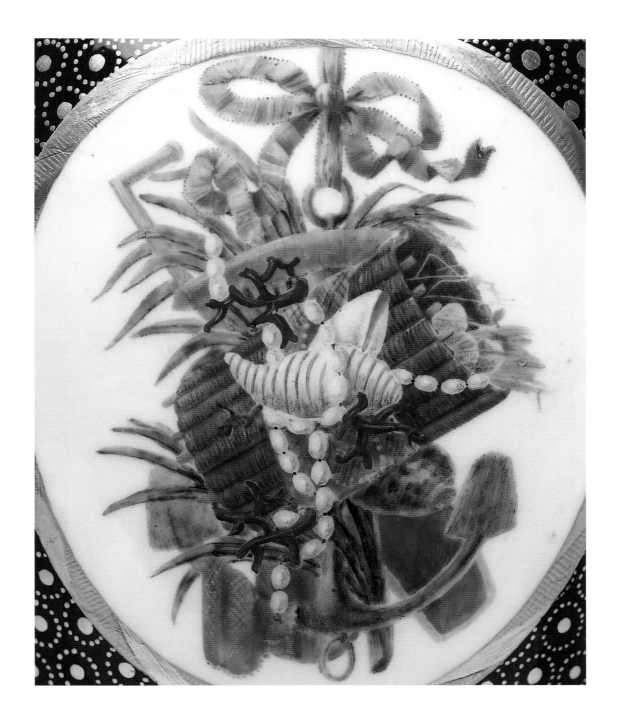

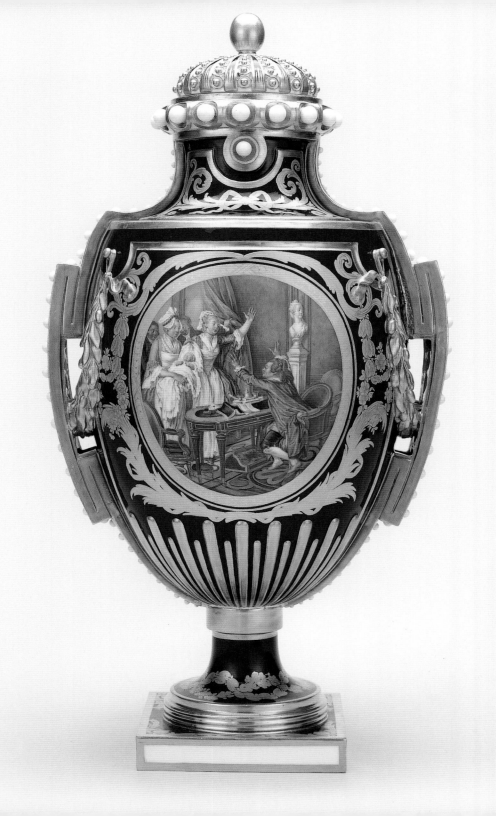

VASE AND COVER
1779–82
(*vase à panneaux* or *vase à perles*) 1st size

The front reserve depicts the jubilant scene of a newborn baby being presented to his father, who, seated in a *bergère* (armchair) at a table in the Louis XVI style, throws up his hands in delight as he greets his son (see p. 1). The scene has been faithfully copied by the Sèvres artist, with only minor modification, from the 1776 engraving *C'est un Fils, Monsieur!*, after the designs by Jean-Michel Moreau *le jeune* (1741–1814). The print formed part of a successful suite, published in three volumes between 1775 and 1783, which was highly regarded by connoisseurs at the time. Illustrations from this publication appear on no fewer than seven vases in the Royal Collection, including the two pairs of *vases des âges* (see pp. 92 and 96). The painting of the reserve recalls the styles of Pierre-André Le Guay *le jeune* (active 1772–1817) and of Antoine Caton (active 1749–98).

On the back is a lakeside scene with prominent hollyhocks and roses in the foreground, which may be the work of Edmé-François Bouillat (active 1758–1810).

Soft-paste Sèvres porcelain, dark blue ground (*beau bleu*)

Measurements:
Height, 50.0; width, 26.6; depth, 20.6

Marks:
Painted in blue, within the neck: interlaced *LLs* above *B* (italic), mark of the gilder Jean-Pierre Boulanger *père*.

Provenance:
Acquired by George IV
RCIN 36095
Cat. no. 55

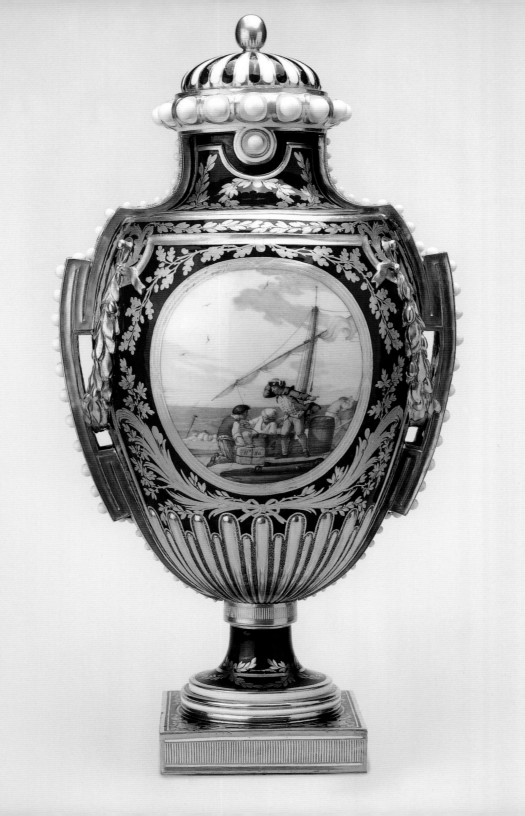

Vase and Cover

*c.*1780

(*vase à panneaux* or *vase à perles*) 1st size

The front reserve depicts a conventional marine scene: an officer wearing a tricorn hat directs sailors shifting cargo on the quayside. The scene may have been painted by Jean-Baptiste-Etienne Genest (active 1752–88). Like his contemporary Jean-Louis Morin, Genest was recognised as a specialist in this genre. The trophy on the back, possibly painted by Charles Buteux *l'aîné père*, incorporates complementary marine elements, including Neptune's trident, a shield emblazoned with a dolphin, a furled sail and a trumpet. Of particular note is the richly gilded decoration, skilfully enhanced with delicate tooling. This is a distinguishing feature of the work of Etienne-Henry Le Guay *père*, who was acknowledged as one of the finest gilders at the manufactory in the eighteenth century.

The vase is a version of the fifth and final variant design of the *vases à panneaux*, which is known to date from 1779. One characteristic of this variant is that it is fitted with a square porcelain plinth.

Soft-paste Sèvres porcelain, dark blue ground (*beau bleu*)

Measurements:
Overall height, 56.0; height (excl. gilt bronze plinth), 49.2; width, 26.7; depth, 21.1

Marks:
Painted in blue: interlaced *LL*s above *LG* (in script), the mark of the gilder Etienne-Henry Le Guay *père*.

Provenance:
Possibly part of a *garniture* – with a pair of *vases ferrés* (cat. no. 34) – bought in Paris by François Benois for George IV from Quintin Craufurd's widow in 1820. RCIN 2292
Cat. no. 56

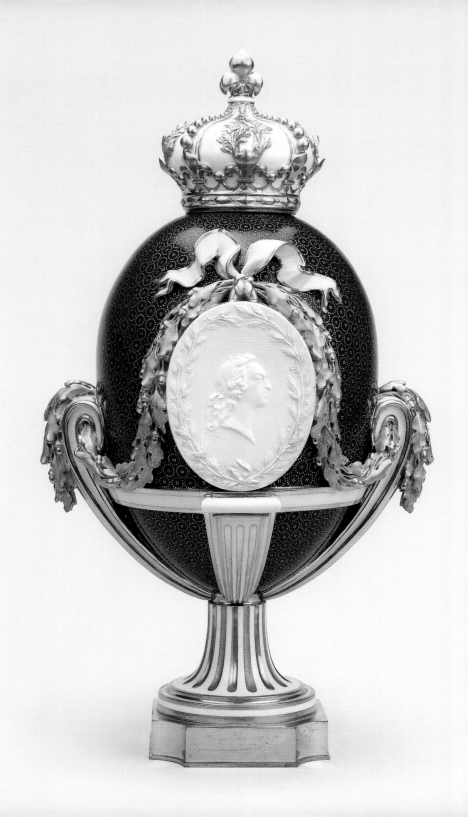

VASE AND COVER
*c.*1768
(*vase à médaillon du roi*)

Of the four known versions of this model, three are in the Royal Collection. This version, decorated with a *bleu nouveau* ground, gold *oeil-de-perdrix* pattern and low-relief medallions in biscuit porcelain, is the finest and most complete.

The youthful profile head of Louis XV reproduces a medallion designed by Edmé Bouchardon (1698–1762), first cast in bronze in 1738 and later used on coinage and commemorative medals. It is possible that this vase is one of three purchased by Madame du Barry from the factory in December 1768, shortly before she was presented at Court and acknowledged as the new official mistress of Louis XV.

The bold modelling, fine decoration and French royal association, symbolised by the profile medallion heads of Louis XV and the closed crown surmounted by the fleur-de-lis, were some of the qualities George IV admired most in Sèvres porcelain.

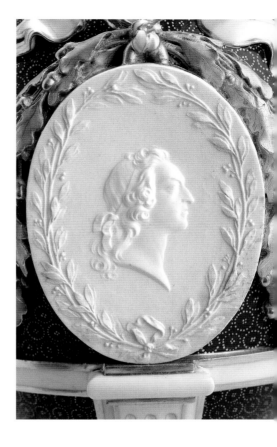

Soft-paste Sèvres porcelain, dark blue ground (*beau bleu*), gilt bronze plinth

Measurements:
Overall height, 39.8; height (excl. plinth), 37.6; width, 21.7; depth, 16.5

Marks:
No painted marks

Provenance:
Bought by George IV from Robert Fogg in 1812 for £63.
RCIN 4966
Cat. no. 58

VASE AND STOPPER
*c.*1767–70
(*vase à têtes de bouc*)

Vases fitted with goats' heads at the shoulders proved a successful line for the manufactory. The pear-shaped body of this model recalls that of a number of vases produced at Vincennes and Sèvres that are attributed to the designer Jean-Claude Duplessis. It seems likely that this version was also designed by him and may date from 1767. The crisply moulded goats' heads, grasping in their jaws vine branches laden with grapes, are particularly striking. The subtle burnishing of the gilded stripes of the foot ring is a refinement characteristic of the finest wares produced *c.*1770.

The predominance of the plain *bleu nouveau* ground gives emphasis to the uncluttered, clean lines of the vase. The decoration is largely confined to the two painted reserves, depicting, on the front, putti playing with military accoutrements, and, on the reverse, a military trophy incorporating a shield charged with the symbol of lightning, pikes and fasces (a bundle of rods with a projecting axe-blade). While the figure scene on the front is attributed to Charles-Nicolas Dodin, the trophy on the back may be the work of Louis-Gabriel Chulot.

Soft-paste Sèvres porcelain, dark blue ground (*bleu nouveau*)

Measurements:
Height, 34.5; width, 21.6; depth, 16.9

Marks:
No painted marks

Provenance:
Purchased by George IV from Robert Fogg on 24 October 1812 for £47 5s.
RCIN 36115
Cat. no. 61

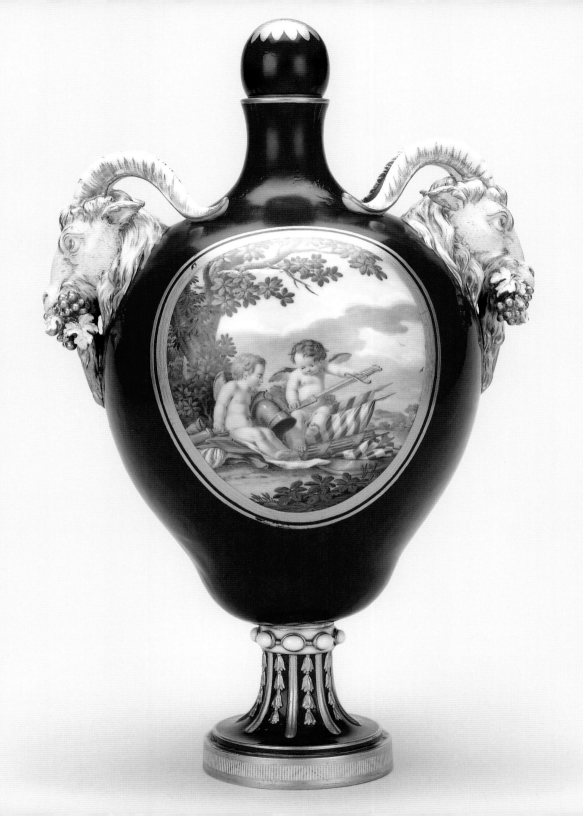

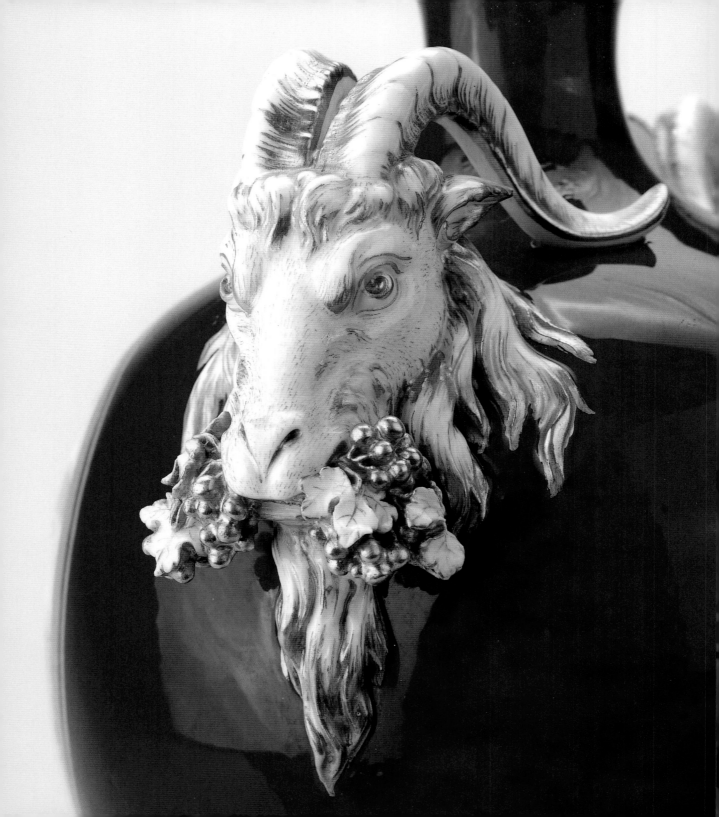

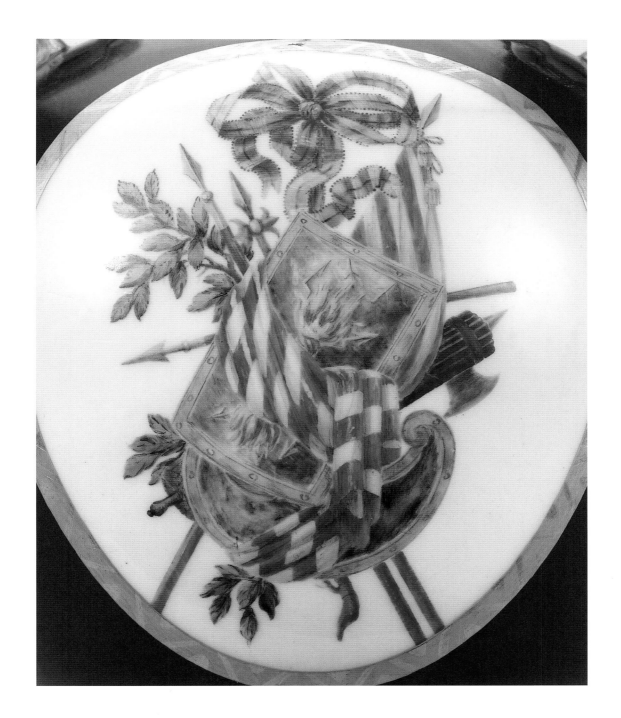

VASE AND COVER

*c.*1768–70

(*vase royal*)

One name by which this vase was known in the eighteenth century was the *vase royal*, which would seem appropriate given the size and complexity of its shape and its crown-like cover. Only three other examples are known, all dating from *c.*1768–70. One of these, painted with a green ground, is also in the Royal Collection.

The painting and gilding of the vase are of very high quality. Of special note are the gilded bands, tooled with alternating upright and reversed burnished T-shapes on a granulated ground. Classical medallion heads were painted at Sèvres principally during the years 1768–72, by, among others, Jean-Baptiste-Etienne Genest and Jean-Louis Morin, as well as Jacques Fontaine (active 1752–1807), who became a specialist in the genre. The scene on the front reproduces the engraving, *Les Charmes de la Vie champêtre*, by Jean Daullé (1703–63) after François Boucher. Although it bears no painter's mark, there is little doubt that it was painted by Charles-Nicolas Dodin.

It is possible that this vase once formed part of a very unusual *garniture* belonging to the comte d'Angiviller (1730–1810), which combined busts of Louis XVI and Marie-Antoinette placed either side of a *vase royal*.

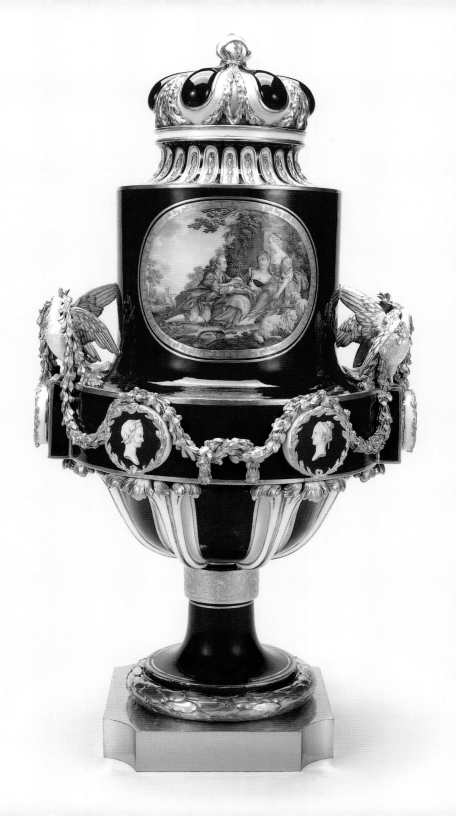

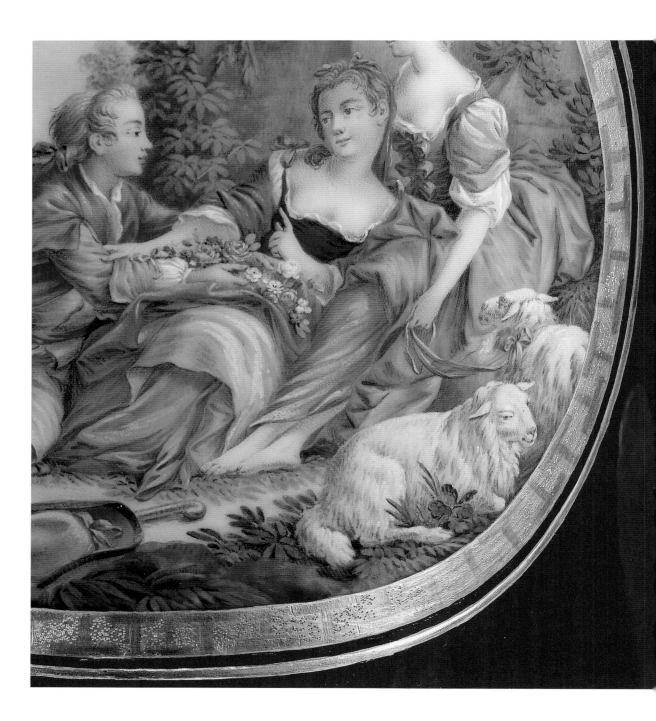

Soft-paste Sèvres porcelain, dark blue
ground (*bleu nouveau*), gilt bronze plinth

Measurements:
Overall height, 55.5;
height (excl. plinth), 51.5; width, 28.0;
depth, 25.7

Marks:
Painted in blue: interlaced *LL*s

Provenance:
Bought for George IV by Edward Holmes
Baldock at Lord Gwydir's sale on 21 May
1829 for £163 16s.
RCIN 2283
Cat. no. 64

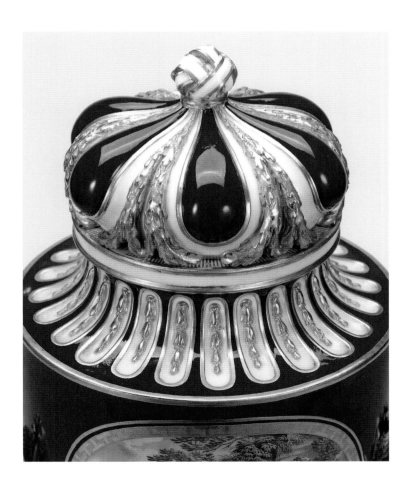

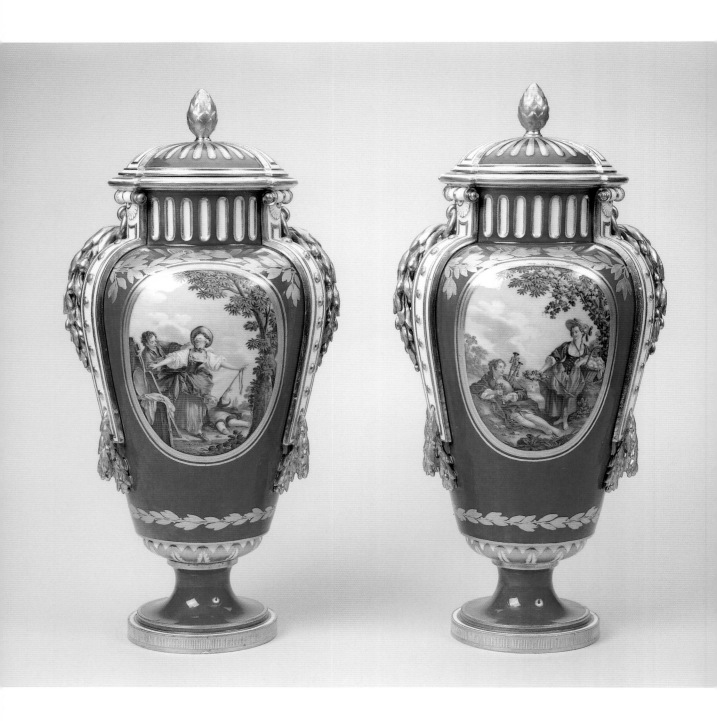

PAIR OF VASES AND COVERS

1771

(*vase à bandes*) 1st size

The skilful *trompe l'oeil* effect, combining moulded with flat decoration, was a successful decorative device employed at Sèvres. In this instance, the gilded high-relief leaf-and-berry garlands on the sides, seemingly suspended from the top by a ring and threaded through straps at the bottom, are visually extended by the finely tooled flat gilded laurel trails.

The pastoral scenes, painted by Dodin, depict (on the left) the game of blind man's buff, copied from the engraving *Le Colin Maillard* by Jacques-Firmin Beauvarlet (1731–97) after Jean-Honoré Fragonard (1732–1806), and (on the right) a reproduction of François Boucher's *Le Berger Récompensé*, as engraved by René Gaillard. The detailed landscape scenes on the back have not been traced to any particular source, although repetition of the same scenes suggests that templates of some sort were sometimes used as models.

This pair of vases is the earliest known to survive of the model created in 1769.

Soft-paste Sèvres porcelain, turquoise blue ground (*bleu céleste*)

Measurements:
Heights, 43.0 and 43.4; widths, 20.5 and 20.6; depths, 17.6 and 17.7

Marks:
Painted on both, in blue: interlaced *LL*s enclosing the date-letter *S* for 1771, with (below) *K*, the mark of the painter Charles-Nicolas Dodin.

Provenance:
Bought as part of a *garniture* (together with a *vase à panneaux* – cat. no. 54) purchased in Paris by François Benois for George IV from Quintin Craufurd's widow in 1820.
RCIN 36105.1–2
Cat. no. 71

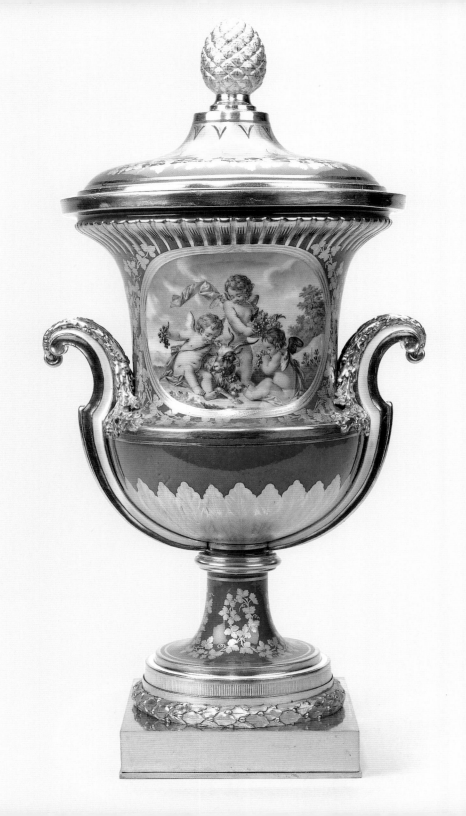

Vase and Cover
1775
(*vase momie rectifié*) 1st size

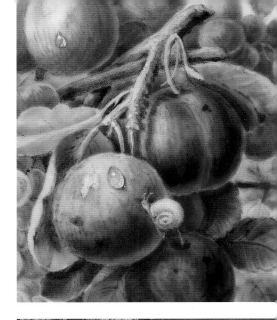

The vase of Medici shape, with ground colour of rich green, is painted with scenes evoking autumn and the wine harvest. On the front, putti clutching bunches of grapes are playing with a goat munching grapes. On the reverse side, the freshness of the bunches of fruit is enhanced by the amusing addition of dewdrops and a small snail on the plums. The bacchanalian theme is discreetly echoed in the particularly delicate and refined gilding incorporating vine-leaf trails.

The vase represents a slightly modified version of the *vase momie*, fitted with sphinx heads for handles, a version of which is held in the Royal Collection. The qualification '*rectifié*' was sometimes added to distinguish this later version from the original model.

Soft-paste Sèvres porcelain, gilt bronze plinth

Measurements:
Overall height, 48.3; height (excl. plinth), 43.6; width, 24.1; depth, 21.9

Marks:
Painted in mauve: interlaced *LL*s enclosing the date-letter *x* for 1775, with (below) *B* (in script), the mark of the gilder Jean-Pierre Boulanger *père*.

Provenance:
Acquired by George IV from Robert Fogg in 1813.
RCIN 2362
Cat. no. 81

VASE AND COVER
1772
(*vase Angora*) 2nd size

Painted by Charles-Nicolas Dodin, one of the most talented artists working at Sèvres, the mythological scene on the front reserve depicts the education of Cupid. The source for the scene was an engraving by René Gaillard, *L'Amour à l'Ecole*, after Jean-Baptiste Van Loo (1684–1745), in which Venus watches her son Cupid receiving instruction from Mercury.

The vase is one of the most sumptuous pieces ever produced by the factory. Its design dates from 1772 and it is thought to be the work of Jean-Jacques Bachelier (artistic director of the manufactory 1748/51–93). Of particular note are the three finely sculpted figures. Mounted on either side of the vase are an eagle trampling on a serpent and a King Charles spaniel barking. The knob of the cover is formed by a hissing Angora cat. These finely executed sculptural elements owe much to the *repareurs*, who picked out and sharpened the detail of the relief decoration.

Today, only two vases of this shape are known; both are in the Royal Collection.

Soft-paste Sèvres porcelain, dark blue ground (*bleu nouveau*)

Measurements:
Height, 46.5; width, 28.6; depth, 25.9

Marks:
Painted in blue: interlaced *LL*s enclosing the date-letter *T* for 1772, with (below) *K*, the mark of the painter Charles-Nicolas Dodin.

Provenance:
Acquired in 1813 by George IV as part of a *garniture*, with a pair of *vases à bâtons rompus* (see p. 40), from Robert Fogg for £346 10s.
RCIN 36101
Cat. no. 82

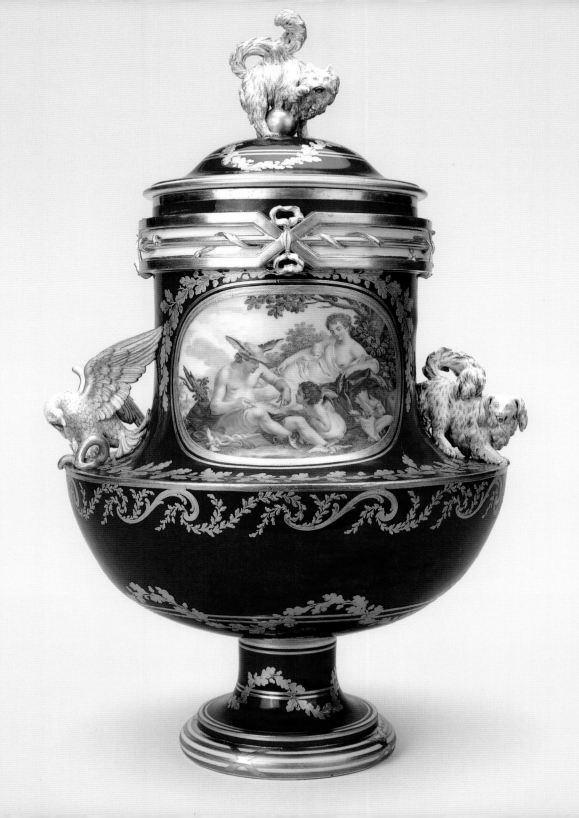

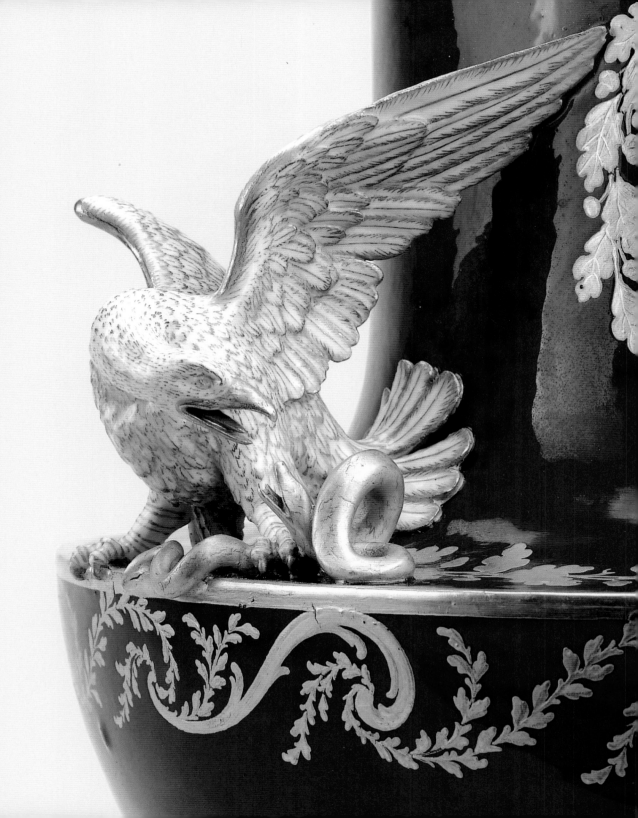

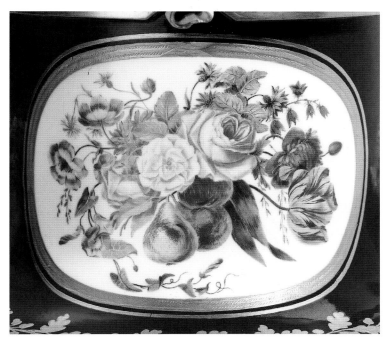

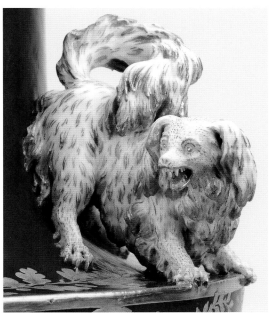

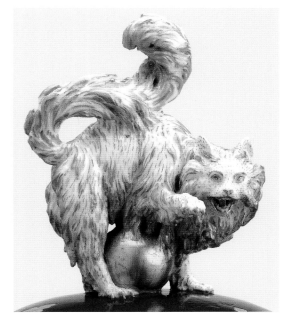

VASE AND COVER

*c.*1773

(*vase Angora*)

The bucolic scene on the front, which includes a young shepherd boy playing his recorder to entertain the two shepherdesses guarding their sheep by a stream, can be confidently attributed to Charles-Nicolas Dodin. One of the finest painters at Sèvres, the hallmarks of his distinctive style include a bright translucent palette, often with hints of autumnal tones, clusters of leaves treated as if they were bunches of bananas, particularly fine rendering of skin tone, and an overall mood of nostalgia imbuing his pastoral scenes.

The source for the scene is an engraving by Joseph Wagner (1706–80) after Francesco Zuccarelli (1702–88) which is still preserved at Sèvres. It is possible that this vase may have formed part of a five-piece *garniture* – now dispersed between four collections – that was purchased by Louis XVI's brother, the comte de Provence (the future Louis XVIII), in December 1773.

Soft-paste Sèvres porcelain, turquoise blue ground (*bleu céleste*)

Measurements:
Height, 43.2; width, 29.5; depth, 26.0

Marks:
Painted in gold: interlaced *LLs*, with (below) *B* (in script), the mark of the gilder Jean-Pierre Boulanger *père*.

Provenance:
Acquired by George IV
RCIN 36104
Cat. no. 83

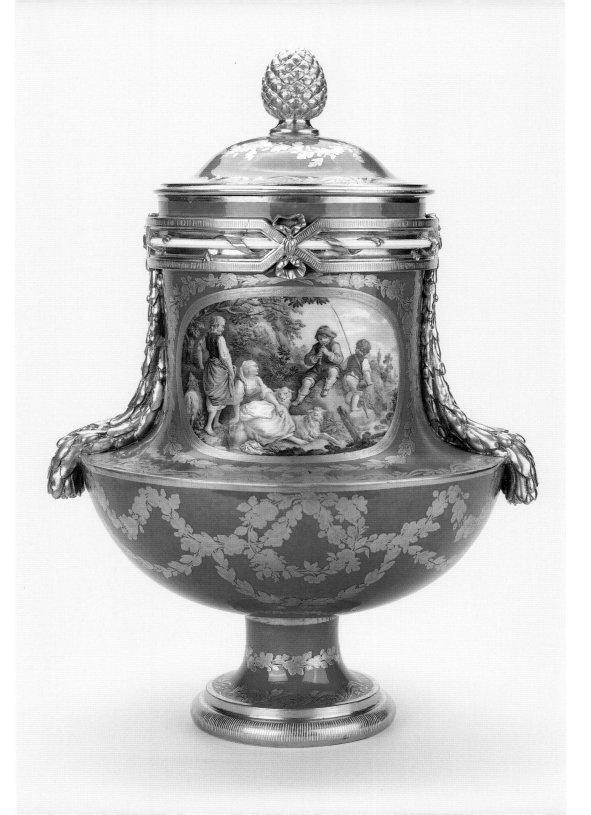

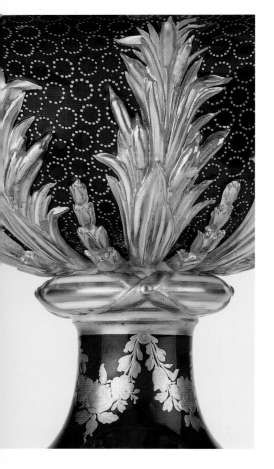

PAIR OF VASES
*c.*1772–8

(*vase Du Barry à guirlandes* or *vase Borie [?Barry] à 4 mascarons* or *vase fontaine Du Barry*)

The most striking feature of the vase is the exceptional sculptural quality of the crisply modelled relief ornament decorated in tooled and burnished gold. It can be likened to the chasing of the finest gilt bronze mounts in the Louis XVI style, and is a characteristic of a number of Sèvres vases dating from the 1770s.

The body of the vase, decorated with a *bleu nouveau* ground overlaid with gold circles of dots, is divided into three registers: the spirally fluted neck with flared rim; the central drum section, adorned with garlands, swags and four *espagnolette* (Spaniard) heads; and the bowl-shaped lower section, with applied gilded swirling bulrushes. The stem and foot are separately moulded.

Soft-paste Sèvres porcelain, dark blue ground (*beau bleu*)

Measurements:
Heights, 40.1 and 40.3;
widths, 25.7 and 26.2;
depths, 25.6 and 25.8

Marks:
Painted on both, in blue: interlaced *LL*s above *B* (in script), the mark of the gilder Jean-Pierre Boulanger *père*.

Provenance:
Acquired by George IV
RCIN 298.1–2
Cat. no. 84

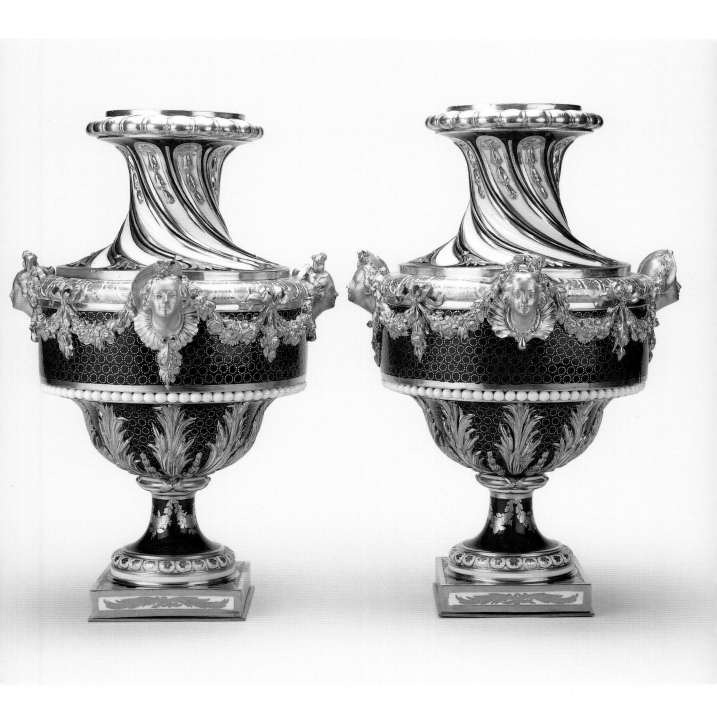

PAIR OF VASES AND COVERS

1773

(*vase fontanieux*) ?2nd size

The beauty of this pair of vases lies principally in the scenes and trophies which were painted with great delicacy and precision. The themes evoked are of tragedy and comedy. On one, where the mood is sombre, emblems allude to war, domination and death. Titles inscribed on the open books are of two tragedies by Voltaire (1694–1778): *Brutus* (first produced in 1730) and *Alzire* (first produced in 1736). On the other, the titles of the comedies *L'Avare* by Molière (1622–73) and *Le Joueur* by Jean-François Regnard (1655–1709) are accompanied by more cheerful emblems of music and the theatre.

The vases are named after designs adapted by the manufactory from Pierre-Elisabeth de Fontanieu's 1770 publication, *Collection de Vases Inventés, et Dessinés Par Mr de Fontanieu…* Three of his vases were reproduced at Sèvres, each in three sizes.

Soft-paste Sèvres porcelain, turquoise blue ground (*bleu céleste*)

Measurements:
Heights, 31.2; widths, 16.2 and 16.3; depths, 14.2 and 14.3

Marks:
Painted on both, in blue: interlaced *LL*s enclosing the date-letter *U* for 1773, with (below) the marks of a painter and two gilders: *K*, the mark of the painter Charles-Nicolas Dodin; *B* (in script), the mark of the gilder Jean-Pierre Boulanger *père*;

BD (scrolling), the mark of the gilder François Baudouin *père*.

Provenance:
Presumably acquired by George IV
RCIN 36084.1–2
Cat. no. 86

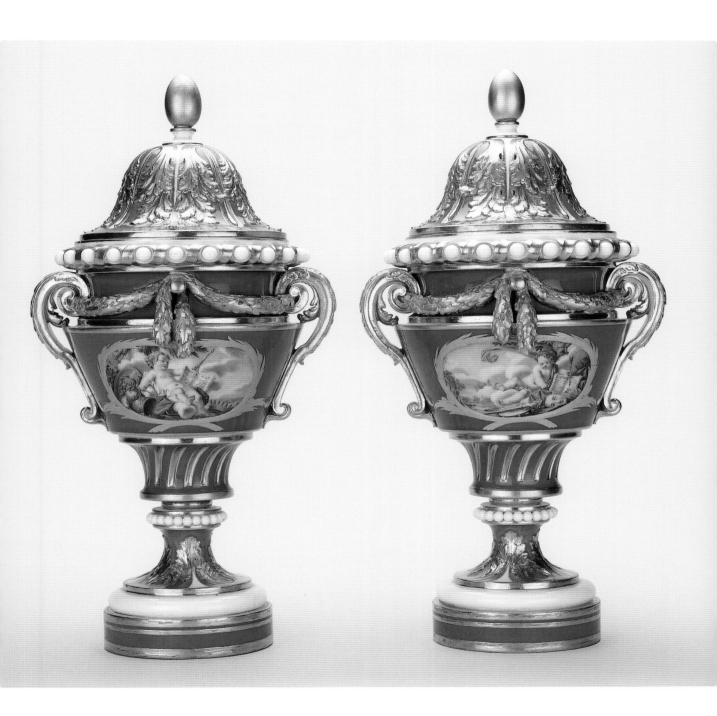

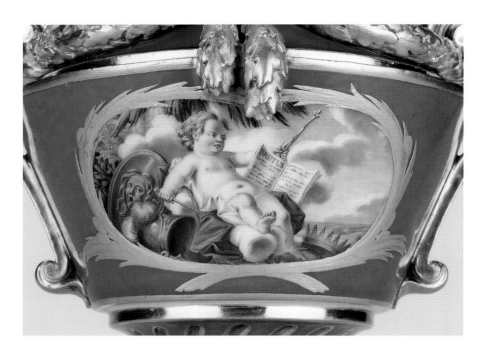

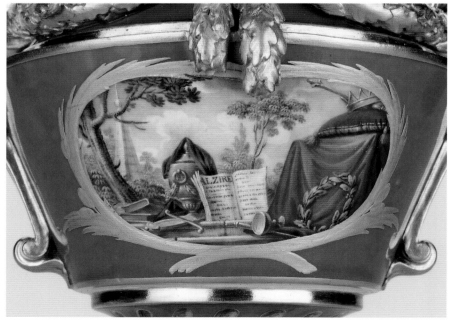

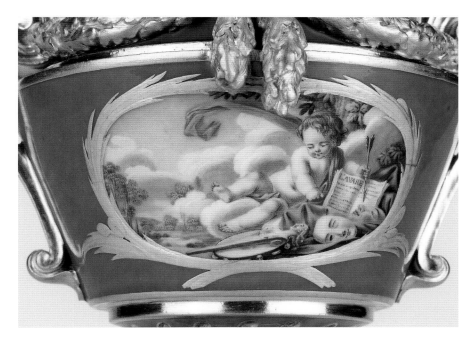

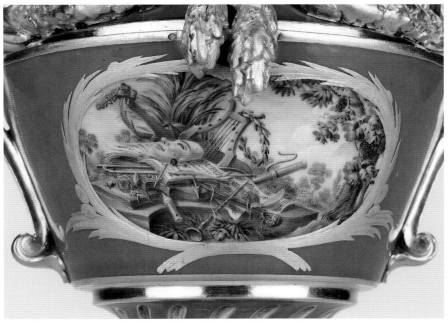

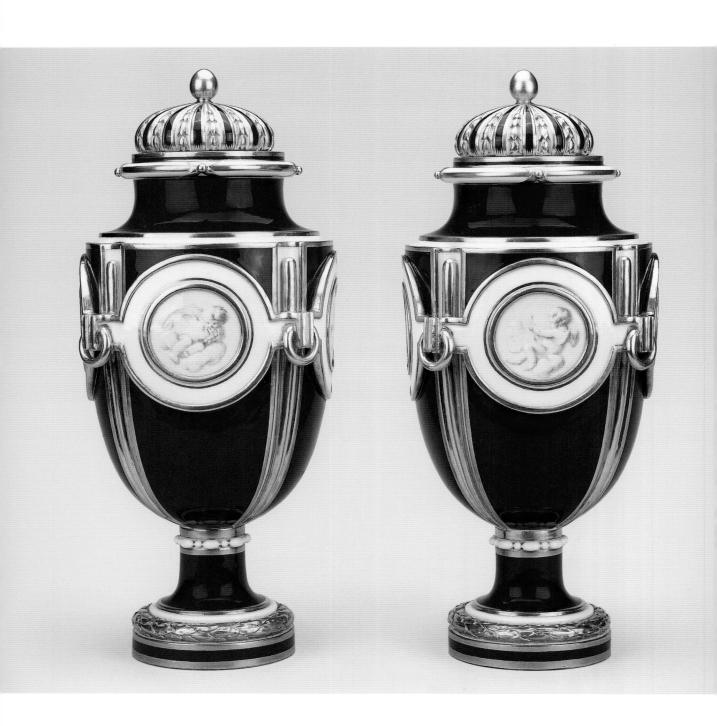

PAIR OF VASES AND COVERS
*c.*1772–5
(*vase solaire*) 2nd size

The broad expanses of *bleu nouveau* ground are set off by the striking burnished gold bands that follow the contours of the vase. The appeal of the vases lies in the clarity of form and the simplicity of the gilded decoration. The same restrained decorative style can be seen in the *vase à têtes de bouc* (see p. 62).

The medallions on the front and back, which are painted in *grisaille* with putti in clouds, and those on the sides with trophies in clouds, are emblematic of Love, Music and Gardening. Grey monochrome painting, inspired by classical low-relief sculpture, became a popular form of decoration at Sèvres during the late 1760s, in keeping with the prevailing fashion for neo-classical ornament. First mentioned in the Sèvres records in 1772, the *vase solaire* was produced in three sizes; this pair belongs to the middle size. The concept of four linked medallions is similar to that of the *vase ferré*, first introduced *c.*1761–2 (see p. 36).

Soft-paste Sèvres porcelain, dark blue ground (*bleu nouveau*), with gilded decoration

Measurements:
Heights, 34.0; widths, 14.2 and 14.4; depths, 14.2 and 14.4

Marks:
No painted marks

Provenance:
Presumably acquired by George IV
RCIN 36116.1–2
Cat. no. 88

GARNITURE OF THREE VASES

*c.*1773

(pair of *vases à gorges* or *vases à trois gorges* and a single ?*vase jardin*)

The pair of flanking vases formed part of a *garniture* with the ?*vase jardin* in the centre when purchased by George IV. As their decoration, gilding and plinths match, there are grounds for believing that they may have been conceived as a *garniture* from the beginning. Among the items bought by Louis XV on 23 December 1773 was a *garniture* of three vases that would seem to match these. The scenes on the vases complement each other: on the front, Turkish figures in garden settings, and on the back, trophies with Ottoman associations. It is possible that the Sèvres artist sought inspiration from *Le Sultan Galant*, engraved in 1768 by Louis Halbou (1730–1809) after Etienne Jeaurat (1699–1789).

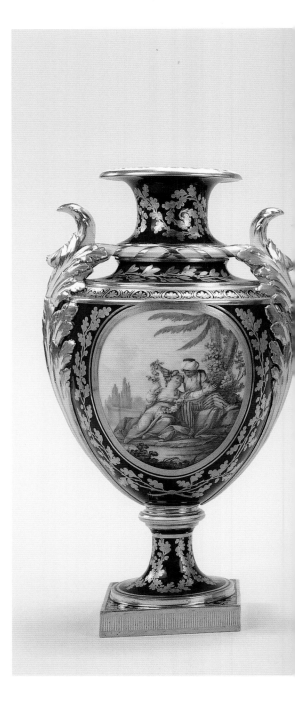

Soft-paste Sèvres porcelain, dark blue ground (*bleu nouveau*)

Measurements:
Flanking vases:
Heights, 34.5 and 34.6;
widths, 18.6 and 18.9;
depths, 15.4 and 16.0
Centre vase:
Height, 41.6; width, 23.2; depth, 19.5

Marks:
Flanking vases: no painted marks
Centre vase: painted in grey, interlaced

*LL*s above *LG* (in script), the mark of the gilder Etienne-Henry Le Guay *père.*

Provenance:
Purchased by George IV from Robert Fogg in 1818.
RCINs 36109.1–2 and 4967
Cat. nos 89 and 90

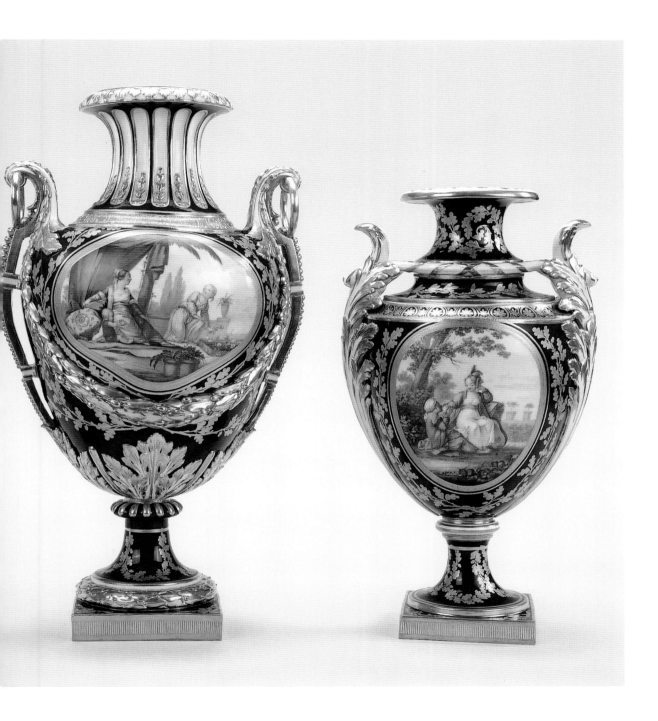

The name *vase à trois gorges* may be explained
by the three cavetto (concave) mouldings of the neck.
The moulded and gilded relief work is of exceptionally
high quality. In particular, the acanthus leaf handles
create an unusual feature as they break away from the
upper part of the vase, seemingly tied with a gilded
ribbon, to form a plume.

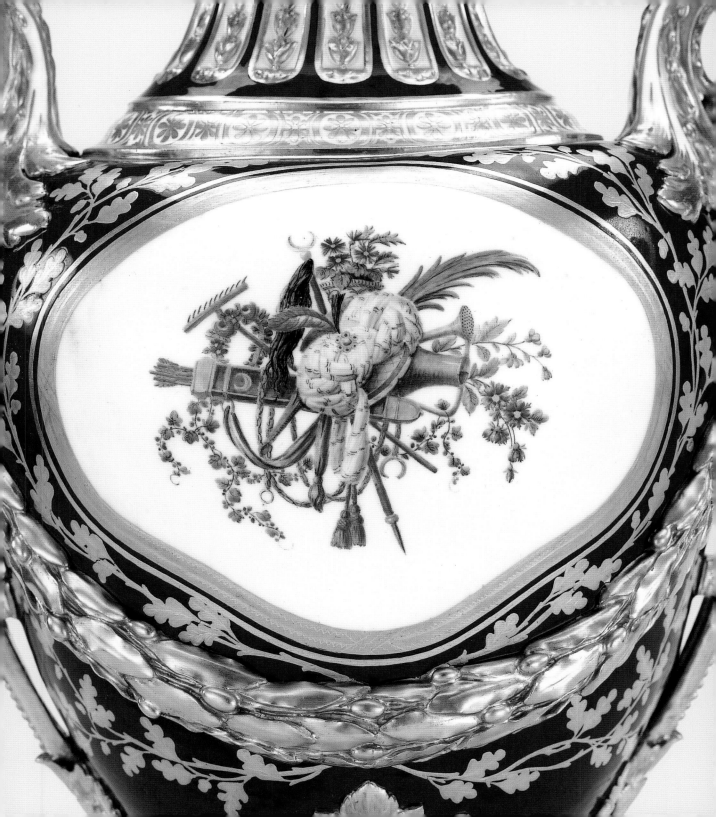

PAIR OF VASES AND COVERS
1782
(*vase des âges*) 2nd size

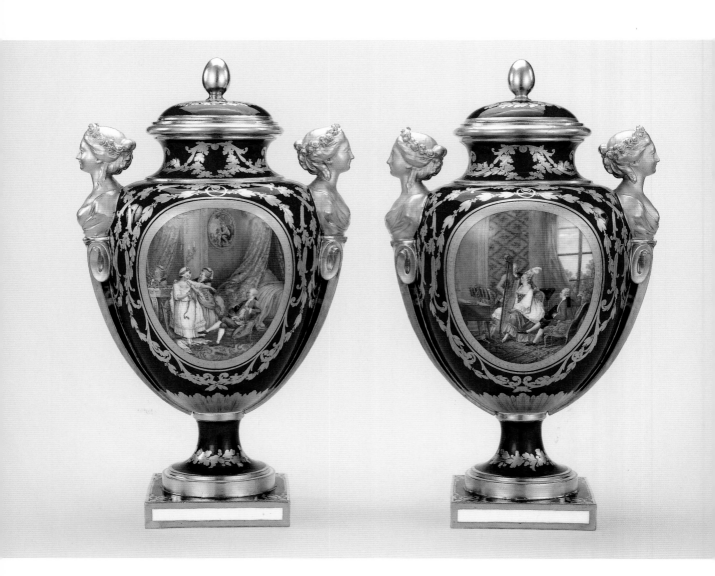

Originally forming part of a *garniture* of five *vases en suite* with the pair of *vases des âges* on page 96, this pair is of the larger second size, adorned with gilded female herm heads. The scene on the left, taken from the engraving by Nicolas de Launay after Sigmund Freudenberger (1745–1801), entitled *Le Petit Jour* (see p. 94), depicts a luxuriously appointed bedroom in which a young woman, assisted by her companion, dresses in front of a fireplace. The reserve on the right reproduces the engraving *L'accord parfait* by Isidore-Stanislas-Henri Helman (1743–1806/9) after Jean-Michel Moreau *le jeune*. In both instances, the Sèvres painter Dodin has hardly deviated from his models. The story of the complete *garniture* unfolds thus:

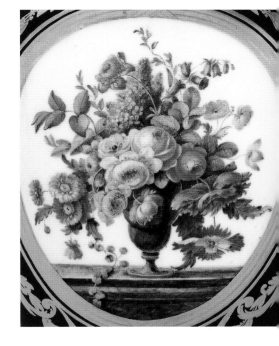

1. The toilette of the lady of the house: *Le Petit Jour* (2nd size).
2. Domestic harmony reigns: *L'accord parfait* (2nd size).
3. The doctor's visit: *Déclaration de la Grossesse* (3rd size).
4. Confinement is imminent: *N'ayez pas peur ma bonne Amie* (3rd size).
5. The joys of motherhood: *Les Délices de la Maternité* (1st size).

Soft-paste Sèvres porcelain, dark blue ground (*beau bleu*)

Measurements:
Heights, 41.0 and 42.0; widths, 23.5 and 23.6; depths, 18.7 and 18.9

Marks:
Painted on both, in blue: interlaced *LL*s enclosing the date-letters *EE* for 1782 (date-letters missing on one vase), above *K*, the mark of the painter Charles-Nicolas Dodin, and, in gold, *HP*, the mark of the gilder Henri-Martin Prévost *l'aîné*.

Provenance:
Acquired by George IV, possibly from Robert Fogg, on 3 August 1812 for £157 10s.
RCINs 36112 and 36096
Cat. no. 97

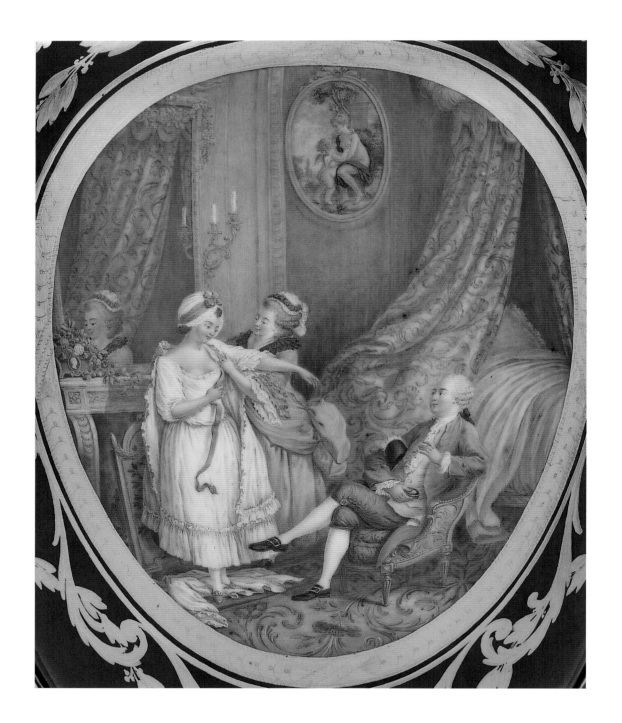

Pair of Vases and Covers
1782
(*vase des âges*) 3rd size

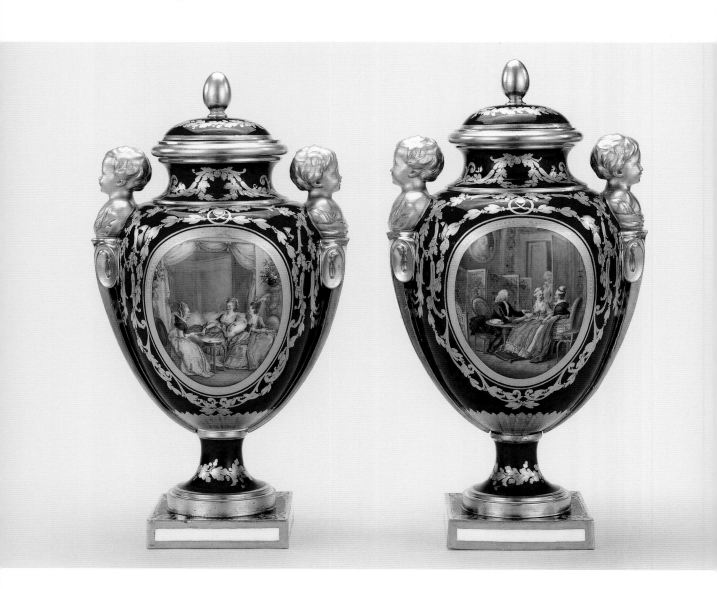

Decorated with a *bleu nouveau* ground and boy herm handles, in imitation of gilt bronze, the vases are known as *vases des âges* and are of the smallest size produced. They probably formed part of a *garniture* of five *vases des âges*, incorporating the three sizes, and including the middle-sized pair with female herms for handles (see p. 92). The centre vase would almost certainly have been a version of the first size, with bearded heads for handles; now in the Metropolitan Museum, New York. It is possible that this *garniture* was purchased by Louis XVI, who acquired a comparable suite of vases in 1783 at the end-of-year sale at Versailles.

The vases would certainly have been destined for luxurious, neo-classical interiors comparable to those represented in the scenes painted on the front reserves. Drawn by Jean-Michel Moreau *le jeune*, the scene on the left reproduces an engraving entitled *N'ayez pas peur ma bonne Amie* (see p. 95), in which an expectant mother is being reassured by her companions. In the scene on the right, which derives from the engraving entitled *Déclaration de la Grossesse*, a young woman has just been informed by the doctor that she is expecting a baby. When the *garniture* is viewed as a whole, the five scenes can be read as a sequence, illustrating the joys of matrimony.

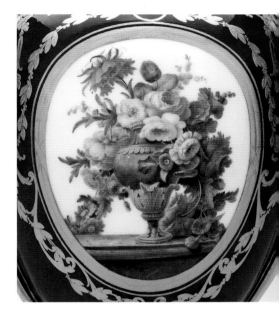

Soft-paste Sèvres porcelain, dark blue ground (*beau bleu*)

Measurements:
Heights, 34.3 and 35.1;
widths, 18.4 and 18.5;
depths, 15.0 and 15.2

Marks:
Painted on both, in blue: interlaced *LL*s enclosing the date-letters *EE* for 1782, above *K*, the mark of the painter Charles-Nicolas Dodin, and, in gold, *HP*, the mark of the gilder Henri-Martin Prévost *l'aîné*.

Provenance:
Acquired by George IV
RCIN 36098.1–2
Cat. no. 96

GARNITURE OF THREE VASES

1779

(*vase Duplessis à bandeau* and
vase Duplessis à monter)

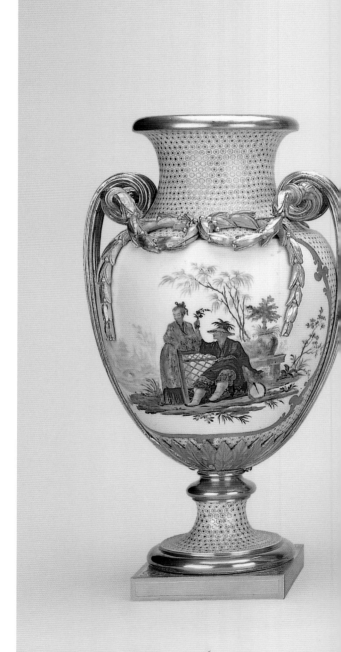

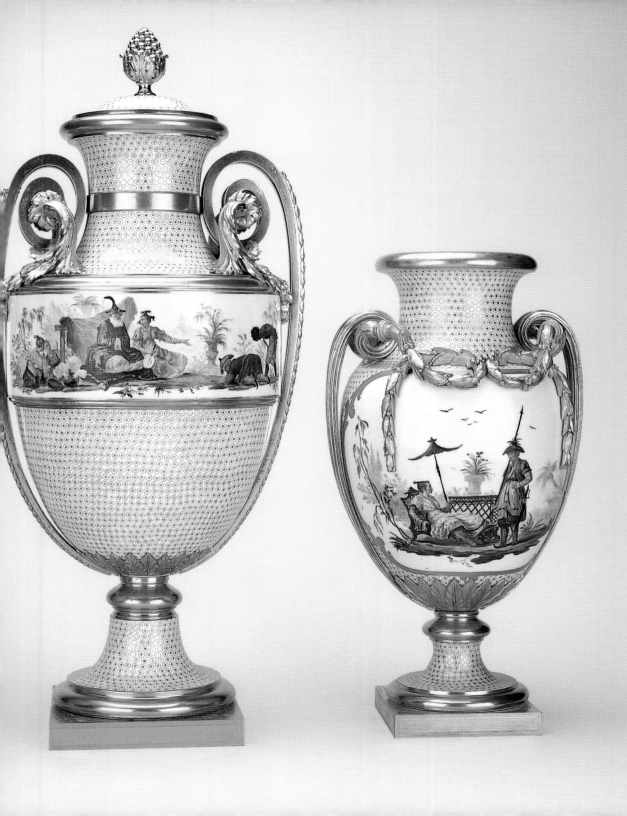

Painted with *chinoiserie* scenes and exotic birds, the *garniture* was purchased by Marie-Antoinette, a demanding and capricious patron of the Sèvres manufactory, in December 1779, at the end-of-year sale held at Versailles. Given her taste at the time for white and gold interior decorative schemes and oriental lacquer, these vases, with their *chinoiserie* themes and finely chased mounts, would have fitted well in her luxuriously appointed apartments. The acquisition of the centre vase in 2004 by Her Majesty The Queen reunited this *garniture* for the first time since the French Revolution.

The inspiration for one of the exotic birds would seem to have been an illustration, *L'Honoré de Cayenne*, designed and engraved by François-Nicolas Martinet (active *c*.1760–1800) for the comte de Buffon's *Histoire Naturelle des Oiseaux*.

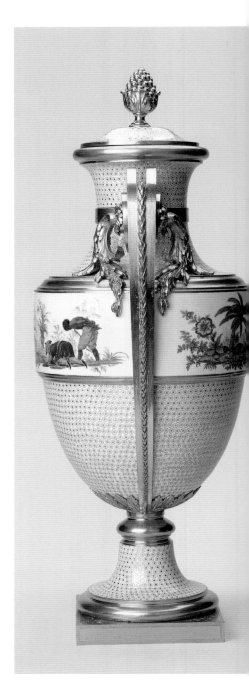

Hard-paste Sèvres porcelain, gilt bronze mounts

Measurements:
Flanking vases:
Overall heights, 32.8 and 33.6;
widths, 17.7 and 18.0;
depths, 16.2 and 16.8
Centre vase:
Overall height, 50.0; width, 21.5;
depth, 18.9

Marks:
Painted in gold: crowned interlaced *LLs* enclosing *bb*, the date-letters for 1779, with (below on the central vase) *A*, the mark of the figure painter Charles-Eloi Asselin, *F*, the mark of the bird painter

Jean-Armand Fallot, and (below on all three vases), in gold, *HP*, the mark of the gilder Henri-Martin Prévost *l'aîné*.

Provenance:
Flanking vases: purchased by George IV from Robert Fogg in 1817 at a cost of £55.
Centre vase: purchased by HM The Queen in November 2004.
RCINs 35594.1–2 and 36361
Cat. nos 100 and 101

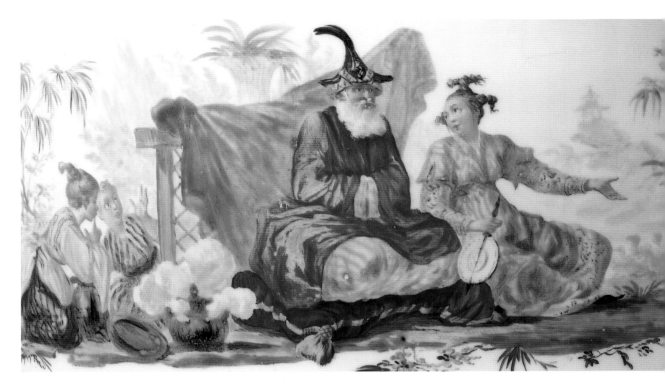

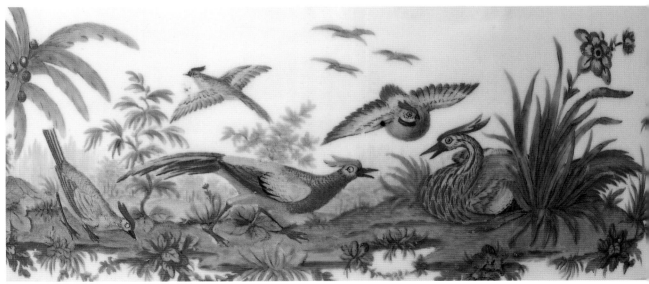

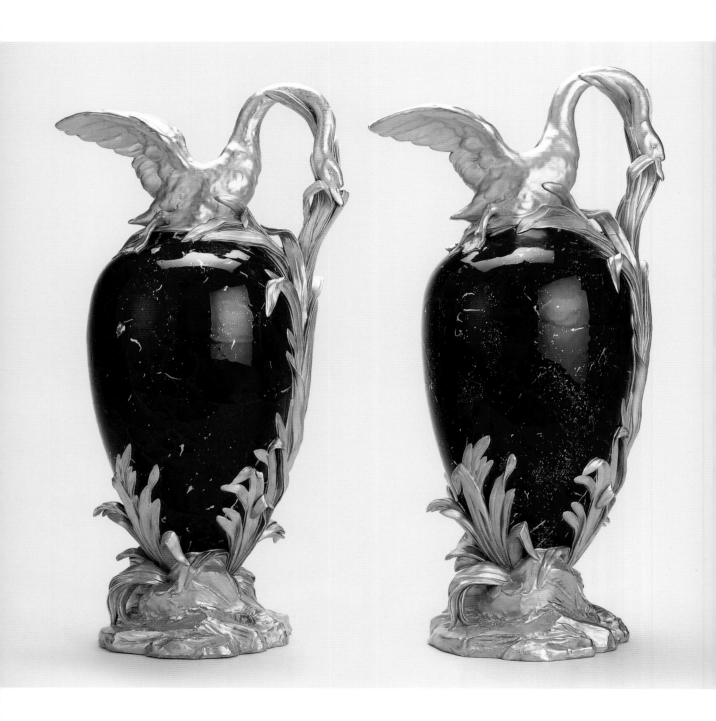

PAIR OF VASES IN THE FORM OF EWERS
1781
(*vase cygne à roseau en buire*)

These vases are among the most extravagant ever put into production at Sèvres, and are formed entirely of hard-paste porcelain, fashioned to simulate the semi-precious stone lapis lazuli, and gilt bronze mounts. The sculptural elements are decorated in two tones of green and yellow gold, with the handle and mouth in the form of a swan, and bulrushes sprouting from a rocky base. The accomplished rendering of the ground colour was achieved by a sophisticated process of applying layers of light tones of blue to convey the subtle gradations of true lapis lazuli. This is one of only two pairs of this version known to survive today.

Hard-paste Sèvres porcelain

Measurements:
Heights, 46.9 and 47.6;
widths, 23.5 and 24.0;
depths, 16.8

Marks:
On one vase only: painted in gold:
interlaced *LL*s with (on either side)
the letter *D*, forming the date-letters *DD*
for 1781, and (below) *2000* (partly
obliterated), the mark of the gilder
Henry Vincent *le jeune, l'aîné.*

Provenance:
Bought by George IV from Robert Fogg
in 1812 for £126.
RCIN 4965.1–2
Cat. no. 102

GARNITURE OF THREE VASES
1780
(*vase chinois*)

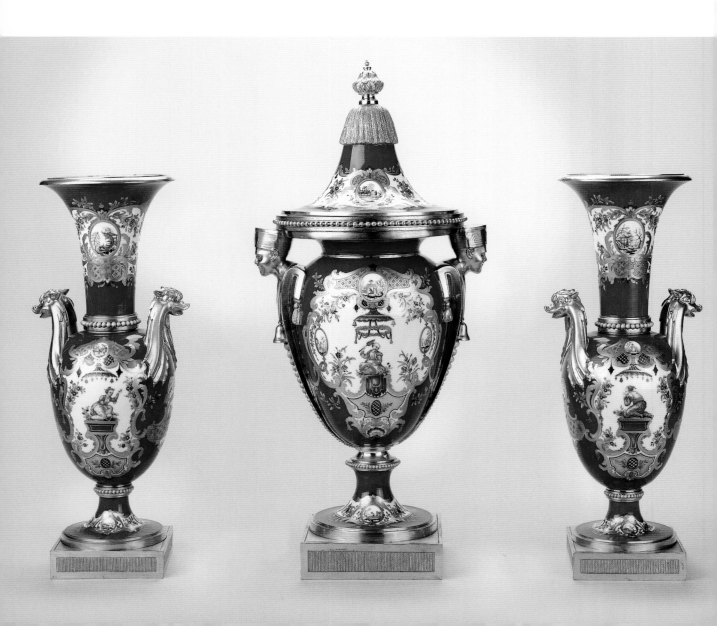

Known collectively as *vases chinois*, this three-piece *garniture*, with its brick-red ground and *chinoiserie*-themed reserves, would have appealed to George IV's passion for jewel-like, colourful and exotic works of art. In 1818 they were sent to furnish Brighton Pavilion, which he was transforming into a 'vision of Cathay'.

The principal reserve on the front and back of each vase contains figures taken from engravings by Gabriel Huquier (1695–1772) after Aléxis Peyrotte (1699–1769). The diminutive roundels and oval reserves on the neck and foot contain *chinoiserie* landscape scenes, which were copied from a series of engravings designed by Jean-Baptiste Pillement (1728–1808). Paradoxically, they recall the early decoration on Vincennes porcelain, when the Meissen influence was predominant. In keeping with usual practice, the Sèvres artist has used the engravings with a greater or lesser degree of fidelity, occasionally picking out a detail, transposing another or reproducing with care the composition as a whole.

Hard-paste Sèvres porcelain, gilt bronze mounts

Measurements:
Centre vase:
Overall height, 50.0;
height (excl. plinth), 46.5;
width, 22.4; depth, 18.5
Flanking vases:
Overall heights, 38.4 and 38.5;
heights (excl. plinth), 35.7 and 35.8;
widths, 15.1; diameters, 12.8 and 12.9

Marks:
Within the foot of each and within the cover of the centre vase: painted in red: crown above interlaced *LL*s enclosing the date-letters *CC* for 1780, with (below) a branch, the mark of the painter Nicolas Schradre.

Provenance:
Acquired by George IV in 1818
RCINs 36075 and 36076.1–2
Cat. no. 103

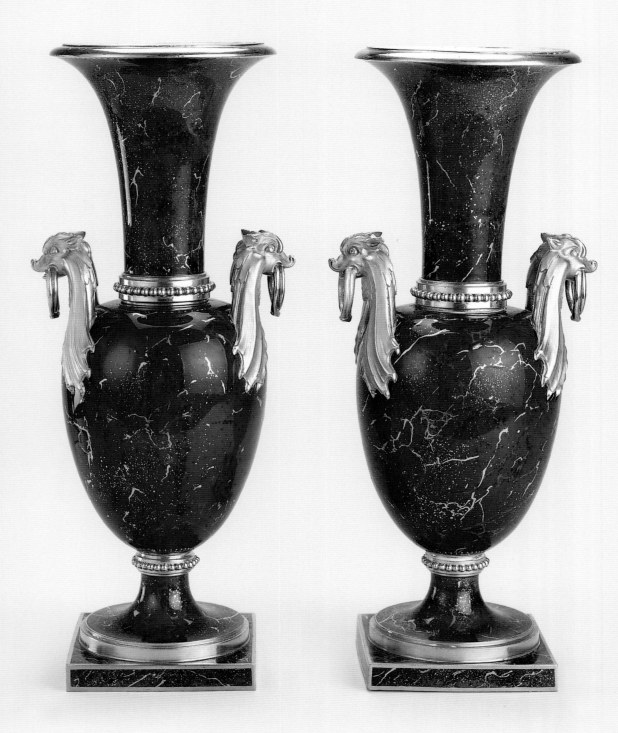

PAIR OF VASES
1781
(*vase chinois de côté*)

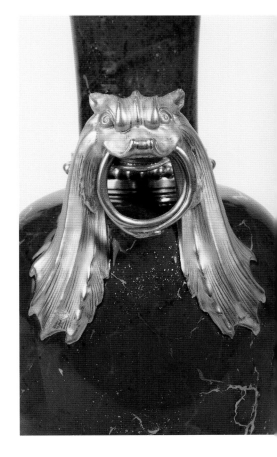

The realistic rendering of lapis lazuli as a ground colour enjoyed a brief period of popularity at the Sèvres manufactory from *c*.1778 to *c*.1785. This pair of vases, decorated with a skilfully applied pale lapis ground, simulates the veining, irregular areas of colour and striated gold lines of the true semi-precious stone. The two Sèvres artists who developed this particular technique were Nicolas Schradre (active 1773–85) and Jean-Jacques Dieu (active 1776–1805), who often worked together on the same pieces. In the jaws of monster-head handles are unusual rings in the form of a serpent biting its own tail, symbolising eternity.

It has been suggested that this pair of vases may have formed a *garniture* of five pieces, acquired in 1783 by Madame Adélaïde, the daughter of Louis XV, the other components being a centre vase (identical in form to that on p. 104) and the two *vases cygne à roseau en buire* in the Royal Collection (see p. 102).

Hard-paste Sèvres porcelain

Measurements:
Heights, 36.5 and 37.1;
widths, 14.7 and 15.8;
depths, 12.7 and 12.8

Marks:
Painted on both, in gold: interlaced *LL*s, with (on either side) *D*, forming the date-letters *DD* for 1781, with (below) *2000*, the mark of the gilder Henry Vincent *le jeune*, *l'aîné*.

Provenance:
Presumably acquired by George IV
RCIN 4962.1–2
Cat. no. 104

PAIR OF MOUNTED VASES AND COVERS

*c.*1782

(?*vase de milieu de Duplessis fils*)

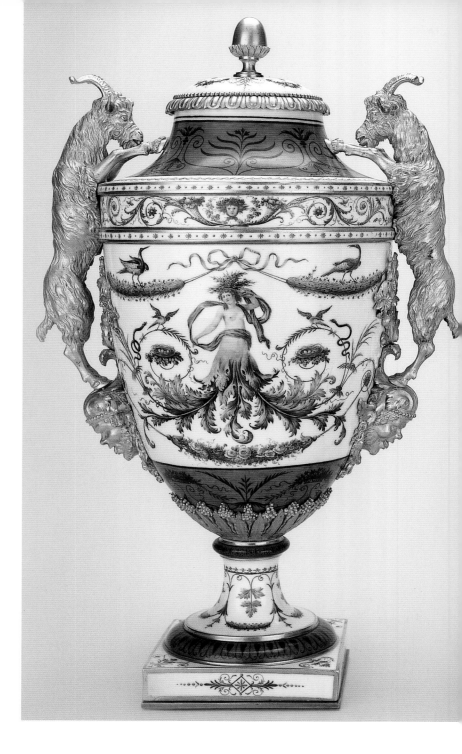

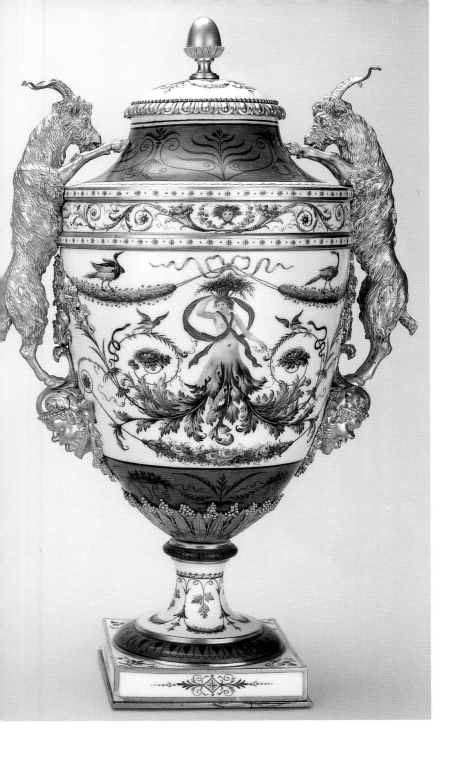

The vases rank among the finest pieces of Sèvres porcelain produced by the manufactory in the Louis XVI style. The delicate polychrome arabesque painting and the finely chased gilt bronze mounts, which may have been supplied by Pierre-Philippe Thomire (1751–1833), are of exceptional quality.

The vases once belonged to Louis XVI and formed part of the furnishings of the *Ancienne Pièce du Café* on the first floor of the King's private apartments at Versailles. Sold by the Revolutionary government in 1797, they were ultimately acquired by George IV in 1812.

Hard-paste Sèvres porcelain, gilt bronze mounts

Measurements:
Heights, 42.1 and 42.5; widths, 25.6 and 25.8; depths, 17.8 and 17.9

Marks:
On one vase only: painted in blue: traces of interlaced *LL*s below a crown, with (on either side) the letter (?)*E*, forming the date-letters (?)*EE* for 1782.

Provenance:
Bought by George IV from Robert Fogg in 1812 for £157 10s.
RCIN 39492.1–2
Cat. no. 108

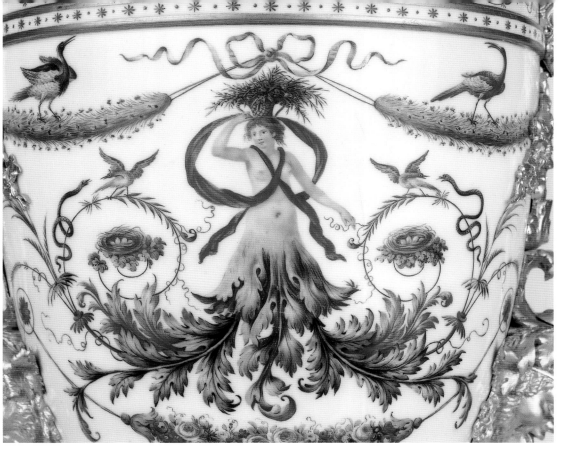

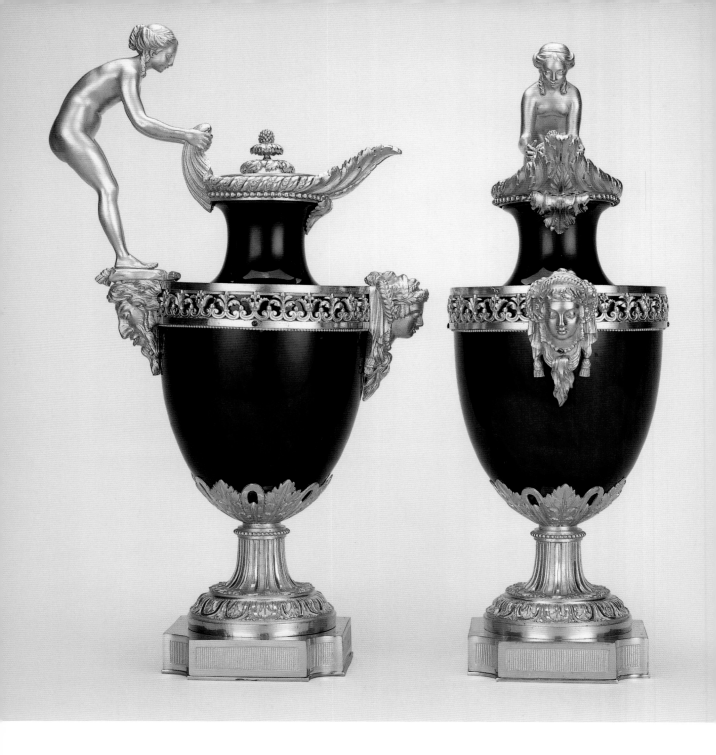

PAIR OF VASES MOUNTED AS EWERS

*c.*1782–7

(*vase à monter*)

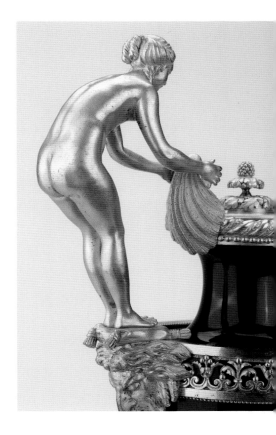

The vases, in the form of a pair of ewers, are essentially a visual conceit as they are entirely non-functional. The plain dark blue ground sets off to advantage the finely chased neo-classical gilt bronze mounts. This combination was consistent with the contemporary fashion for furniture combining simple figured woods, such as mahogany, with rich gilt bronze mounts.

These vases were commissioned from the manufactory by the dealer Dominique Daguerre. The bespoke mounts, probably supplied by the manufactory's accredited supplier Jean-Claude-Thomas Duplessis *fils* (*c.*1730–83), can also be found on other types of ornamental vases. It is conceivable that these vases and a similar pair were among those acquired direct by George IV from Daguerre in the late 1780s.

Hard-paste Sèvres porcelain, gilt bronze mounts

Measurements:
Heights, 41.0 and 41.2;
widths, 23.5 and 23.7;
depths, 13.4 and 13.6

Marks:
No painted marks

Provenance:
Probably acquired by George IV, together with a similar pair, through Dominique Daguerre in the late 1780s.
RCIN 35514.1–2
Cat. no. 111

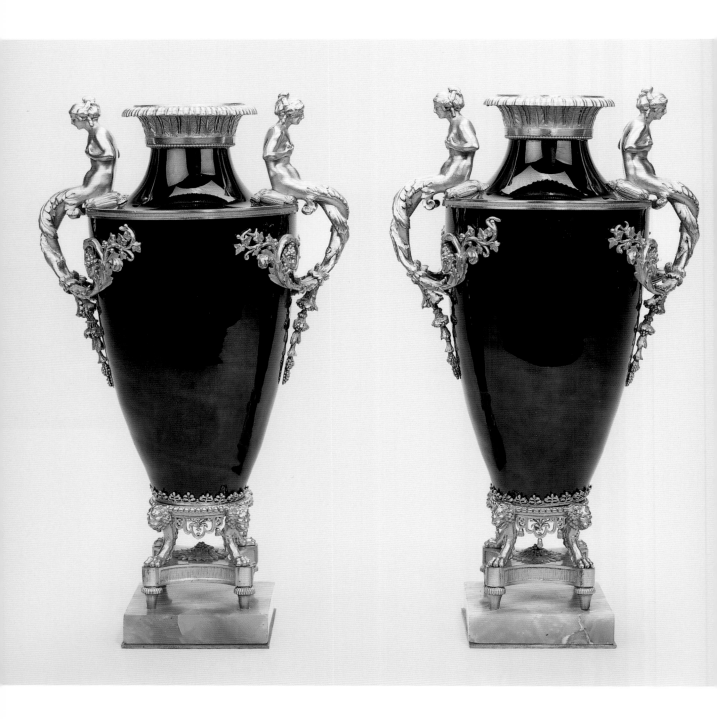

Pair of mounted Vases
*c.*1785
(*vase à monter*)

The elegance and beauty of these vases lie in the skilful combination of a simple form, mottled brown-black ground in simulation of lacquer and finely chased gilt bronze mounts, including mermaid figures and lion's paw monopodia.
The vases resemble an annotated drawing that survives in the manufactory archives, dated 14 March 1785. Designed by Louis-Simon Boizot (1743–1809), this vase was intended to be fitted with mounts supplied by Pierre-Philippe Thomire: '*Vase Serpent Boizot…fait pour Monte par Monsieur Tomire*'. The vases were displayed at Carlton House under protective glass domes, as indicated in an inventory drawing dating from *c.*1825–8.

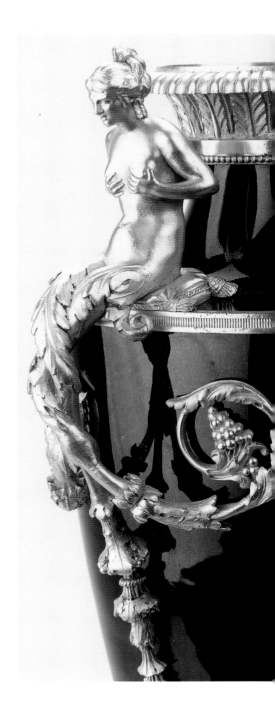

Hard-paste Sèvres porcelain, gilt bronze mounts, onyx stand

Marks:
No painted marks

Measurements:
Heights, 35.0 and 35.5;
widths, 19.0 and 19.2;
depths, 12.8 and 13.0

Provenance:
Purchased by George IV
RCIN 253.1–2
Cat. no. 113

PAIR OF MOUNTED VASES
1789–90

The inspiration for this model may have been one of the so-called Etruscan vases sold to Louis XVI by Vivant Denon (1747–1825) in 1786. This collection was placed on deposit at Sèvres to provide inspiration for the artists and sculptors. Only one other pair of vases of this form is known.

The fashion for black-ground *chinoiserie* scenes at Sèvres, variously described as *fond noir* or *fond écaille*, reflected the taste for oriental-inspired decoration and reached its height between 1790 and 1793. A possible source for the two figures worshipping a monkey seated on a column is an engraving published in 1759 by Pierre-Charles Canot (*b.*1710) after Jean-Baptiste Pillement.

The prevailing neo-classical style is represented by the gilded swags and garlands and scrolling arabesques, which, stylistically, are close to the gilt bronze mounts fitted to furniture in the Louis XVI style.

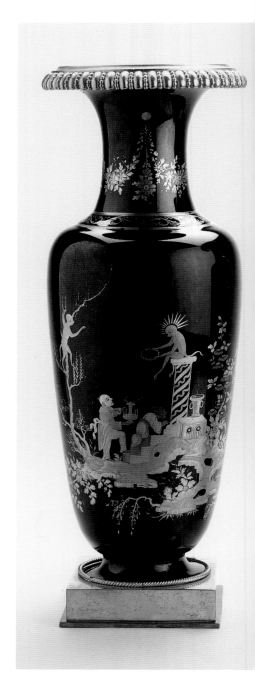

Hard-paste Sèvres porcelain, decorated in platinum and two tones of gold, gilt bronze mounts

Measurements:
Overall heights, 33.5 and 33.7; heights (excl. mounts and plinth), 31.0 and 32.2; widths, 11.5; depths, 11.5

Marks:
On left-hand vase: painted in gold: interlaced *LL*s, with (on either side) (?)*M*, forming the date-letters (?)*MM* for 1789. On right-hand vase: painted in gold: interlaced *LL*s with (on either side) *n*, forming the date-letters *nn* for 1790.

Provenance:
Acquired by George IV, possibly from Robert Fogg, in 1812. RCIN 2344.1–2
Cat. no. 116

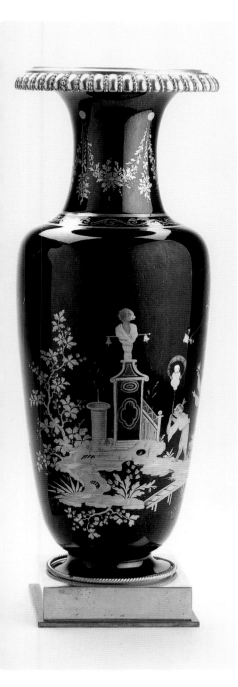

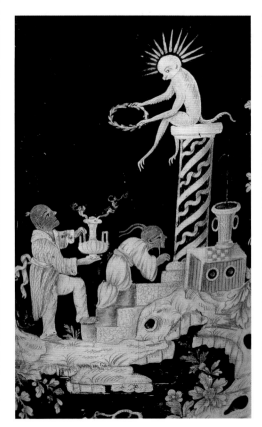

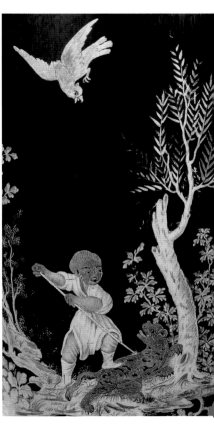

Pair of mounted Pot-pourri Vases

*c.*1790

(*vase à monter*)

The fanciful oriental scenes are rendered in two tones of gold and platinum on a black ground. The vases probably conform to designs provided by Dominique Daguerre, who would have added the bespoke gilt bronze mounts.

The known sources for *chinoiserie* decoration on black-ground Sèvres porcelain, introduced at the factory *c.*1790, include engravings after designs by Jean-Baptiste Pillement, Cantonese lacquer patterns, Chinese woodcuts and debased generic *chinoiserie* scenes. In this instance, two scenes on the vases are taken from engravings by Jean-Jacques Avril (1771–1835) after Pillement, published in the series *Cahier de Balançoires Chinoises*.

The use of platinum on a black ground, as a substitute for silver (which tarnishes), was a technical innovation introduced at Sèvres *c.*1789. It was used extensively in the 1790s on black-ground vases and tableware decorated with *chinoiserie* scenes.

Hard-paste Sèvres porcelain, decorated in platinum and two tones of gold, gilt bronze mounts

Measurements:
Heights, 42.0 and 42.7; widths, 33.9 and 34.0; depths, 20.6 and 20.7

Marks:
Painted on both, in gold: crowned interlaced *LL*s, flanked by the letters *G* and *I* (*G* omitted on one vase), the mark of the gilder Etienne-Gabriel Girard.

Provenance:
Possibly bought by George IV from Robert Fogg in 1815 for £157 10s.
RCIN 2347.1–2
Cat. no. 117

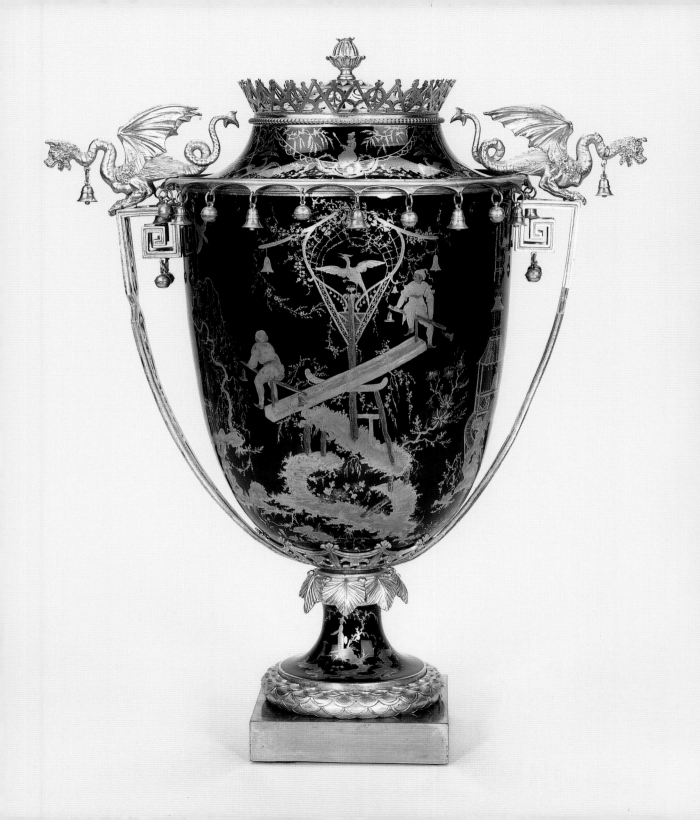

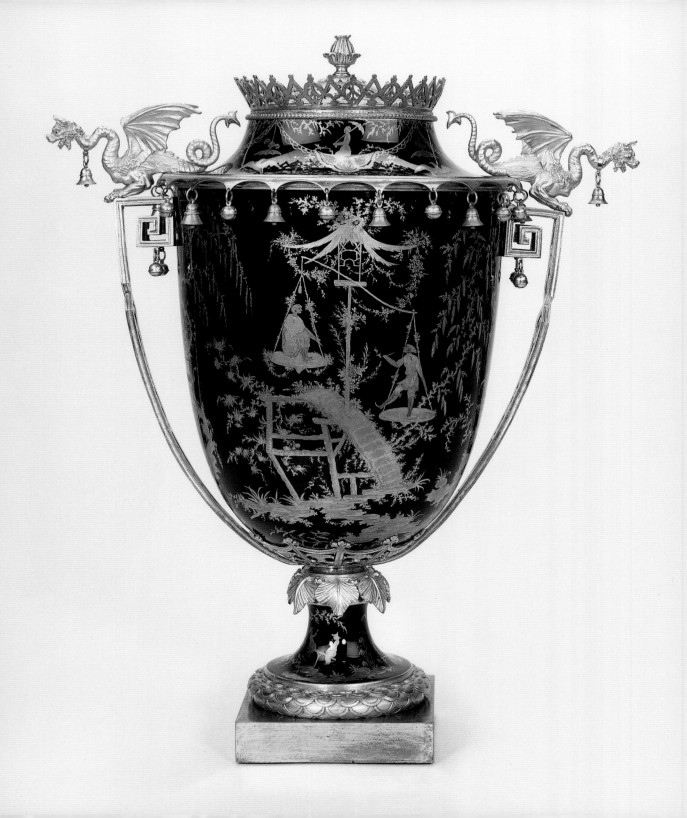

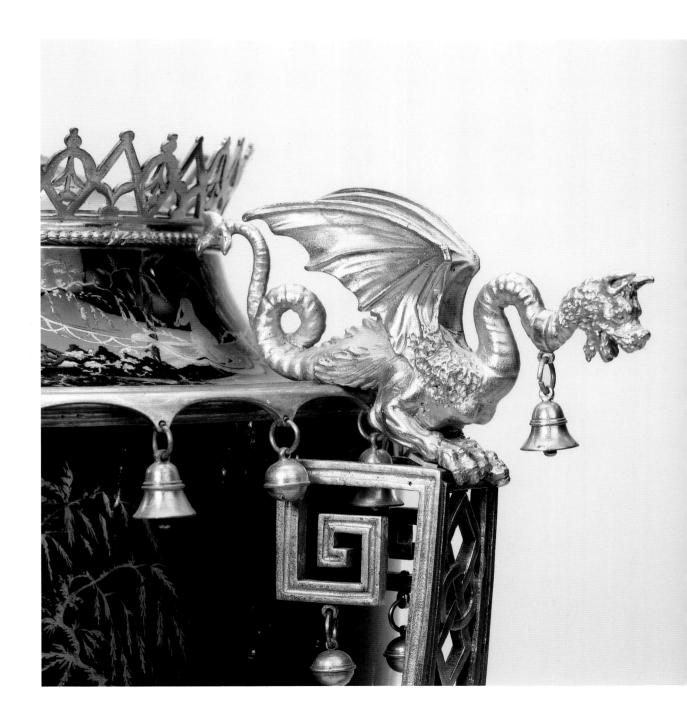

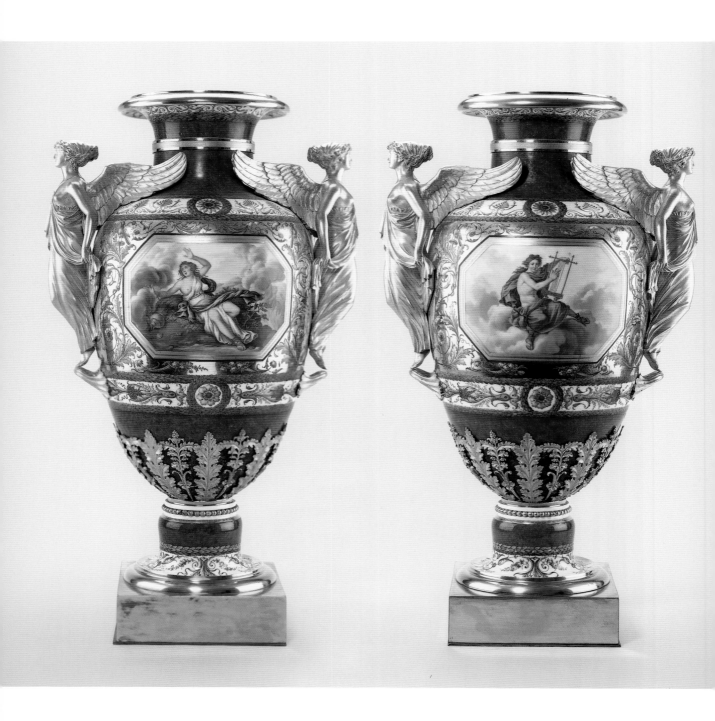

Pair of mounted Vases

Probably 1792–3

(?*vase japon*)

The imitation porphyry ground colour (*fond porphyre*) is decorated with octagonal reserves depicting mythological figures on the front and back of each vase. Some of these figures may derive from drawings attributed to Jean-Jacques Lagrenée *le jeune* (1739–1821) and engravings after Jean-Michel Moreau *le jeune* published in abbé Banier's translation of Ovid's *Métamorphoses* (1767–71).

Unusually, in order to accommodate the gilt bronze winged figures of Victory, the body of the vase has been transformed and lengthened by the addition of a false bottom in metal, painted to simulate the porcelain ground colour. No other Sèvres vase of this shape is known.

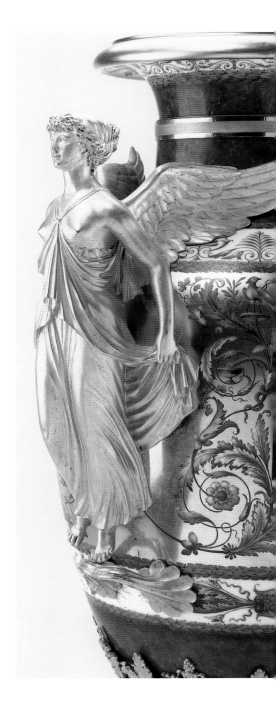

Hard-paste Sèvres porcelain, gilt bronze mounts, plinth and metal base cap

Marks:
No painted marks

Measurements:
Overall heights, 62.7 and 62.8; widths, 37.0; depths, 25.3 and 25.7
Porcelain:
Height of vase proper (excl. mouth and the foot and stem combined), 37.5; diameter, 25.5

Provenance:
Purchased in Paris for George IV by Jean-Baptiste Watier in 1816.
RCIN 537.1–2
Cat. no. 120

Two half-size Wine-bottle Coolers

c.1754

(seau à demi-bouteille)

On a rich underglaze dark blue ground (*bleu lapis*), the elaborate rococo gilded decoration of exotic and asymmetrical design incorporates mosaic and trellis panels, flowers and foliage. The coolers, which are among the finest examples of their type, are thought possibly to have belonged to Madame de Pompadour.

They correspond in shape to a model which pre-dates March 1753. An indication of their early date is the manner in which ground colour extends over the rim of the coolers. On later models, the rim and foot are generally decorated in white and gold.

It was not until 1752 that pieces decorated with *bleu lapis* ground were recorded in any quantity.

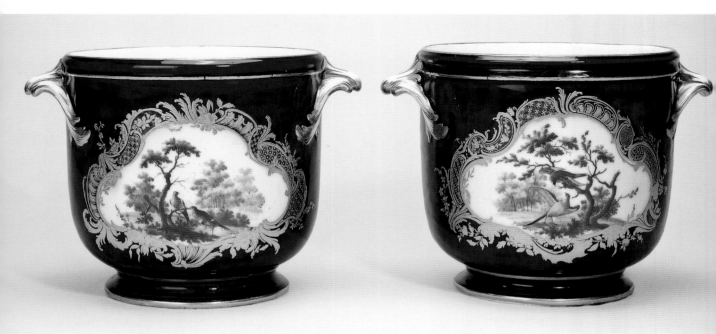

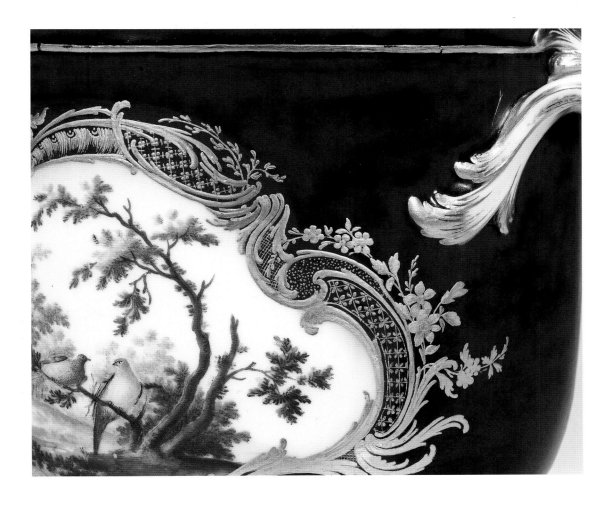

Soft-paste Vincennes porcelain, dark blue ground (*bleu lapis*)

Measurements:
Heights, 17.0; widths, 22.9; diameters, 17.6

Marks:
On left-hand cooler: painted by the rim, in underglaze blue: two dots
On right-hand cooler: painted in underglaze blue: interlaced *LL*s

Provenance:
Presumably acquired by George IV
RCIN 36091.1–2
Cat. no. 132

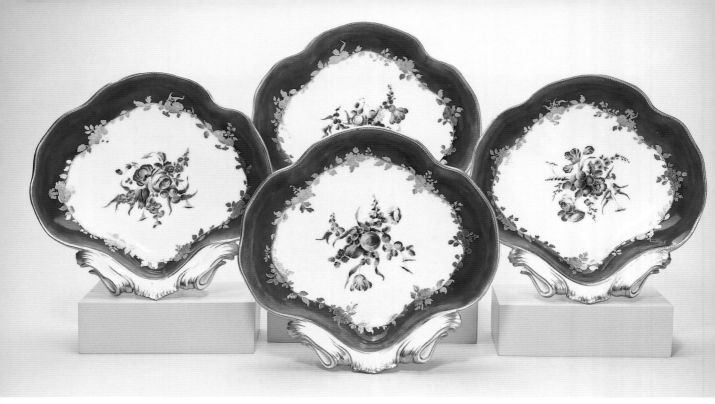

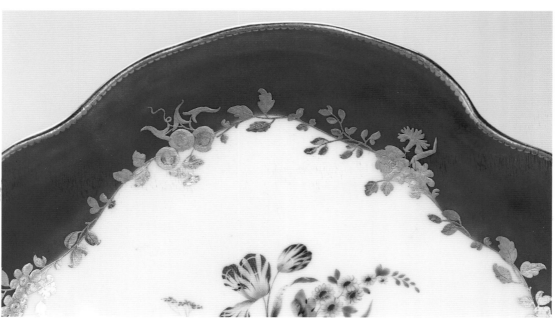

Four shell-shaped Fruit Dishes

1754/5
(*compotier coquille*)

Fruit dishes (*compotiers*) were produced at Vincennes in a variety of shapes and sizes. The form of the shell-shaped fruit dish derives ultimately from the scallop shell. Its bold serpentine lines conform perfectly to the rococo style that prevailed in France during the mid-eighteenth century. The quatrefoil reserves, painted with polychrome fruit and flowers, are the work of the Sèvres flower painter and gilder Antoine-Toussaint Cornailles (active 1755–1800). His compositions are often imbued with a diaphanous quality. Characteristics of his style are a distinctive pale green palette and the subtle double twisting back of the tips of petals and foliage.

 Compotiers were used as part of the dessert service and intended for dried and fresh fruit, the latter sometimes caramelised. Red fruit (strawberries, raspberries, currants, cherries) were arranged on *compotiers* in pyramids or mounds.

Vincennes soft-paste porcelain, turquoise blue ground (*bleu céleste*)

Measurements:
Heights, 5.5–6.0; widths, 22.0–22.6; depths, 22.0–22.3

Marks:
On all, in underglaze blue: *LL*s enclosing the date-letter *B* for 1754/5, with (below) a quaver, the mark of the flower painter Antoine-Toussaint Cornailles.

Provenance:
Part of the service bought by George IV in December 1815 from A-C-C-B. Perregaux.
RCIN 59302.1–4
Cat. no. 133

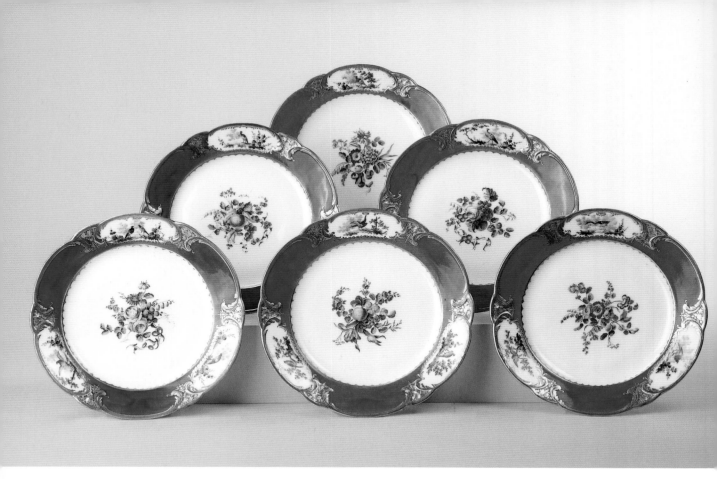

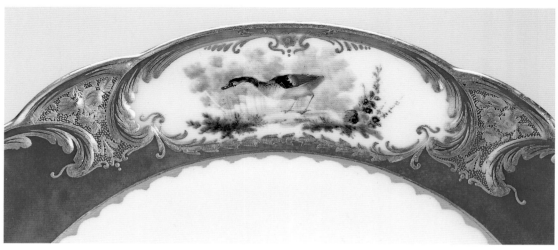

TWENTY PLATES
1755/6
(*assiette à palmes*)

The uneven ground colour, a clouded *bleu céleste*, is an attribute particularly associated with the early ground colours of Vincennes porcelain. Initially it proved particularly difficult for the manufactory to obtain a more even-toned colour, in emulation of Chinese and Meissen porcelain. In later years, the smoother turquoise blue, such as that of the *vase Angora* of *c.*1773 (see p. 78), became standard. The unevenness in colour of the early wares later came to be regarded among connoisseurs and collectors of Sèvres as a desirable quality.

It is possible that the plates once formed part of a dessert service purchased in 1756 by Frederick St John, 2nd Viscount Bolingbroke, from the Parisian dealer Lazare Duvaux.

Soft-paste Vincennes porcelain, turquoise blue ground (*bleu céleste*)

Measurements:
Heights, 2.8–3.2; diameters, 25.2–25.8

Marks:
Painted on 15, in blue: interlaced *LL*s enclosing the date-letter *C* for 1755/6, with (above, on one only) a cross, the mark of the painter Philippe Xhrouet *père*. Five are unmarked.

Provenance:
Acquired by George IV; possibly part of the service purchased from A-C-C-B. Perregaux in 1815.
RCIN 59358.18–37
Cat. no. 135

Twelve Plates

c.1770

(assiette unie)

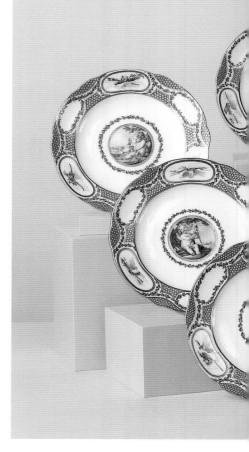

The 12 plates once formed part of a dinner service purchased in 1770 by Madame du Barry. The *assiette unie*, with its serpentine rim and alternating large and smaller scallops, was a popular model for Sèvres dinner services.

On one plate, a putto in the guise of a shepherd holds a recorder and rests his arm on a sheep; the respective trophies depict elements associated with bucolic pastimes, including an open book marked 'PASTOR FIDO' (faithful shepherd). Comedy is represented on another plate with a putto wearing an ivy crown and holding an actor's mask; beside him is a script marked 'MOLIERRE' [*sic*]. The corresponding trophies include a fool's stick, an actor's mask and musical paraphernalia.

While some of the figures correspond in broad terms to engravings after François Boucher, it is likely that his designs served as inspiration rather than as precise models.

Soft-paste Sèvres porcelain, turquoise blue *oeil-de-perdrix* ground

Measurements:
Heights, 2.4–3.0; diameters, 23.4–23.7

Marks:
Painted on all except one (which is unmarked): interlaced *LL*s (in blue on eight, in purple on one, in pink on two)

Provenance:
Acquired by George IV
RCIN 58644.1–12
Cat. no. 156

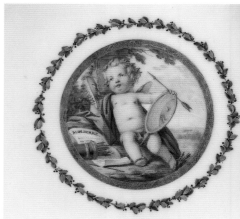

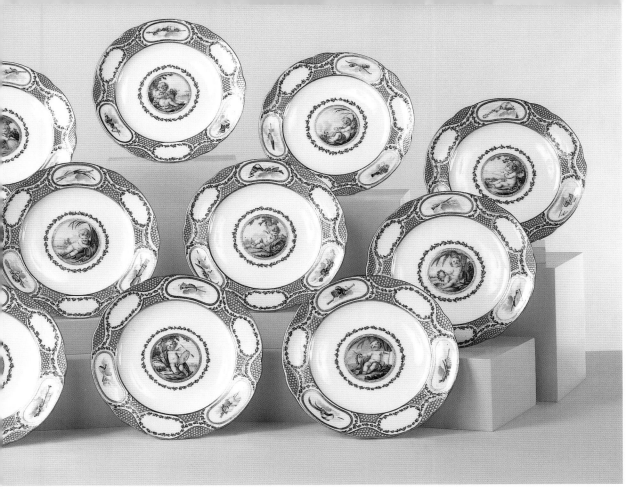

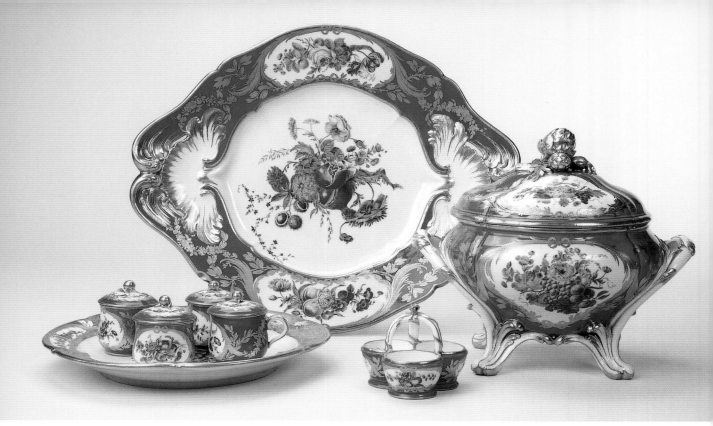

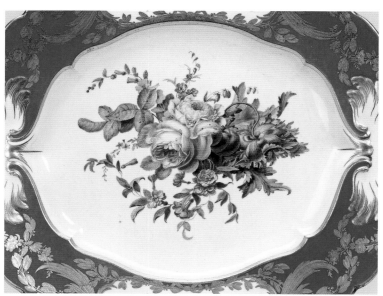

DINNER AND DESSERT SERVICE (241 PIECES)

1776–83

(*1er service* and *service à dessert*)

The service formed part of the diplomatic gifts given in 1783 by Louis XVI to the then British Ambassador to the Court of Versailles, the Duke of Manchester, and his wife. In recognition of his negotiation of the Treaty of Versailles that year, which brought to an end the War of American Independence, the Duke received the customary diamond-encrusted gold box, incorporating a portrait of the king, valued at 31,453 *livres*. Exceptionally, the Duchess also received a present, the magnificent *bleu céleste* Sèvres dinner and dessert service, valued at 21,080 *livres*. The only precedent for such a gift was the service given by Louis XV in 1763 to the Duchess of Bedford, whose husband, the 4th Duke, had signed the treaty which brought to an end the Seven Years War (1756–63) between France and England.

Soft-paste Sèvres porcelain, turquoise blue ground (*bleu céleste*)

Marks:
On all the pieces (except for one oval tureen): painted in blue: interlaced *LLs* enclosing – or accompanied by (to one side of the *LLs*) – date-letters between 1776 and 1783.
The marks of 20 flower painters and 6 gilders are represented; the most actively involved include:
Painters:
(1) Edmé-François Bouillat, 24 pieces;
(2) Jacques-François-Louis de Laroche, 18 pieces;

(3) Denis Levé, 25 pieces;
(4) Jacques-François Micaud *père*, 14 pieces;
(5) Jean-Jacques Pierre, 15 pieces;
(6) Vincent Taillandier, 28 pieces.
Gilders:
(7) Jean-Pierre Boulanger *père*, 21 pieces;
(8) Michel-Barnabé Chauvaux *l'aîné*, 143 pieces.

Provenance:
Purchased by George IV from the Duchess of Manchester (the London auctioneer Harry Phillips acting as intermediary) c.March 1802 for £882.
Cat. no. 162

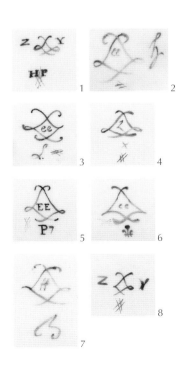

PART OF A DINNER AND DESSERT SERVICE
1783–93

The most costly and sumptuous service ever created at Sèvres in the eighteenth century was commissioned by Louis XVI in 1783 for his personal use at Versailles. It was intended to take 23 years to complete and was the swansong of the great services produced in soft-paste porcelain at Sèvres. Only half the service had been delivered when production was brought to a halt following the execution of the King in 1793.

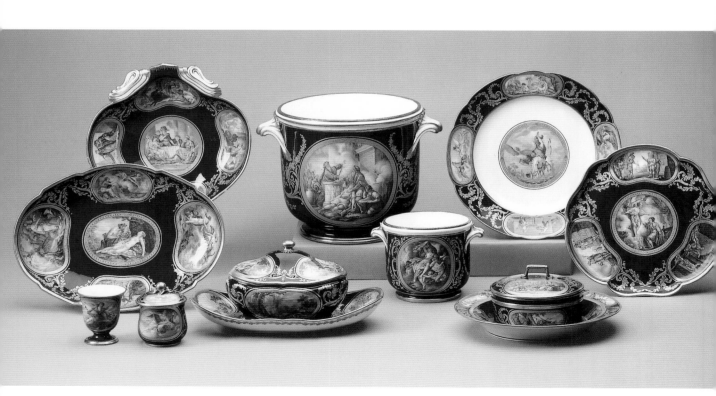

Painted with a *bleu nouveau* ground and reserves with scenes taken from mythology and Greek and Roman history, the service was largely conceived as a showpiece and was not intended for general use. When completed, it was to include 60 plates (30 delivered) without painted decoration; they were clearly intended for use. Special purchases of engravings were made by the manufactory for the artists to copy. These included complete series of illustrations from the Paris editions of Ovid's *Métamorphoses* and Fénelon's *Les Aventures de Télémaque* (1773).

Each plate cost an unprecedented 480 *livres*, compared with 36 *livres* for the Manchester service (see p. 132). The most costly element was the painting of the scenes. For example, it was estimated that the painting of one large tureen tray would cost 1,200 *livres* and would require one artist to work 8–10 hours per day for 12–15 months in order to paint the four reserves.

Soft-paste Sèvres porcelain, dark blue ground (*beau bleu*)

Marks:
Artists listed as having provided painting: Charles-Eloi Asselin; Charles-Antoine Didier *père*; Charles-Nicolas Dodin; Claude-Charles Gérard *fils aîné*; Etienne-Henry Le Guay *père*; François-Pascal Philippine *l'aîné*; Nicolas-Pierre Pithou *le jeune*.

Artists listed as having provided gilding: Charles-Nicolas Buteux *fils aîné*; Antoine-Toussaint Cornailles; Louis-François Lécot; Etienne-Henry Le Guay *père*; Pierre-Antoine Méreaud *l'aîné*; Guillaume Noël; Henri-Martin Prévost *l'aîné*; Henry Vincent *le jeune*, *l'aîné*.

Provenance:
The bulk of the service was acquired by George IV in 1811 for £1,973 4s 8d, through his intermediary Robert Fogg.

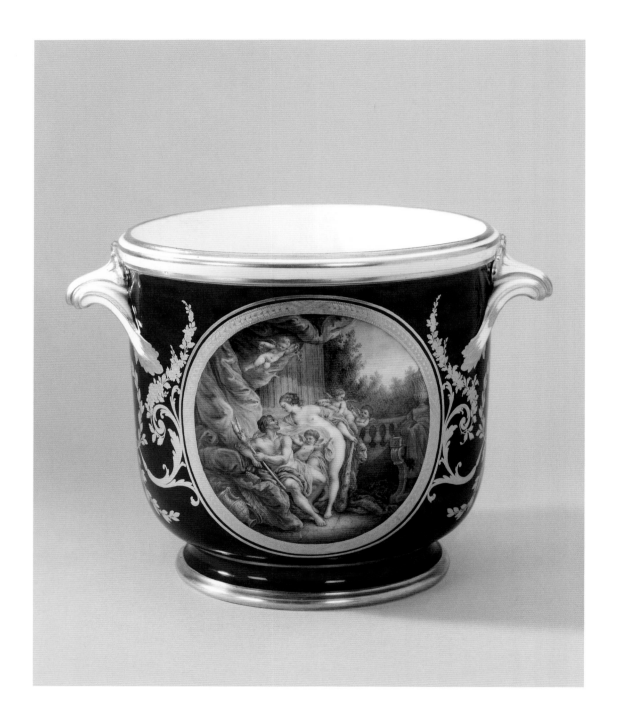

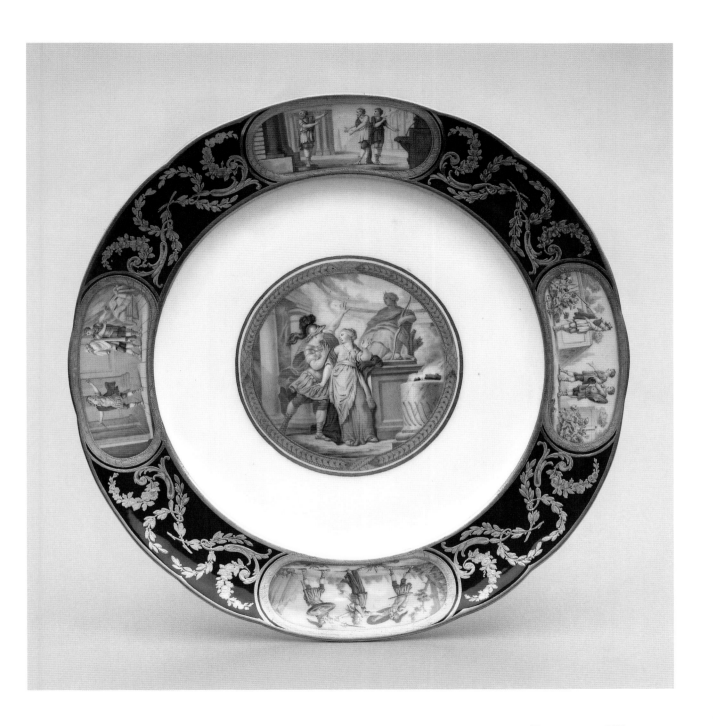

PLATE

1788

(*assiette unie*)

This exceptional plate was sold to George IV as part of the Sèvres service commissioned by Louis XVI (see p. 134). On 8 January 1790, Louis XVI did indeed purchase from the manufactory '1 assiette animaux' at a cost of 300 *livres*, which was not, however, part of the service. It would seem that during the preparations for the Revolutionary sales, the plate was inadvertently classified with the service.

The painted scenes of animals can be confidently attributed to Pierre-Nicolas Pithou *l'aîné* (active 1759–90), who paid close attention to detail and developed a distinctive palette of opaque greens and browns and a rich olive green. The sources for the scenes have been traced to a number of studies of animals by François Desportes (1661–1743). Following the death of the artist, the collection of sketches and paintings in his studio was acquired by Louis XVI at the behest of his *directeur général des Bâtiments et Manufactures*, the comte d'Angiviller, and was despatched to Sèvres in April 1785. Surprisingly, little use was made of this collection at the manufactory.

Soft-paste Sèvres porcelain, dark blue ground (*beau bleu*)

Measurements:
Height, 2.8; diameter, 24.0

Marks:
Painted in gold: foliate interlaced *LL*s enclosing *ll*, the date-letters for 1788, with (below) *HP*, the mark of the gilder Henri-Martin Prévost *l'aîné*.

Provenance:
Purchased by George IV in 1811
RCIN 58235
Cat. no. 172

DESSERT SERVICE (31 PIECES)
*c.*1827–34

The service was almost certainly part of the gift given in 1834 by King Louis-Philippe to the composer Gioachino Rossini (1792–1868), following the inaugural performance of *The Barber of Seville* given in the royal theatre at the Château de Fontainebleau. Composers were traditionally rewarded with gifts after command performances at the *châteaux* of Compiègne and Fontainebleau.

The trophies, emblematic of food and drink, with the subject inscribed below each one, are transfer-printed, with the colouring and gilding work painted by hand. The service was admirably suited to Rossini, a discerning connoisseur and gourmet, whose generous proportions and appetite were renowned.

Watercolours of the still lifes drawn by Jean-Charles-François Leloy (active 1816–44), used as models for the scenes, still survive in the Sèvres Archives. The decoration of the service was largely confined to 1830, the gilding being entrusted for the most part to Jean-Louis Moyez (active 1818–48) and the colouring of the trophies to Jean-Baptiste-Etienne-Nicolas Noualhier *père* (active 1775–1835).

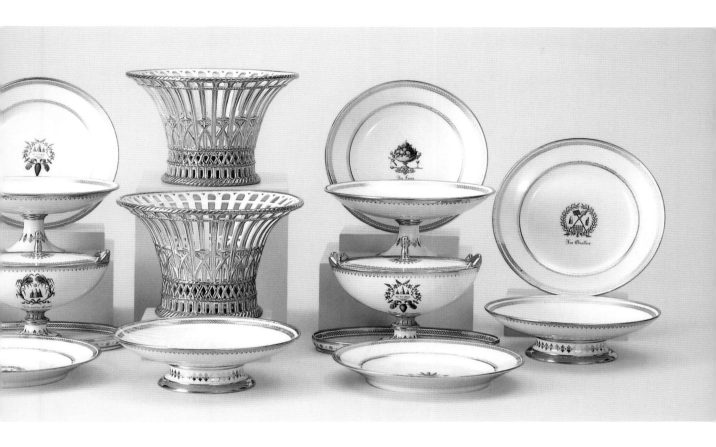

Hard-paste Sèvres porcelain

Measurements:

Plates: heights, 3.0–3.2;
diameters, 22.1–22.5
Tazzas for fruit: heights, 10.0;
diameters, 22.4, 22.6
Fruit dishes: heights, 6.4;
diameters, 21.5
Baskets: heights, 14.9, 15.2;
diameters, 23.0, 23.3

Marks:

Painted on the majority, in blue: the
manufactory's mark: a circle enclosing
SÈVRES, with (above) two overlying
triangles, and (below) [*18*]*33*,
accompanied by a further mark:
Sèvres, with (above) a fleur-de-lis, and
(below) [*18*]*30* followed by the years,
1829, 1830.
Painted on the majority, in gold:
M, the mark of Jean-Louis Moyez,
followed by the day and month,
e.g. 14 O (14 ?octobre).

Provenance:

Purchased by Queen Elizabeth
The Queen Mother in 1949.
RCINs 101311.1–22; 101313.1–2;
101314.1–3; 101312.1–2; 101497.1–2
Cat. no. 303

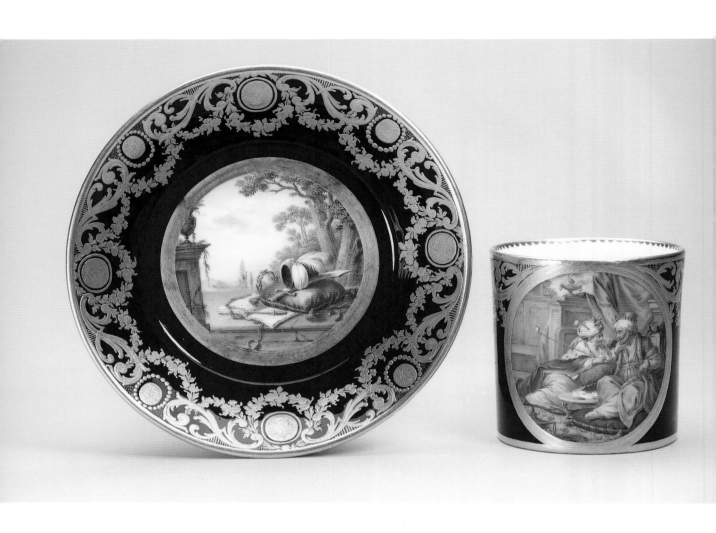

CUP AND SAUCER
1779
(*gobelet litron*) 1st size

First produced in 1752, the *gobelet litron* was a popular model at Vincennes and Sèvres throughout the eighteenth century. It was produced in large numbers in five sizes, varying in the style of the decoration and the form of the handles. The cylindrical cup received its name because of its resemblance to the *litron*, an old wooden cubic measure of slightly larger dimensions, used to quantify salt, grain, flour and peas.

The refined and detailed scene on the cup, painted by Charles-Nicolas Dodin, depicting a Turk with his concubine, reproduces the engraving *L'Amour Asiatique* by Pierre-François Basan (1723–97) after Charles Eisen (1720–78). On the saucer, the trophy combines attributes associated with Islam in a landscape setting.

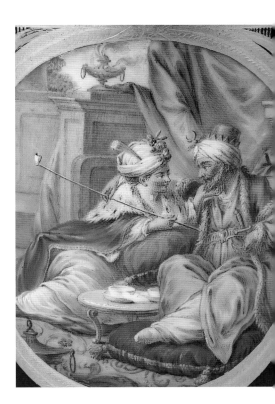

Soft-paste Sèvres porcelain, dark blue ground (*beau bleu*)

Measurements:
Cup: height, 7.5; depth, 10.0; diameter, 7.4
Saucer: height, 3.2; diameter, 15.1

Marks:
Painted on the cup and saucer, in blue: interlaced *LL*s enclosing *bb*, the date-letters for 1779, with (below) *K*, the mark of the painter Charles-Nicolas Dodin. Painted on the cup and saucer, in gold: *ᾔ*, the mark of the gilder Michel-Barnabé Chauvaux *l'aîné*.

Provenance:
Acquired by George IV
RCIN 58202.a–b
Cat. no. 207

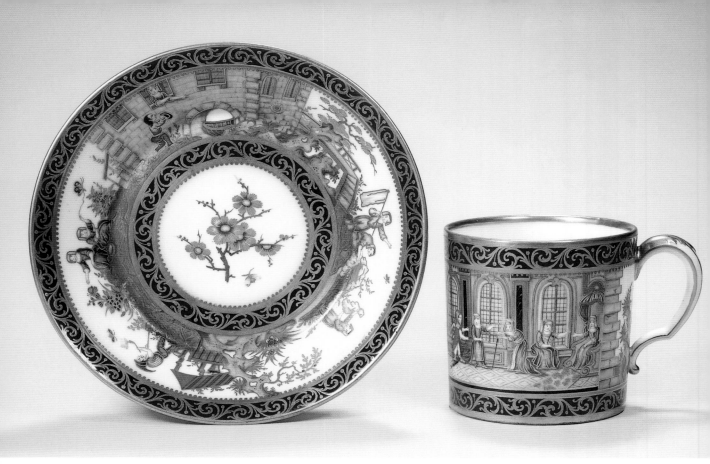

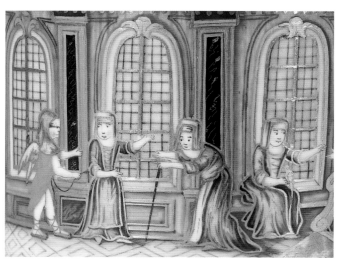

CUP AND SAUCER
1778 and 1779
(*gobelet litron*) 1st size

The decoration of this cup and saucer is exceptional in terms of both its subject and the manner of execution. There is no known parallel at Sèvres. The appearance of two sets of date-letters painted on the underside of the cup and saucer may indicate that it was several years in the making.

The Gothic-cum-Chinese scenes, depicting peasants in medieval costume, nuns and a winged figure, no doubt derive from illustrations of a contemporary novel, play or poem. One possible tale may be the account of the fall from grace of Ver-Vert, a pious pet parrot belonging to a convent in Nevers. Famed for its ability to recite chaste readings from the Scriptures, the parrot was sent to visit another convent. During the journey by sea, its memory of the sacred texts was replaced by the scabrous tales and coarse language of the sailors. Sent home in disgrace, Ver-Vert eventually emerged spiritually reborn after months of penance and died in the arms of the abbess. Published in 1734, Jean-Baptiste-Louis Gresset's (1709–77) comic narrative poem, *Ver-Vert*, was an instant success.

Soft-paste Sèvres porcelain

Measurements:
Cup: height, 7.5; width, 10.2; diameter, 7.7
Saucer: height, 3.3; diameter, 15.5

Marks:
Painted on the cup and saucer, in underglaze blue: crowned interlaced *LL*s enclosing, on the cup, *AA* (illegible on the saucer), the date-letters for 1778, which is overlain on both, in gold, by *BB*, the date-letters for 1779, with (below) in blue, *L.*, the mark of the painter and gilder Louis-François Lécot.

Provenance:
Acquired by George IV
RCIN 5676.a–b
Cat. no. 206

Cup (saucer missing)

1779

(*gobelet litron*) 2nd size

The accomplished Sèvres artist Louis-Denis Armand *l'aîné* (active 1746–88), who was particularly admired for his skilful rendering of birds, may have been responsible for painting the exotic birds and animals on this cup. A possible source for the porcupine with his quills raised is a print from a series of engravings, used for the training of craftsmen in the decorative arts, by Jean-Jacques Bachelier at the *Ecole Royale Gratuite de Dessin*, which he established in 1766.

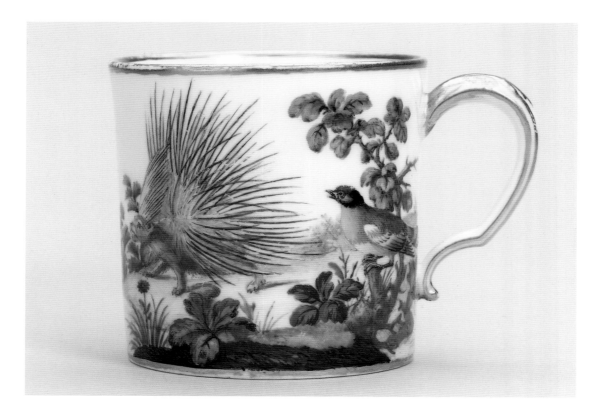

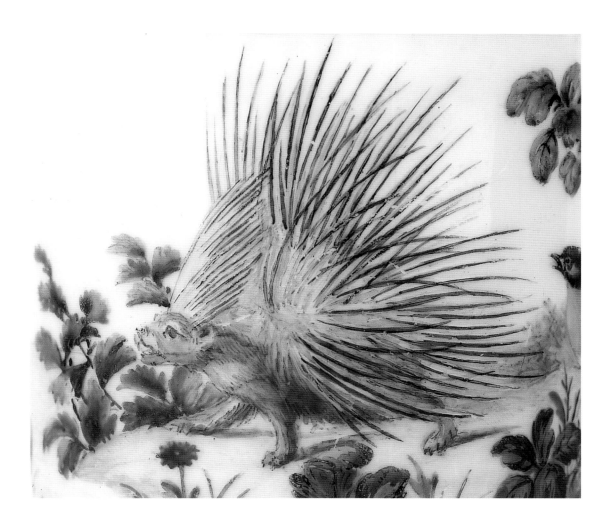

Soft-paste Sèvres porcelain

Measurements:
Height, 6.8; width, 9.4; diameter, 6.9

Marks:
Painted in blue: foliate interlaced *LL*s enclosing *BB*, the date-letters for 1779, with the *LL*s overlain at the top by a *V* reversed, probably a variant mark of the painter Louis-Denis Armand *l'aîné*.

Provenance:
Acquired by George IV
RCIN 39874
Cat. no. 208

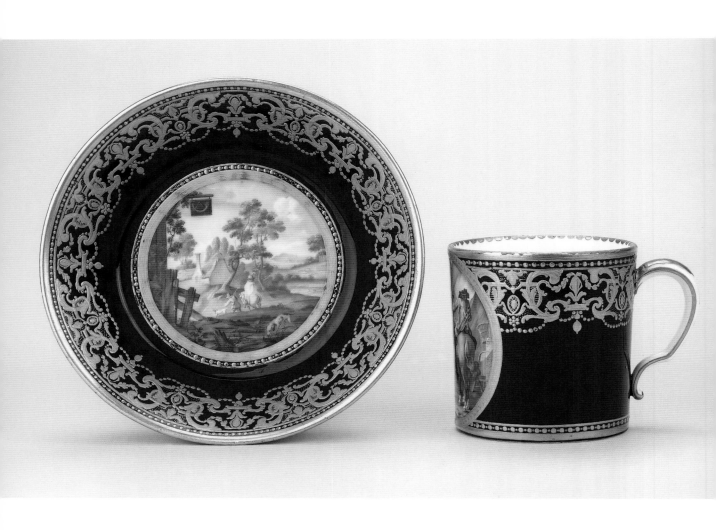

CUP AND SAUCER
*c.*1779–82
(*gobelet litron*) 1st size

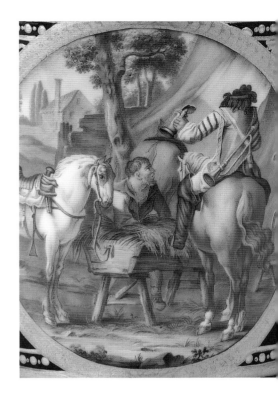

This exceptional cup and saucer, richly gilt on a *beau bleu* ground, is finely painted with scenes of huntsmen taking refreshment and travellers in a landscape setting. Copied with meticulous attention from an engraving dated 1774, *Le Chasseur prenant des Forces*, by Peeter Bout after Carl Wilhelm Weisbrod (1743–1806), the reserves are examples of Pierre-Nicolas Pithou *l'aîné*'s style at its most accomplished. The finely rendered detail – in particular the coats of the horses and the use of glowing colours painted in a diaphanous manner – accentuates the overall elegiac mood of the scenes.

Soft-paste Sèvres porcelain, dark blue ground (*beau bleu*)

Measurements:
Cup: height, 7.6; width, 9.9; diameter, 7.3
Saucer: height, 3.6; diameter, 15.0

Marks:
Painted on the cup and saucer, in blue: interlaced *LL*s, with (below) *PT.L* (in script), the mark of the painter Pierre-Nicolas Pithou *l'aîné*, and *B* (in script), the mark of the gilder Jean-Pierre Boulanger *père*.

Provenance:
Purchased by George IV from Joseph Fogg in 1828.
RCIN 58200.a–b
Cat. no. 209

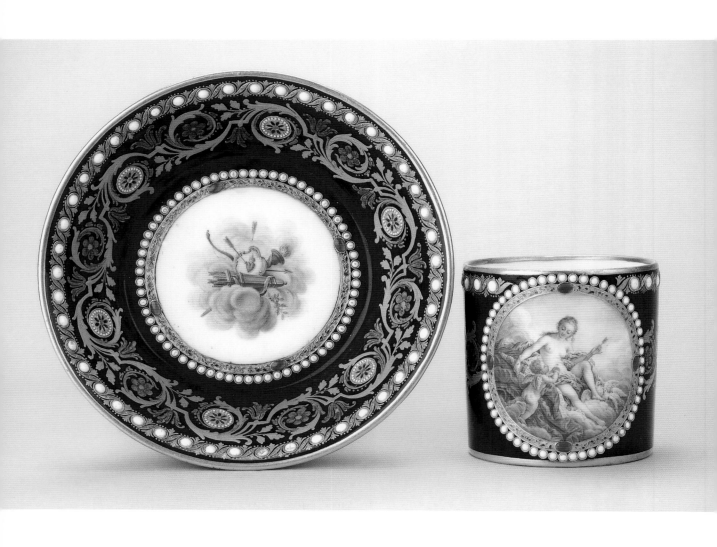

Cup and Saucer

*c.*1780–85
(*gobelet litron*) 2nd size

Gilded in two tones of gold, the cup and saucer are enriched with jewelled enamelling. The scene of Venus and Cupid on the cup is faithfully copied from an engraving dedicated to Madame de Pompadour by Etienne Fessard (1714–77), *L'Amour D'Esarmé* [*sic*], after François Boucher. The same scene can be found on a plate belonging to the Louis XVI service (see p. 134). The saucer is decorated with a trophy emblematic of love.

Soft-paste Sèvres porcelain, dark blue ground (*beau bleu*)

Measurements:
Cup: height, 6.9; width, 9.2; diameter, 6.8
Saucer: height, 3.5; diameter, 14.1

Marks:
Painted on both, in blue: interlaced *LL*s, with (below) *LG* (in script), the mark of the gilder Etienne-Henry Le Guay *père*. On the cup, by the rim: a blue dot

Provenance:
Bought by George IV from Joseph Fogg in 1828.
RCIN 58192.a–b
Cat. no. 213

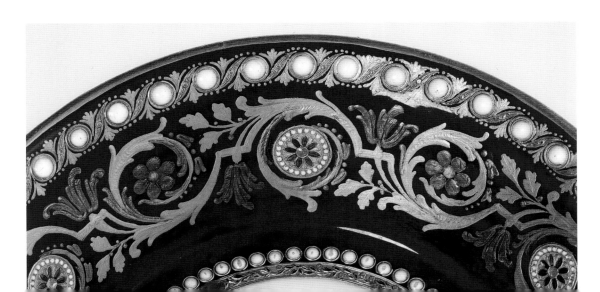

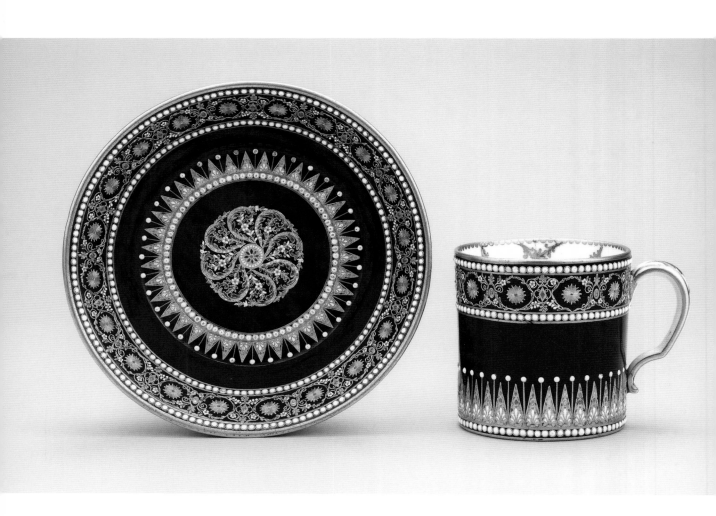

CUP AND SAUCER
1782
(*gobelet litron*) 1st size

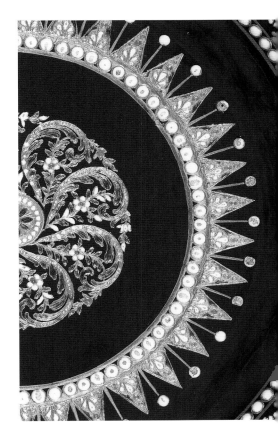

The ornate jewelled decoration of the cup and saucer, incorporating filigree bands, lambrequin motifs and rows of pearls, is set off to advantage against the dark blue ground. It is one of many similarly decorated cups and saucers collected by George IV. Because of the fragile nature of jewelling, pieces so decorated were intended as ornaments for display rather than for practical use. The technique of jewelling, perfected at Sèvres in the 1770s and 1780s, involved a complicated process of applying globules of enamel on pre-cut gold foils. Steel dies used to cut the foils were produced by the Parisian engraver Jean-Pascal Le Guay (active at Sèvres 1780–85), generally to the designs of Jean-Baptiste-Etienne Genest, the head of the manufactory's artists' studio. The two artists most associated with this luxurious decorative process were Joseph Coteau (active at Sèvres 1780–85) and Philippe Parpette (active 1755–7, 1773–1806).

Soft-paste Sèvres porcelain, dark blue ground (*beau bleu*)

Measurements:
Cup: height, 7.8; width, 10.0; diameter, 7.5
Saucer: height, 4.1; diameter, 15.5

Marks:
Painted on both, in gold: interlaced *LL*s, with (above), on the cup, *EE*, and on the saucer (on either side), *e* (date-letters for 1782).

Painted on both, in gold: *L* (followed, on the saucer, by a full stop), the mark of the painter and gilder Louis-François Lécot. Painted on both, by the rim, in blue: a dot. Painted on the rim of the cup, in black: an imprecise mark of an unidentified gilder/painter: (?)*a.m* or (?)*a.r* or (?)*a.n*

Provenance:
Presumably acquired by George IV
RCIN 58188.a–b
Cat. no. 218

Cup (saucer missing)

*c.*1780–85

(*gobelet litron*) 1st size

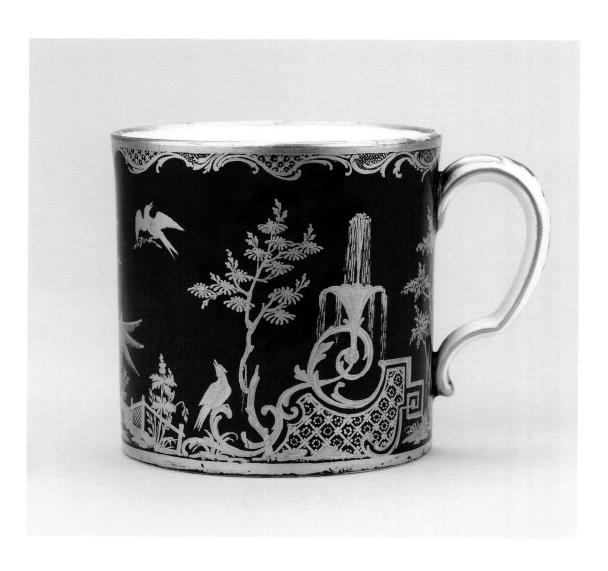

The richly gilt *chinoiserie*-type scenes hark back to the manufactory's earlier wares of the Vincennes era. The asymmetrical panels and serpentine scrolls, surrounded by exotic birds, palms, fountains and a peacock teasing a serpent, create an imaginative and harmonious decoration typical of the earlier Louis XV style, evocative of the designs of painter Jacques de Lajoue (1687–1761).

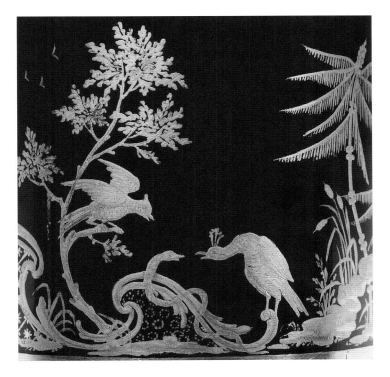

Soft-paste Sèvres porcelain, dark blue ground (*beau bleu*)

Measurements:
Height, 7.5; width, 9.9; diameter, 7.5

Marks:
Painted in gold: interlaced *LL*s, with (below) *LG* (scrolling), the mark of the gilder Etienne-Henry Le Guay *père*.

Provenance:
Acquired by George IV
RCIN 39843
Cat. no. 219

Cup (saucer missing)
1781
(*gobelet litron*) 2nd size

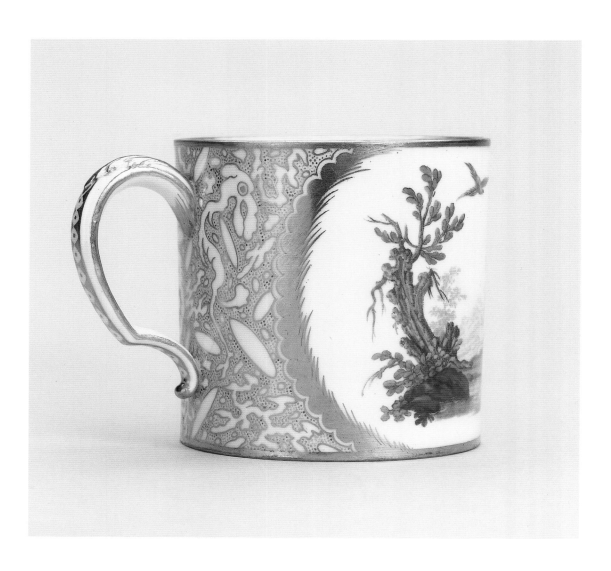

An enchanting feature incorporated within the rare and distinctive *caillouté* decoration is the strange animal-like forms. The painted scene of the duck standing in a lakeside setting accurately reproduces *Sarcelle Mâle de la Chine*, one of a set of hand-coloured engravings by François-Nicolas Martinet, commissioned to accompany the publication of *Histoire Naturelle des Oiseaux* (1770–83) by Georges-Louis Leclerc, comte de Buffon. The popularity at Sèvres of Buffon's birds as a source for decoration endured until the Revolution.

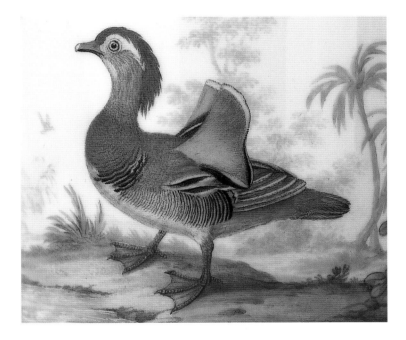

Hard-paste Sèvres porcelain

Measurements:
Height, 6.7; width, 9.2; diameter, 6.7

Marks:
Painted in mauve: crowned interlaced *LL*s enclosing *dd*, the date-letters for 1781, with (below) a painter's mark composed of four splayed strokes-cum-dots (probably the mark of Philippe Castel).

Provenance:
Acquired by George IV
RCIN 39875
Cat. no. 223

Cup and Saucer

1786

(*gobelet litron*) 2nd size

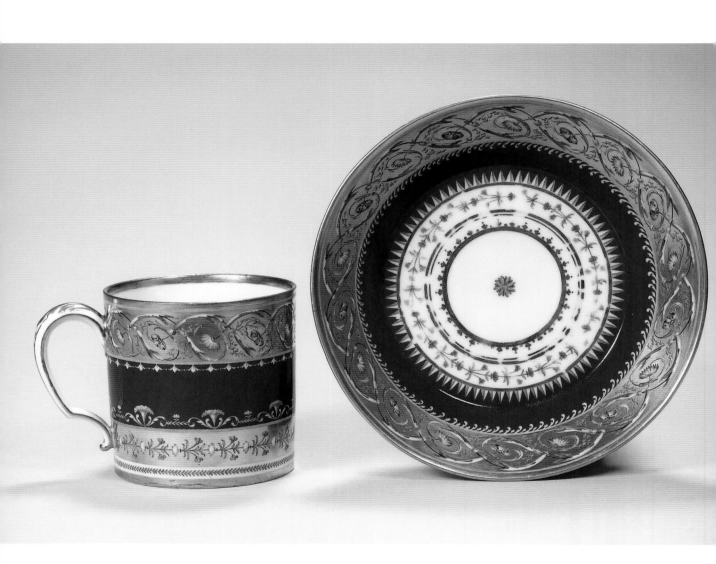

Decorated with a burnished gold ground (*fond plein or*) and painted with delicate arabesque patterns, the cup and saucer illustrate the extremes of sophistication attained by the artists at Sèvres in their bid to satisfy the demands of their fastidious clientele.

The scrolling arabesque frieze, incorporating daisy-like flowers, reproduces a composition designed and engraved by Henri Salembier (1753–1820), taken from his series entitled *Cahier de Frises*.

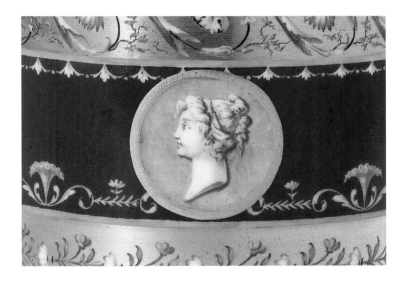

Hard-paste Sèvres porcelain

Measurements:
Cup: height, 6.5; depth, 9.1;
diameter, 6.7
Saucer: height, 3.0; diameter, 13.5

Marks:
Painted on both, in gold: interlaced *LL*s enclosing *jj*, the date-letters for 1786, with (below) *LB* (in script), the mark of the painter Jean-Nicolas Le Bel.

Provenance:
Presumably acquired by George IV
RCIN 5670.a–b
Cat. no. 230

CUP AND SAUCER

1794

(*gobelet litron*) 1st size

Painted with Republican and Masonic emblems symbolising Liberty and Equality, the decoration of the cup and saucer illustrates the ability of the former royal manufactory to adapt to the requirements of the newly created Republic of France in order to ensure its own continued survival. The seated female figure representing Equality holds aloft a Phrygian bonnet on a pike, symbolising Liberty. Within the complex and delicate gilded frieze, a cockerel – an attribute of both Liberty and Equality – stands above a plumb line, also associated with Liberty.

The painted reserve scenes derive from two allegorical biscuit groups, sculpted at Sèvres by Louis-Simon Boizot and entitled *La France gardant sa Constitution* (1791) and *La Force guidée par la Raison* (1794).

Soft-paste Sèvres porcelain, dark blue ground (*beau bleu*)

Measurements:
Cup: height, 7.5; width, 9.7; diameter, 7.3
Saucer: height, 3.6; diameter, 14.5

Marks:
Painted on the cup, in blue: *la / République Française. / RF / de / rr* (date-letters for 1794), with (below) *K*, the mark of the painter Charles-Nicolas Dodin.

Painted on the saucer, in blue: *RF. / de Sévres. / rr*, with (below) Dodin's mark, and (to the right) *LG* (in script), the mark of the gilder Etienne-Henry Le Guay *père*.

Provenance:
Acquired by George IV
RCIN 58184.a–b
Cat. no. 236

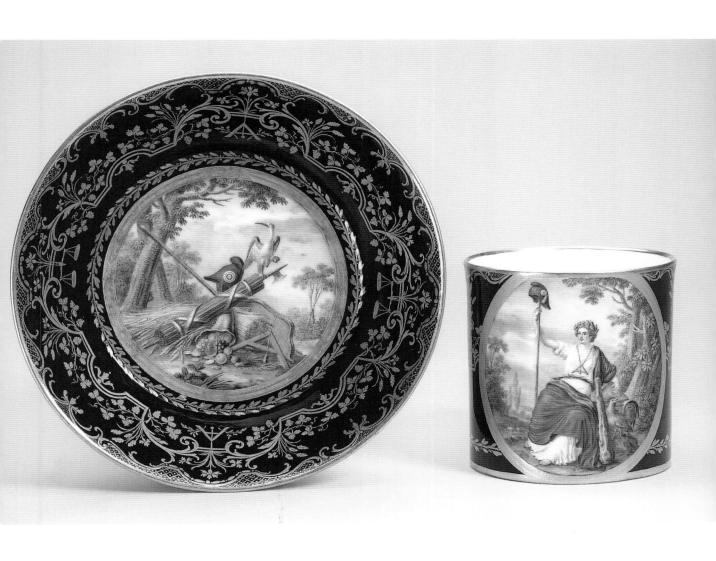

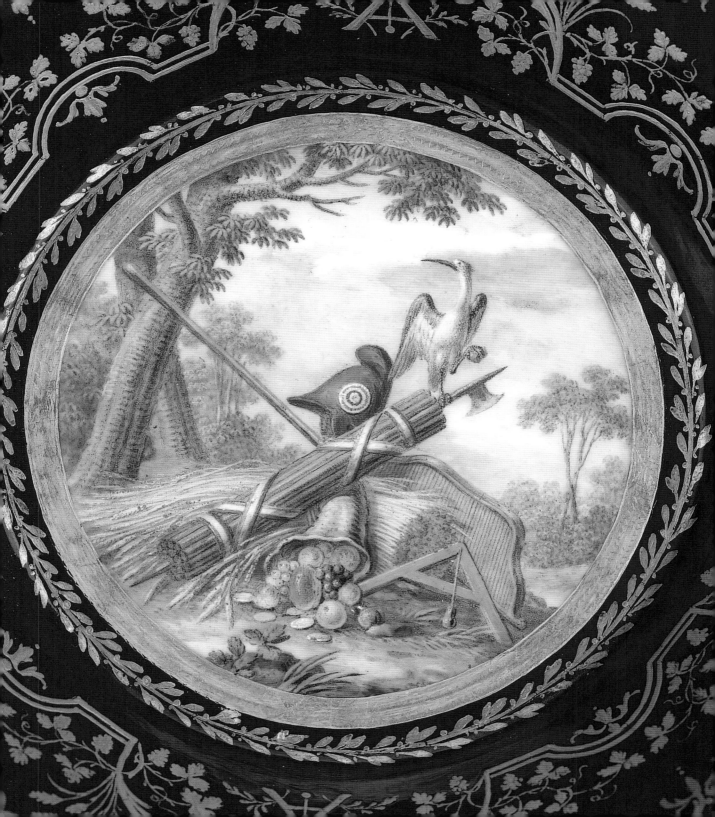

Chocolate Cup and Saucer

1828

(tasse à chocolat AB)

The burnished gold ground, tooled with thick foliate scrolls, serves as a foil for the cup's exceptionally rich decoration. It incorporates imitation jewels (ruby, garnet and emeralds) around reserves painted with hunting scenes and medallions of classical heads. In some scenes, putti are depicted preparing for the hunt, and, in others, returning home carrying dead game.

According to the Sèvres records, the cup and saucer were known in 1828 as 'Les Petits Chasseurs', from the hunting scenes painted in the two reserves on the cup, very likely after a design by the Sèvres painter Pierre Huard (active 1811–47).

Hard-paste Sèvres porcelain, gold ground

Measurements:
Cup: height, 11.9; width, 11.0; depth, 9.2
Saucer: height, 2.5; diameter, 15.6

Marks:
Painted on both, in blue: interlaced *LL*s enclosing a fleur-de-lis above *Sevres*, above *28* (date mark for 1828).
Painted on the cup, in gold: *M 2 9b.*, the mark of the gilder Jean-Louis Moyez, followed by the date 2 ?November.
Painted on the saucer, in gold: *MC.19 mars 25*, the mark of the gilder Pierre-Louis Micaud *fils*, followed by the date 19 March (?)1825.

Provenance:
Probably acquired by Queen Victoria
RCIN 39911.a–b
Cat. no. 298

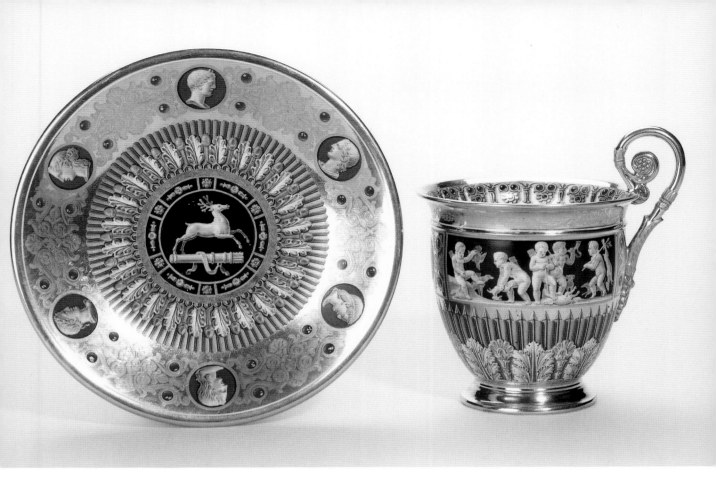

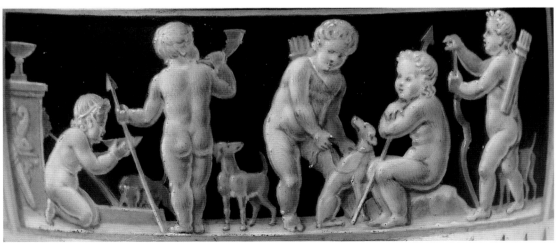

TRAY AND TEA SERVICE

*c.*1755–7

(?déjeuner grand plateau carré)

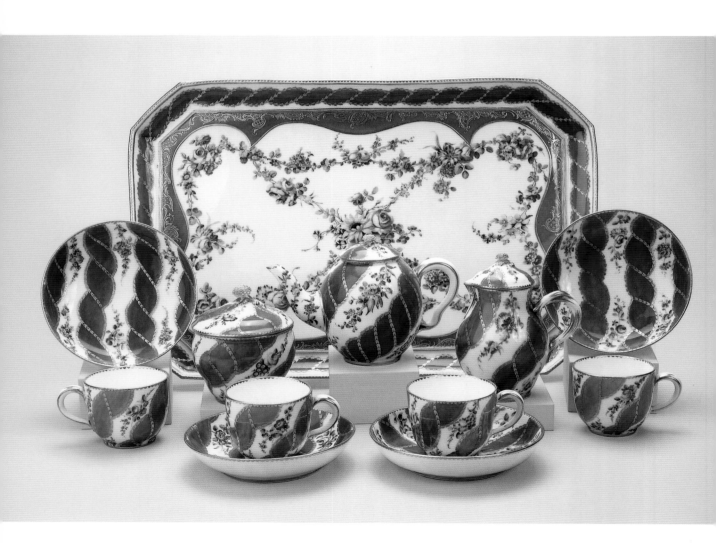

Only four other examples of the large rectangular tray with canted corners are known. An unusual feature is the green painting on its underside, possibly intended to conceal damage on what would have been an expensive component of the set. Often, new shapes were named after significant figures associated with the manufactory. In the case of this *déjeuner*, four pieces are so named: the milk jug (*pot à lait Hébert*) and sugar bowl (*sucrier Hébert*), named after the *marchand-mercier* Thomas-Joachim Hébert or possibly the *secrétaire du roi* Hébert, the cups (*gobelet Bouillard*) and the tea pot (*théière Calabre*), named after the factory's shareholders, the *fermier-général* (tax collector) Antoine-Augustin Bouillard and Pierre Calabre respectively.

It has been suggested that this *déjeuner* could be the one bought from the factory by the dealer Lazare Duvaux, for the large sum of 1,200 *livres*, and subsequently sold by him to Madame de Pompadour.

Soft-paste Vincennes–Sèvres porcelain

Measurements:
Tray: height, 3.2; width, 46.2; depth, 31.0
Tea pot: height, 12.1; width, 17.4; depth, 9.2
Milk jug: height, 13.1; width, 11.0; depth, 8.1
Sugar bowl: height, 10.2; diameter, 9.0
Cups: heights, 5.9–6.0; widths, 9.0–9.5; diameters, 7.0
Saucers: heights, 3.0–3.1; diameters, 13.6–13.8

Marks:
Painted on all, in blue: interlaced *LL*s, enclosing the date-letter *C* for 1755/6 on the milk jug and the date-letter *D* for 1756/7 on one cup and three saucers.

Painters represented: François Binet; Jacques Fontaine, Denis Levé; Pierre-Antoine Méreaud *l'aîné*; Jean-Baptiste Tandart *l'aîné*.

Provenance:
Possibly bought for George IV in Paris by François Benois in May 1814.
RCINs 39900; 39930.a–b; 39896; 39899.a–b; 39897.1–4 a–b
Cat. no. 257

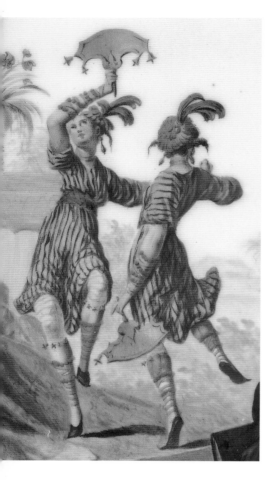

TRAY AND TEA SERVICE
1780 and 1783
(*déjeuner Bolvry*)

The colourful *chinoiserie* scenes are imbued with a sense of gaiety and light-heartedness. They include an oriental figure accompanied by his concubine, who are being entertained by two dancing figures in exotic costumes and plumed headdresses. The painting on all the pieces can confidently be attributed to Charles-Eloi Asselin (active 1765–1804), whose use of broad brushstrokes conveys a sense of animation in his figures. The tufted hats appear to be a leitmotif of Asselin's *chinoiserie* painting dating from the late 1770s and early 1780s. The figures on the tray recall tapestry cartoons by François Boucher entitled *L'Audience de L'Empereur de Chine* and *La Dance Chinoise*, from which Asselin could have drawn his inspiration.

Hard-paste Sèvres porcelain

Measurements:
Tray: height, 8.2; width, 57.1; depth, 36.2
Tea pot: height, 12.9; width, 16.9; depth, 9.9
Milk jug: height, 12.0; width, 11.7; depth, 9.1
Sugar bowl: height, 11.3; diameter, 9.4
Cups: heights, 5.9–6.0; widths, 7.7–7.9; diameters, 5.8–5.9
Saucers: heights, 2.7–2.9; diameters, 12.2–12.6

Marks:
Painted on the tray, in gold: crowned *LL*s, with (below) *AN*, the mark here attributed to the painter Charles-Eloi Asselin.

Painted on the other components (excluding one cup and saucer), in gold: crowned interlaced *LL*s enclosing *cc*, the date-letters for 1780, with (above and below) single dots.
Painted on one cup and saucer, in gold: crowned interlaced *LL*s enclosing *ff*, the date-letters for 1783.

Provenance:
Possibly bought for George IV by François Benois in Paris on 16 May 1814.
RCINs 4959; 4956; 4957; 4958; 4960.1–4 a–b
Cat. no. 258

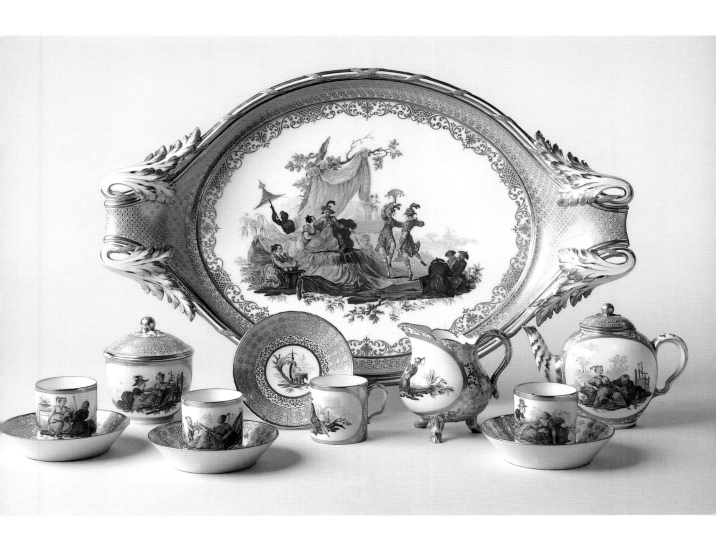

BROTH BASIN, COVER AND OVAL STAND

*c.*1748

(*écuelle à 4 pans ronds à cachet* or *écuelle à 4 pans ronds de M. Hébert* or *écuelle à 4 pans ovales*)

Decorated with the Stuart royal arms and island scenes inhabited by farmyard birds and a dog, this Vincennes broth basin is an exceptional and rare example of the manufactory's early wares. It is likely that it was specially commissioned for or by a prince of the House of Stuart. The most likely candidate is Charles Edward Stuart (1720–88), the Young Pretender, who spent many years in exile in France. Some of the animal scenes may have been inspired by the compositions of Jean-Baptiste Oudry (1686–1755).

Broth basins were designed for use principally in the bedroom or boudoir, rather than the dining room, as broth was appreciated for its remedial qualities and was often served to the sick.

Soft-paste Vincennes porcelain

Measurements:
Bowl and cover: height, 12.2; width, 22.2; depth, 21.5
Stand: height, 4.7; width, 29.0; depth, 21.5

Provenance:
Purchased by HM The Queen: the bowl and cover in 1964; the stand in 1997.
RCIN 19605.a–c
Cat. no. 262

Marks:
Painted on the bowl and stand, in blue: bold foliate interlaced *LL*s

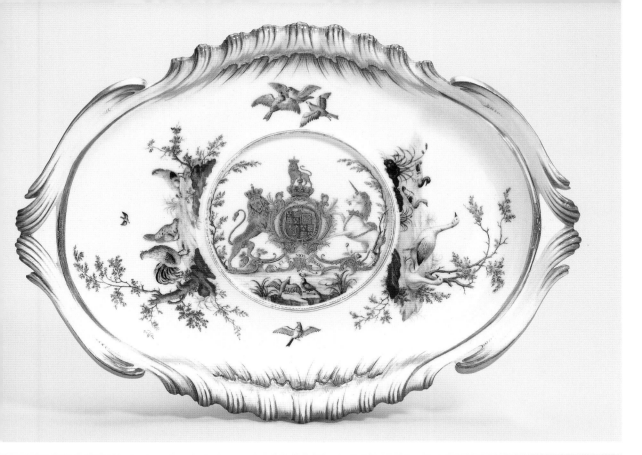

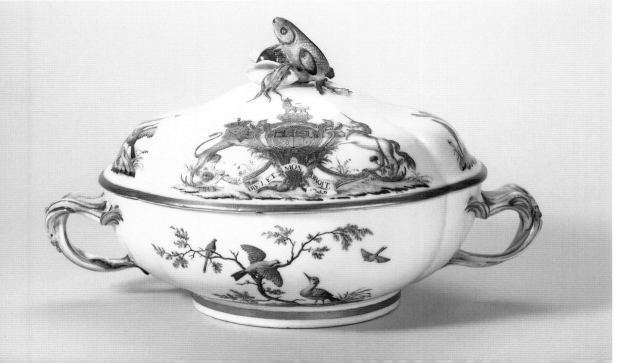

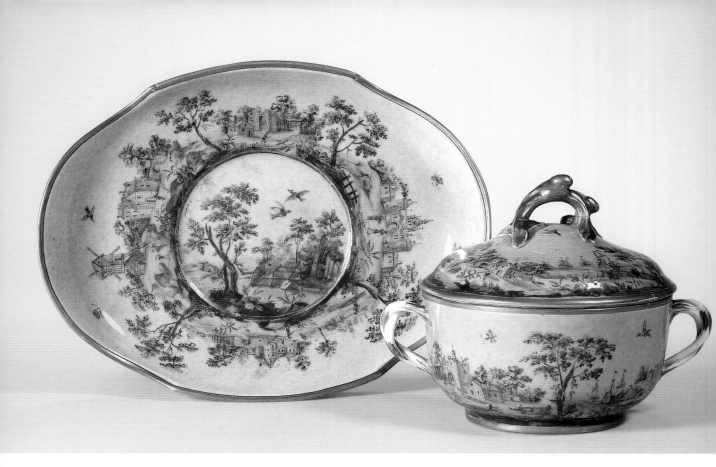

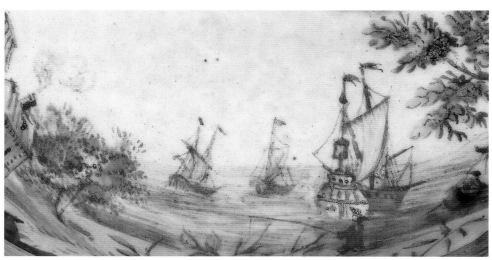

BROTH BASIN, COVER AND OVAL STAND

1787

(*écuelle ronde* and *plateau ovale*) 4th size

The unusual duck-egg blue ground colour is painted with panoramic scenes which recall the miniature painting on eighteenth-century fans. The circular landscape scene, of a type occasionally listed in the Sèvres records as *paysages circulaires*, includes castles, windmills and farmhouses inhabited by peasants, and a seascape in which ships are putting to sea.

Panoramic views were a favoured decorative style during the Vincennes years and became fashionable again in the 1780s at Sèvres. The artist responsible for the decoration on the broth basin, André-Vincent Vielliard *père* (active 1752–90), was well suited to this type of work, for he had been a fan painter prior to joining the manufactory.

Soft-paste Sèvres porcelain

Measurements:
Basin and cover: height, 9.6; width, 12.4; depth, 9.5
Stand: height, 3.2; width, 17.8; depth, 14.0

Marks:
Painted on the basin and stand, in blue: interlaced *LL*s above a horizontal line supporting three dots, the mark of André-Vincent Vielliard *père*, with (below) *KK*, the date-letters for 1787.

Provenance:
Acquired by George IV
RCIN 5699.a–c
Cat. no. 270

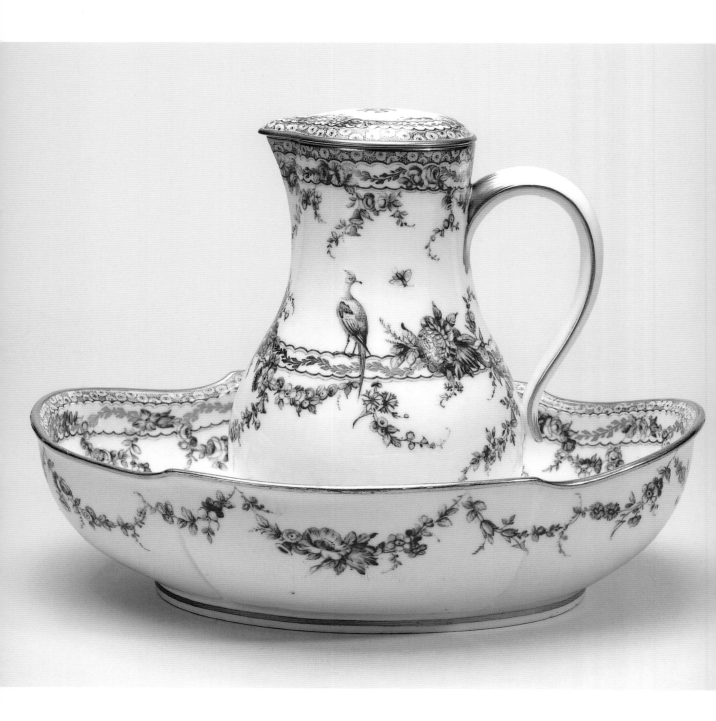

WATER JUG, COVER AND BASIN

1771

(*pot à l'eau ordinaire* and *jatte ovale*) ?1st size

Much of the appeal of this jug and basin lies in the contrast between the delicate decorative scheme in blue, combining garlands, insects and exotic birds, and the creamy-white ground of the soft-paste porcelain. Although monochrome painting was practised at Sèvres throughout the eighteenth century, the painting of trails of flowers (often in cobalt blue) was particularly favoured in the 1760s and 1770s.

In eighteenth-century France, jugs and basins were largely intended for use in private apartments. Displayed on the dressing table in the *garde-robe*, they served as an early form of handbasin, which played a part in the ritual of the morning *toilette*.

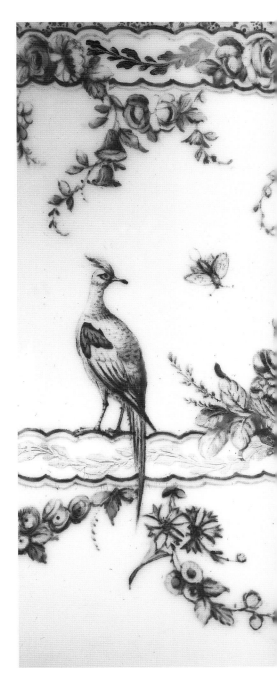

Soft-paste Sèvres porcelain

Measurements:
Water jug and cover: height, 19.3; width, 15.2; depth, 12.2
Basin: height, 7.9; width, 27.4; depth, 21.4

Marks:
Painted on the jug and basin, in blue: interlaced *LL*s, with (below) *S*, the date-letter for 1771, and (above) a stippled crown, the mark of the flower painter Jean-Charles Sioux *l'aîné*.

Provenance:
Possibly bought at auction by George IV at Dominique Daguerre's sale held at Christie's, London, 15–17 March 1790 (first day, lot 35).
RCIN 35548.a–c
Cat. no. 278

CABINET MOUNTED WITH SÈVRES PLAQUES

*c.*1783

Furniture embellished with Sèvres plaques would have
appealed to George IV's taste for the bright, the ornate and
the eye-catching, well suited to enhance the richness of his
schemes of interior decoration. This cabinet is the most opulent
and harmoniously designed survival from a once-large
collection of porcelain-mounted furniture acquired by him.

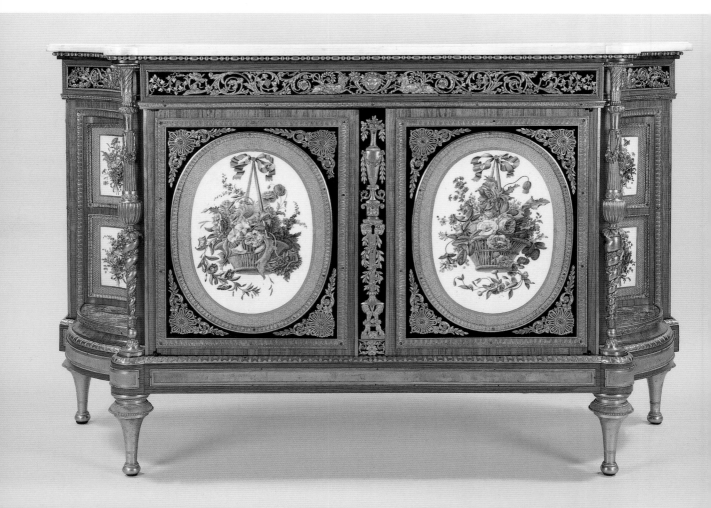

The plaques were undoubtedly bought from the manufactory by the *marchand-mercier* Dominique Daguerre, who monopolised the market for Sèvres plaques in the 1780s. He would commission the *maître-ébéniste* (master cabinetmaker) Martin Carlin to make plaques of Daguerre's own design. Daguerre may have sold the piece directly to George IV when working closely with him on the refurbishment of Carlton House at the end of the decade.

The distinctive speckled blue ground (*fond Taillandier*) was named after the Sèvres painter Vincent Taillandier (active 1753–90), who specialised in it and is credited with its invention.

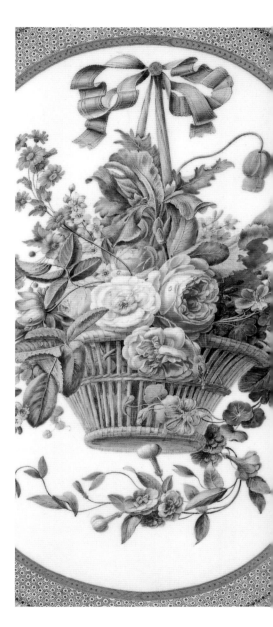

A cabinet of oak veneered with tulipwood, purplewood, mahogany and boxwood, fitted with *brocatello* marble, elaborately chased gilt bronze mounts, inset with ten plaques of soft-paste Sèvres porcelain

Measurements:
Cabinet: height, 95.9; width, 152.4; depth, 50.8
Porcelain:
Oval plaques: 42.1 × 32.3 × 0.7 and 42.5 × 32.4 × 0.7
Rectangular plaques: 9.5 × 14.2, varying in thickness from 0.4 to 0.5

Marks:
Stamped on the back and top of the cabinet (repeated four times, traces only for two of the stamps): *M. CARLIN* (Martin Carlin, *maître-ébéniste*).
Painted on two oval plaques, in blue: interlaced *LL*s, accompanied by *y* (in script), the mark of the flower painter Edmé-François Bouillat, and *B* (in script), the mark of the gilder Jean-Pierre Boulanger *père*.

Painted on eight rectangular incurving plaques, in purple: interlaced *LL*s enclosing *ff*, the date-letters for 1783, with (above) *2000*, the mark of the gilder Henry Vincent *le jeune, l'aîné*. In addition, on six, inscribed in purple (at the top) the word *haut* (Plaques 3, 4, 6, 8, 9, 10).
Painted on Plaque 3, in blue: *Bordure fond pointillé de M Taillandier, Bleu Celeste, di[x] neuf lignes.*

Provenance:
Acquired by George IV
RCIN 21697
Cat. no. 286

TABLE OF THE GRAND COMMANDERS

1806–12

Known as the *Table des Grands Capitaines*, the table was commissioned by Napoleon in 1806 and was originally intended to form part of a set of four grand presentation tables designed to immortalise his reign.

Made almost entirely of hard-paste Sèvres porcelain, it took six years to complete and combines some of the finest and most technically challenging work achieved by the factory in the early nineteenth century. An internal wooden structure supports the revolving top. The delicately painted porcelain sections were decorated by the Sèvres artists Louis-Bertin Parant (active 1806–41) and Antoine Béranger (active 1808–48), and the finely chased gilt bronze mounts were supplied by Pierre-Philippe Thomire. The most striking and original feature of the table is the elaborately decorated top, painted in imitation of sardonyx, with heads and scenes resembling cameos. In the centre, the profile head of Alexander the Great is surrounded by 12 smaller heads of other commanders and philosophers from antiquity and scenes recalling notable events of their lives.

The table was the most prestigious and conspicuous present given to George IV by a grateful Louis XVIII, two years after the defeat of Napoleon. So highly did George IV regard this gift, and such was its status in his eyes, that it became part of the ceremonial backdrop for all his state portraits (see p. 180).

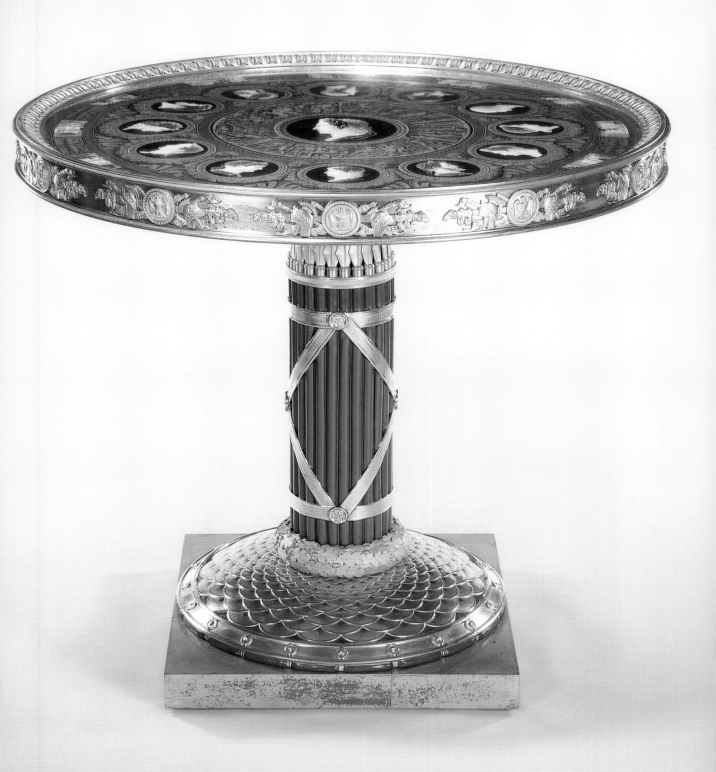

Hard-paste Sèvres porcelain, gilt bronze mounts, internal wooden frame structure

Measurements:
Overall: height, 92.4; diameter, 104.0
Plaque: thickness, 1.1; diameter, 94.5
Shaft: height, 27.2; diameter, 16.9
Shield: height, 8.4; diameter, 54.5

Marks:
Signed and dated in white on black in the centre of the plaque under the head of Alexander the Great: *L.B. Parant 1812* (Louis-Bertin Parant, figure painter). Painted on the plaque below the scene representing Alexander's entry into Babylon, in gold on green: $M^{RE} P^{LE} S\acute{E}VRES$ [*sic*]. Stencilled on the underside of the plaque, in deep purple: the manufactory's mark

and date (stamped five times): *M. Imple / de Sevres / 1812*. By the rim of the plaque, in brown: *No 1*. Painted on the rim of the shaft at the top, in green: *D. 25 mrs (?25 mai) 11* (unidentified potter's mark followed by the date, 25 March (?25 May) 1811). Painted on the underside of the shield, in green: *5 10me 11* (?5 December 1811). On the underside of the oak plaque at its top, which supports the porcelain plaque, in black ink: *haut*.

Provenance:
Presented by Louis XVIII to George IV and delivered to Carlton House on 3 May 1817.
RCIN 2634
Cat. no. 305

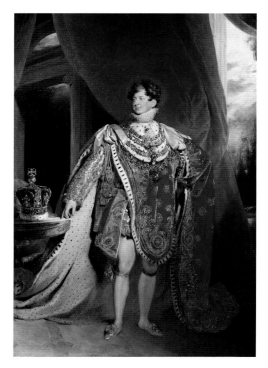

Sir Thomas Lawrence (1769–1830), *George IV in Coronation Robes*, 1821
RCIN 405918

PÉRICLÈS.

GROUP OF TWO CHINESE FIGURES FLANKING A BASKET

c.1752–4

(groupe de Chinois soutenant une corbeille)

Considered to be one of the most ambitious and successful sculptural groups modelled at Vincennes, the sculpture is remarkable in both size and complexity. The imperfections of the paste are evidence of the difficulties the potters encountered during the process of manufacture. Not surprisingly, only four groups appear to have been made, the first being fired in March 1753. Its design has been plausibly attributed on stylistic grounds to François Boucher and has been likened to his compositions of *chinoiserie* designs for Beauvais tapestries. On a rocky base strewn with coral and algae, a boy dressed in fur-lined leggings and cape approaches a girl reclining on a tasselled cushion.

An unusual feature of the group is the gold highlights. It is likely that these were added in the early nineteenth century, when the group was incorporated into an elaborate gilt bronze clock case.

Soft-paste Vincennes porcelain

Measurements:
Height, 42.0; width, 47.6; depth, 30.2

Marks:
Painted on the ledge at the back, in blue:
three dots forming a triangle, within
which are foliate interlaced *LL*s
enclosing a fleur-de-lis.
Painted above the interlaced *LL*s, in blue:
a pair of calipers, which appears to be
the mark of the painter Mutel.

Provenance:
Purchased in Paris for George IV
by François Benois in 1819.
RCIN 3150.b
Cat. no. 306

Pair of Busts of Louis XVI and Marie-Antoinette

*c.*1786–8
2nd size

George IV had an especially keen interest in the history of France under the Bourbons and earlier dynasties, and he assembled a gallery of biscuit figures of the kings of France, ranging from Louis XII to Louis XVIII. Of the busts, only those of Louis XVI and Marie-Antoinette survive in the Royal Collection.

The matt white surface of the unglazed and undecorated porcelain resembles flawless marble. The King wears the mantle and ribbon of the Order of the Saint Esprit and, hanging through a buttonhole, the badge of the Order of the Golden Fleece. Marie-Antoinette is more simply attired, with a diadem on her head and a string of pearls in her hair. Busts in biscuit porcelain of the King and Queen were produced throughout their reign and modelled by a variety of sculptors. This pair, modelled by the sculptor Louis-Simon Boizot, dates from 1785. Often sold as pairs, many featured in the end-of-year sales held at Versailles.

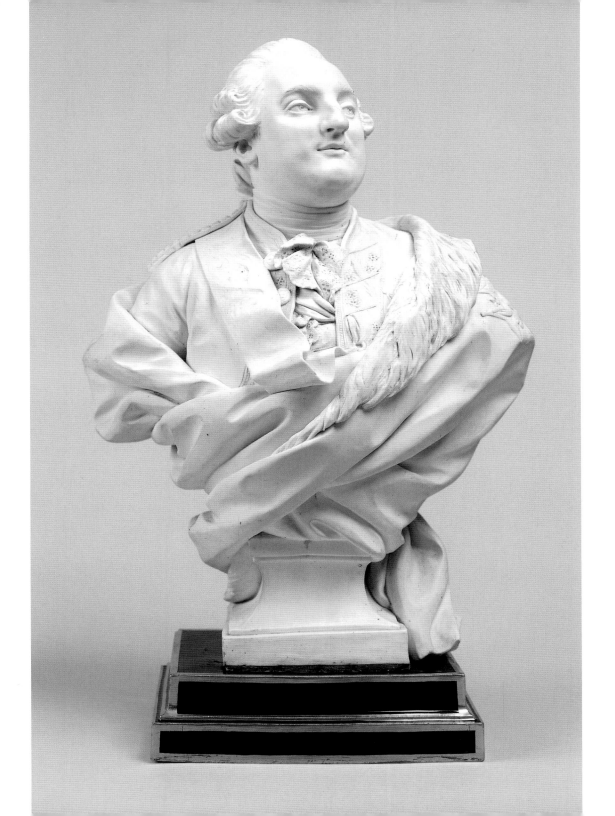

Hard-paste Sèvres biscuit porcelain, stepped bases of hard-paste Sèvres porcelain decorated with a dark blue ground (*beau bleu*) and gilding

Measurements:
Louis XVI:
Overall: height, 42.3
Bust: height, 37.2; width, 27.4; depth, 18.0

Marie-Antoinette:
Overall: height, 44.3
Bust: height, 39.5; width, 25.1; depth, 15.8

Marks:
Louis XVI: painted on the underside of the base, in blue: interlaced *LL*s flanked by the letters *G* and *I*, the mark of the gilder Etienne-Gabriel Girard. Incised on the left side of the biscuit plinth: *LR* (in script) *12* (the mark of the sculptor Josse-François-Joseph Le Riche, in his capacity as *chef des sculpteurs* (head sculptor), followed by *12*, an unidentified mark).

Marie-Antoinette: painted on the underside of the base, in blue: interlaced *LL*s flanked by the letters *G* and *I*, the mark of the gilder Etienne-Gabriel Girard.
Incised: none visible

Provenance:
Acquired by George IV, prior to 19 April 1811
RCINs 39496 and 39497
Cat. nos 307 and 308

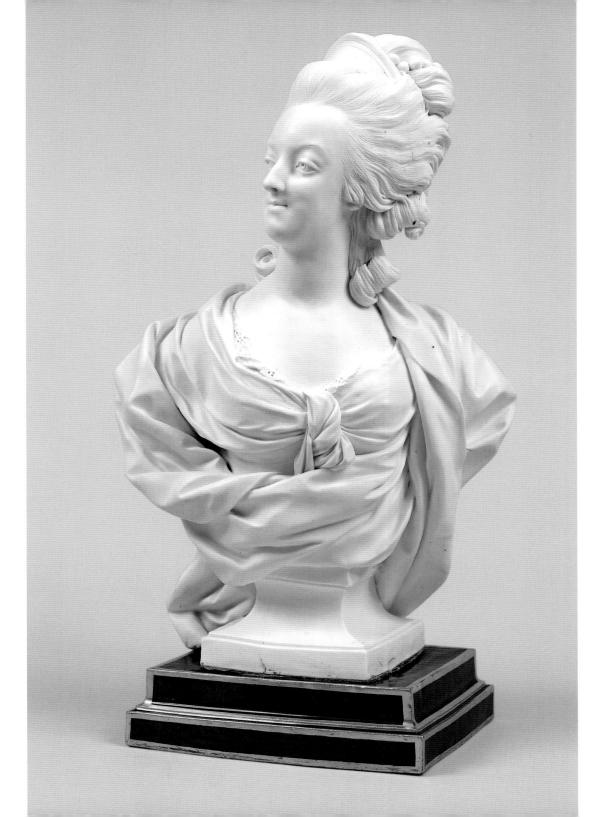

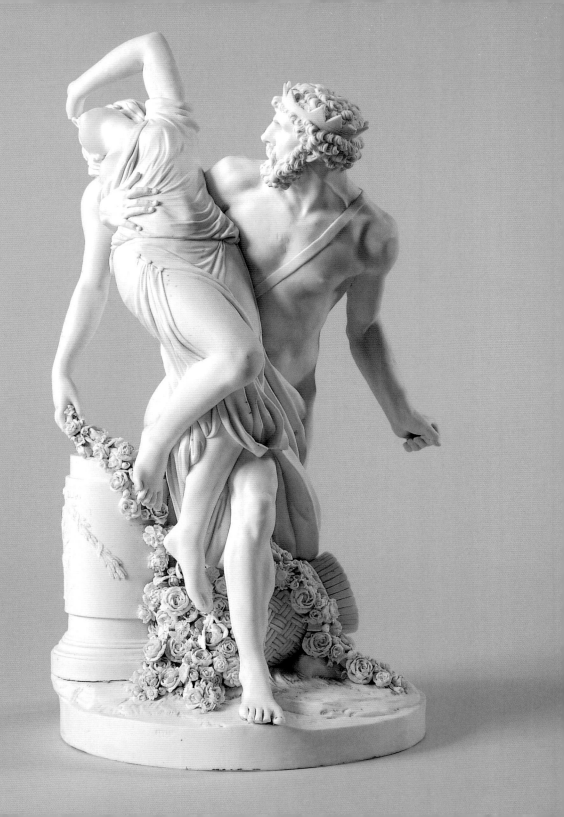

RAPE OF PROSERPINE
1814
(*L'Enlèvement de Proserpine*)

In the eighteenth and early nineteenth centuries, the Rape of Proserpine was a popular subject. Ovid describes how Proserpine, the daughter of Ceres, was innocently picking flowers in a meadow with her companions when Pluto, who had just been struck by one of Cupid's arrows, was so inflamed with passion at the sight of her that he seized her and carried her off to Hades. This group was modelled in 1786, possibly by Louis-Simon Boizot, after the group sculpted by François Girardon in 1677 for Versailles.

George IV was an avid collector of biscuit figures and acquired some 240 pieces in all. Only a small proportion survives in the Collection today.

Already in his possession when he acquired this group were two plates from the Louis XVI service, painted with this scene. He later acquired a Gobelins tapestry on the same theme, forming part of *Les Amours des Dieux*, as well as bronze reductions of the *Rape of Proserpine* after François Girardon (1628–1715).

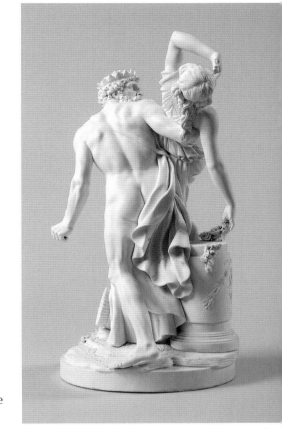

Hard-paste Sèvres biscuit porcelain

Measurements:
Height, 41.6; width, 21.6; depth, 21.3

Marks:
Incised on the front of the base: the Sèvres mark for 1800–50. Incised on the left of the base: *Li.* (in script), the mark of the sculptor Auguste-Marie Liancé.

Incised on the back of the base: *A.B.* (in script) *6. av. QZ.* (visa mark of the *administrateur* Alexandre Brongniart, followed by the date 6 April 1814).

Provenance:
Purchased for George IV from the Sèvres manufactory, together with the *Rape of Orithyia*, by Jean-Baptiste Watier, on 7 November 1816.
RCIN 33936
Cat. no. 322

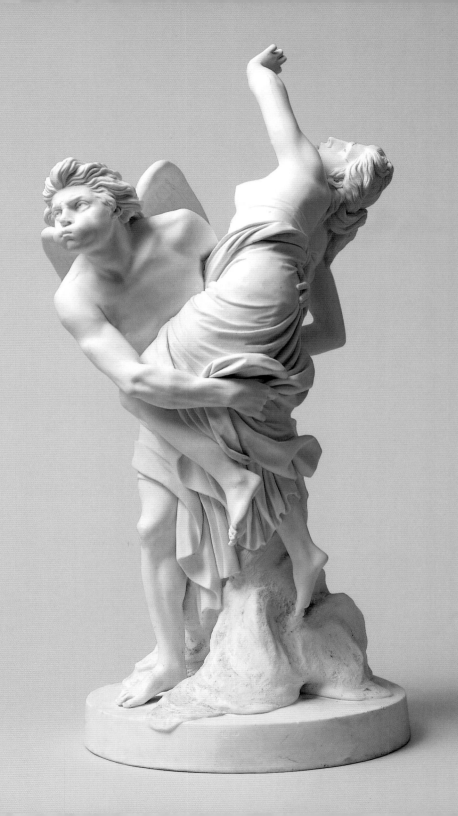

RAPE OF ORITHYIA
1814
(*L'Enlèvement d'Orythie*)

The Rape of Orithyia, as recounted by Ovid in his *Metamorphoses*, was a story which proved popular among artists and craftsmen in France in the eighteenth century. It was copied on a wine-glass cooler among the pieces forming part of the Louis XVI service (see p. 134), largely acquired by George IV in 1811. According to the legend, Boreas, the personification of Winter, after failing to obtain permission to marry Orithyia from her father, carried her off against her will.

The Sèvres biscuit group, possibly modelled by Louis-Simon Boizot in 1786, reproduces the sculpture by Gaspard Marsy (1624–81) commissioned for Versailles.

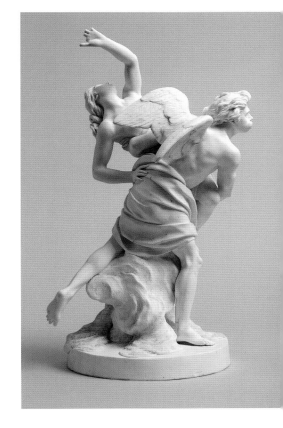

Hard-paste Sèvres biscuit porcelain

Measurements:
Height, 47.0; width, 26.5; depth, 24.0

Marks:
Incised on the front of the plinth: the Sèvres mark for 1800–50.
Incised on the back of the plinth: *A.B.* (in script) *6. av. QZ.* (mark of the *administrateur* Alexandre Brongniart, followed by the date, 6 April 1814).

Provenance:
Purchased by Jean-Baptiste Watier for George IV (as a pair to the *Rape of Proserpine*) from the Sèvres manufactory on 7 November 1816.
RCIN 3723
Cat. no. 323

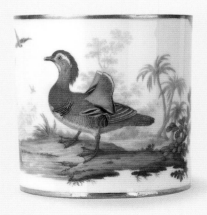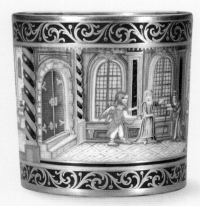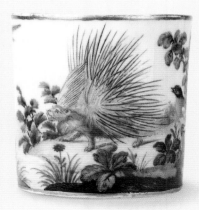
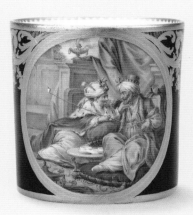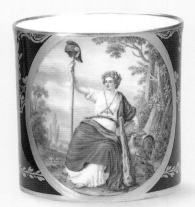
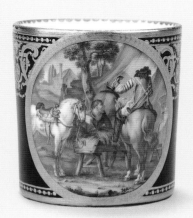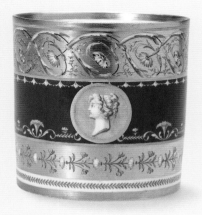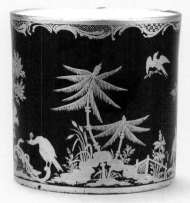

Recommended Reading

Books

de Bellaigue, Geoffrey, *French Porcelain in the Collection of Her Majesty The Queen*, 3 vols, The Royal Collection, London 2009

de Bellaigue, Geoffrey, *Sèvres Porcelain in the Collection of Her Majesty The Queen: The Louis XVI Service*, The Royal Collection, Cambridge 1986

Dawson, Aileen, *A Catalogue of French Porcelain in the British Museum*, London 1994

Eriksen, Svend and de Bellaigue, Geoffrey, *Sèvres Porcelain: Vincennes and Sèvres 1740–1800*, London 1987

Peters, David, *Sèvres Plates and Services of the Eighteenth Century*, Little Berkhamsted, Hertfordshire 2005

Préaud, Tamara and d'Albis, Antoine, *La Porcelaine de Vincennes*, Paris 1991

Roth, Linda H. and Le Corbeiller, Clare, *French Eighteenth-century Porcelain at the Wadsworth Atheneum: The J. Pierpont Morgan Collection*, Hartford, CT 2000

Sargentson, Carolyn, *Merchants and Luxury Markets: The Marchands-merciers of Eighteenth-century Paris*, London 1996

Sassoon, Adrian, *Vincennes and Sèvres Porcelain*, The J. Paul Getty Museum, Malibu 1991

Savill, Rosalind, *Catalogue of Sèvres Porcelain*, 3 vols, The Wallace Collection, London 1988

Whitehead, John, *The French Interior in the Eighteenth Century*, London 1992

Exhibition catalogues

London, The Queen's Gallery, *Sèvres Porcelain from the Royal Collection* (text by Geoffrey de Bellaigue), 1979–80

London, The Queen's Gallery, *Carlton House: The Past Glories of George IV's Palace* (text by Geoffrey de Bellaigue *et al.*), 1991–2

Paris, le Grand Palais, *Porcelaines de Vincennes, les Origines de Sèvres* (text by Tamara Préaud and Antoinette Faÿ-Hallé), 1977–8

Versailles, Musée national des châteaux de Versailles et de Trianon, *Versailles et les Tables Royales en Europe XVIIème – XIXème siècles* (text by Jean-Pierre Babelon *et al.*), 1993–4

Periodicals

'Sèvres Porcelain: Patronage and Design', *The French Porcelain Society Journal*, III, 2007

Opposite: *Gobelets litrons*
Across from top left to lower right: p. 156; p. 144; p. 146; p.142; p.152; p.160; p.148; p.158; p.154

GLOSSARY

Biscuit: Porcelain, produced by the first firing, is left unglazed and undecorated. The term 'biscuit' means twice-fired, alluding to the fact that the frit (ground glass of a special composition) in the soft paste was also fired. The matt white surface resembles marble or the spun sugar used to make table ornaments. It was introduced at Vincennes in the early 1750s for the production of small sculpture.

Bleu céleste: Turquoise blue overglaze ground colour

Bleu lapis: An underglaze dark blue ground colour developed at the Vincennes manufactory in 1751

Bleu nouveau: An overglaze dark blue ground colour introduced at Sèvres in 1763, also known as *beau bleu* (beautiful blue)

Burnishing: Polished gilding

Caillouté: Gilding pattern resembling pebbles

Enamel colour: Opaque or translucent painted colour derived from metallic oxides such as cobalt (blue), copper (green), iron (brown, red), manganese (purple) and antimony (yellow)

Fond taillandier: Pattern consisting of a ground, usually blue, with white circles edged with gilding and containing coloured dots with smaller circles of gilded dots over the ground colour. It was named after the Sèvres painter Vincent Taillandier, who specialised in this form of decoration.

Garniture: A group of porcelain vases, usually numbering three, five or seven to create a unity, either of shape, ground colour or a theme used in their gilded or painted decoration

Gilding: The final stage of fired decoration. During the eighteenth century two different techniques of gilding were used at Sèvres. For soft paste, a gold powder of crushed gold leaf was painted or powdered onto the surface and secured through the use of a mixture of garlic, onions and vinegar. It was generally applied up to two or three times to produce the desired thickness. Fired at a low temperature, it was polished with a smooth hard stone, such as agate. It could be tooled with decorative motifs. After 1770, a second technique of gilding was applied to both hard- and soft-paste porcelain, using chloride of gold precipitated with iron sulphate, which was then transformed into powder. It was painted on the ceramic surface with a size made of turpentine oil and then fired at low temperature. It too was polished with a hard stone and could then be tooled. Transfer gilding was used at Sèvres from the early nineteenth century.

Gilt bronze (ormolu): Gilded bronze was made by applying a paste of gold and mercury to bronze and then firing it. In the eighteenth century, gilt bronze was used to make mounts to enhance decorative objects, including porcelain and furniture.

Glaze: A transparent, coloured or opaque coating applied to ceramics before firing to create a glassy finish. Primarily composed of silica, various oxides (fluxes) were added to lower its melting temperature. Eighteenth-century fluxes included lead oxide or feldspar. After the biscuit firing, soft-paste porcelain was covered in a lead glaze and hard-paste porcelain in a feldspathic glaze (i.e. including feldspar).

Grisaille: Painting in grey on white or on dark brown, in imitation of stone or low-relief classical sculpture

Ground colour: Background colour used to cover the surface of porcelain, with decoration painted either directly onto the colour or in reserves left blank for this purpose. Applied either as a powder over a sticky mordant or in liquid form painted onto the porcelain. Most were applied over the glaze, with the exception of early Vincennes–Sèvres *bleu lapis*.

Hard-paste porcelain: 'True porcelain' made from china clay (kaolin) and china stone or petuntse (silicate of potassium and aluminium), fired at a high temperature (1,250–1,350 °C) to produce a glassy matrix. Covered with a feldspathic glaze after the biscuit firing, hard-paste porcelain usually has a colder white colour than soft paste. Enamel colours do not sink into the glaze, but tend to sit on top in very slight relief. First made in China in the ninth century, the recipe was not known in Europe until 1709, when production began at the German factory of Meissen. In France, the essential ingredient of kaolin was discovered only at the end of the 1760s, near Limoges. It became part of the production at Sèvres in 1769 and continues today.

Jewelling: A rare form of decoration perfected and popularised at Sèvres during the late 1770s and 1780s, used on vases, cups and saucers and other types of wares. Its extreme fragility indicates that these wares were ornamental rather than for practical use. Engraved steel dies were used to produce individual foils in gold leaf, to which small drops of translucent enamel were applied and fired at a low temperature. Jewelled decoration was often added during the nineteenth century.

Lambrequin: Short decorative panels of material used to decorate shelf edging or window casing

Oeil-de-perdrix: Partridge-eye pattern, consisting of coloured or gilded circles of dots surrounding a central dot

Petit verd: Pale blue ground colour

Repareur: Repairer or modeller responsible for preparing the object for firing. This included chasing sculptural details, providing handles, spouts and knobs, and assembling biscuit figures.

Reserve decoration: An area of surface decoration left unpainted when a ground colour is applied. It is subsequently painted with coloured enamel decoration, such as floral, pastoral or mythological scenes.

Soft-paste porcelain: An 'artificial porcelain' consisting of frit mixed with clay capable of withstanding temperatures up to 1,250 °C only. Covered with lead glaze after the biscuit firing, soft-paste porcelain is a translucent creamy-white, and colours and gilding tend to sink into the glaze when fired. The term 'soft' refers to its inability to remain rigid at high temperatures. The lower firing temperature enabled the use of a wider palette of colours for decoration. It was the first paste used at Vincennes and Sèvres, and production continued until 1804.

Tooling: Engraved decoration on gilding

Currency (eighteenth-century France):
1 sol (sou) = 12 deniers
1 livre = 20 sols (sous)
1 louis d'or = 24 livres

Currency (eighteenth-century England):
1 shilling (s) = 12 pennies (d)
1 pound (£) = 20 shillings
1 guinea (gn) = £1 1s 0d

The rate of exchange in the mid-eighteenth century was 24 livres to £1 sterling. In 1809 the Republican monetary unit was 23 francs to £1 sterling.

INDEX OF SÈVRES PAINTERS AND GILDERS

Index of painters and gilders represented in this book. Dates given indicate period of activity at the manufactory.

Armand, Louis-Denis *l'aîné* (1746–88), painter 146, 147

Asselin, Charles-Eloi (1765–1804), painter 100, 135, 168

Baudouin, François *père* (1750–1800), gilder 82

Béranger, Antoine (1808–48), painter 178

Binet, François (1750–75), painter 167

Bouchet, Jean (1757–93), painter and gilder 49

Bouillat, Edmé-François (1758–1810), painter 57, 133, 177

Boulanger, Jean-Pierre *père* (1754–85), painter and gilder 57, 73, 78, 80, 82, 133, 149, 177

Buteux, Charles *l'aîné père* (1756–82), painter 52, 59

Buteux, Charles-Nicolas *fils aîné* (1763–1801), painter and gilder 52, 135

Castel, Philippe (1772–97), painter and gilder 157

Caton, Antoine (1749–98), painter and gilder 57

Chauvaux, Michel-Barnabé *l'aîné* (1752–88), gilder 133, 143

Chulot, Louis-Gabriel (1755–1800), painter 52, 62

Cornailles, Antoine-Toussaint (1755–1800), painter and gilder 127, 135

Didier, Charles-Antoine *père* (1787–1825), painter and gilder 135

Dodin, Charles-Nicolas (1754–1803), painter 41, 45, 62, 66, 71, 74, 78, 82, 93, 97, 135, 143, 160

Fallot, Jean-Armand (1765–90), painter 100

Fontaine, Jacques (1752–1807), painter and gilder 66, 167

Genest, Jean-Baptiste-Etienne (1752–88), painter and head of the painters' workshop 59, 66, 153

Gérard, Claude-Charles *fils aîné* (1771–1825), painter 135

Girard, Etienne-Gabriel (1762–1800), gilder and painter 118, 186

Huard, Pierre (1811–47), painter 164

Laroche, Jacques-François-Louis de (1759–1801), painter 133

Le Bel, Jean-Nicolas (1765–93), painter 159

Lécot, Louis-François (1764–1802), gilder 135, 145, 153

Le Guay, Etienne-Henry *père* (1742–97), painter and gilder 59, 88, 135, 151, 155, 160

Le Guay, Pierre-André *le jeune* (1772–1817), painter 57

Levé, Denis (1754–1805), painter 133, 167

Méreaud, Pierre-Antoine *l'aîné* (1754–91), painter 135, 167

Micaud, Jacques-François *père* (1757–1810), painter 133

Micaud, Pierre-Louis *fils* (1792–1834), gilder 164

Morin, Jean-Louis (1754–87), painter 20, 35, 36, 38, 49, 50, 52, 59, 66

Moyez, Jean-Louis (1818–48), gilder 140, 141, 164

Mutel (1754–9, 1765, 1771–4), painter and gilder 26, 183

Noël, Guillaume (1755–1807), painter and gilder 135

Noualhier, Jean-Baptiste-Etienne-Nicolas *père* (1775–1835), painter 140

Parant, Louis-Bertin (1806–41), painter 178, 180

Philippine, François-Pascal *l'aîné* (1778–91, 1802–25), painter 135

Pierre, Jean-Jacques *le jeune* (1763–1800), painter 133

Pithou, Nicolas-Pierre *le jeune* (1763–7, 1770–95, 1817), painter 135

Pithou, Pierre-Nicolas *l'aîné* (1759–90), painter 139, 149

Prévost, Henri-Martin *l'aîné* (1757–97), gilder 93, 97, 100, 135, 139

Schradre, Nicolas (1773–85), painter and gilder 105, 107

Sioux, Jean-Charles *l'aîné* (1752–92), painter 175

Taillandier, Vincent (1753–90), painter and gilder 133, 177

Tandart, Jean-Baptiste *l'aîné* (1754–1803), painter 20, 50, 167

Vielliard, André-Vincent *père* (1752–90), painter and gilder 173

Vincent, Henry *le jeune, l'aîné* (1753–1806), gilder 103, 107, 135, 177

Xhrouet, Philippe *père* (1750–75), painter 129

General index

acanthus leaf handles 90
Adélaïde, Madame 107
Angiviller, Charles-Claude Flahaut de la Billarderie, comte d' (1730–1810), *directeur général des Bâtiments et Manufactures* 66, 139
assiette *see* table wares, plates
Avril, Jean-Jacques (1771–1835), engraver 118

Bachelier, Jean-Jacques (1724–1806), artistic director of the manufactory (1748/51–93), designs 15, 74, 146
Baldock, Edward Holmes 69
Basan, Pierre-François (1723–97), engraver: *L'Amour Asiatique* 143
basin (*jatte ovale*) *174*, 175, *175*
Beauvarlet, Jacques-Firmin (1731–97), engraver: *Le Colin Maillard* 71
Beechey, Sir William (1753–1839), artist: *George IV when Prince of Wales 6*
Benois, François, confectioner to George IV 8, 17, 33, 59, 71, 167, 168, 183
Boileau de Picardie, Jacques-René, Director of Sèvres manufactory (1751–72) 35
Boizot, Louis-Simon (1743–1809), sculptor 115
 bust of Louis XVI 184, *185*, 186
 bust of Marie-Antoinette 184, 186, *187*
 La Force guidée par la Raison 160
 La France gardant sa Constitution 160
 [?] *Rape of Orithyia* 189, *190*, 191, *191*
 [?] *Rape of Proserpine* 188, *189*, 189, 191
Bolingbroke, Frederick St John, 2nd Viscount (1732–87) 129
Bouchardon, Edmé (1698–1762), sculptor 61

Boucher, François (1703–70), artist 45, 66, 130, 183
 L'Amour D'Esarmé 151
 L'Audience de L'Empereur de Chine 168
 Le Berger Récompensé 71
 La Dance Chinoise 168
Bouillard, Antoine-Augustin, *fermier-général, marchand-mercier*, shareholder in the Vincennes manufactory 167
Bout, Peeter: *Le Chasseur prenant des Forces* 149
Brongniart, Alexandre (1770–1847), Director of Sèvres manufactory (1800–1847) 189, 191
broth basins 170, *171*, *172*, 173
Buffon, Georges-Louis Leclerc, comte de (1707–88): *Histoire Naturelle des Oiseaux* 100, 157

cabinet with Sèvres plaques *176*, 176–7
Calabre, Pierre, shareholder in Vincennes manufactory 167
Canot, Pierre-Charles (*b.*1710), engraver 116
Carlin, Martin (*c.*1730–85), *maître ébéniste* 177
Carlton House, London 7, 8, *9*, *11*, 115
Charlotte, Queen (1744–1818) 45
Chinese figures flanking a basket *182*, 183
colours, ground
 beau bleu/bleu nouveau 36, 47, 50, 57, 59, 61, 62, 69, 74, 80, 88, 93, 97, 135, 143, 149, 151, 153, 155, 160
 bleu céleste 20, 71, 78, 82, 129, 133
 bleu lapis 23, 25, 28, 124
 bleu lapis caillouté 35
 bleu nouveau see beau bleu/bleu nouveau
 duck-egg blue 173
 fond écaille 116

 fond noir 116
 fond plein or 159
 fond porphyre 123
 lapis lazuli 103, 107
 oeil-de-perdrix pattern 61, 130
 petit verd 20, 33
 porphyry 123
compotier coquille see table wares, fruit dishes
Coteau, Joseph (active at Sèvres 1780–85) 153
Courteille, Dominique-Jacques Barberie, marquis de (1696–1767), royal representative at Vincennes (1751–67) 18
Craufurd, Mrs Quintin 49, 59, 71
cups and saucers *see* tea wares
cuvettes see vases

Daguerre, Dominique, (*d.*1796), *marchand-mercier* 8, 113, 118, 177
dating system 13
Daullé, Jean (1703–63), engraver and painter: *Les Charmes de la Vie champêtre* 66
déjeuner Bolvry 168, *169*
 (*see also* tea wares)
déjeuner grand plateau carré 166, 167
 (*see also* tea wares)
Delafosse, Jean-Charles (1734–89), designer, engraver and architect 38
Demarteau, Gilles (1722–76), artist and engraver: *La Pipée* 45
Denon, Dominique Vivant (1747–1825) 116
Desportes, François (1661–1743), artist 139
Dieu, Jean-Jacques (active 1776–1805), painter 107
dinner and dessert services 10, 132–7, 140–1 (*see also* table wares)
du Barry, Jeanne Bécu de Vaubernier, Madame (1743–93) 10, 61, 130
Dubois, Gilles (*b.*1712) 12

Dubois, Robert (1709–59) 12

Duplessis, Jean-Claude, *père* (c.1690–1774), artistic director of models (1745/8–74), bronze manufacturer and designer 15, 23, 62

Duplessis, Jean-Claude-Thomas, *fils* (c. 1730–83), bronze manufacturer 113

Duvaux, Lazare (d.1758), *marchand-mercier* 129, 167

écuelles see broth basins

Eisen, Charles (1720–78), artist: *L'Amour Asiatique* 143

Endymion 41

ewer shapes *102*, 103, *112*, 113

Falens, Carel van (1683–1733), artist *Halte de Chasseurs* 33 *Rendez-vous de Chasse* 33

Fénelon, François de (1651–1715), author: *Les Aventures de Télémaque* 135

Fessard, Etienne (1714–77), engraver: *L'Amour D'Esarmé* 151

flower vases 18, *19*, 20, *21*, 26, *27*, 28, *29–31* (*see also* vases, *vase hollandois*)

Fogg, Joseph, dealer 149, 151

Fogg, Robert, dealer 8, 10, 41, 61, 62, 73, 74, 88, 93, 100, 103, 110, 116, 118

Fontanieu, Pierre-Elisabeth de (1730–84): *Collection de Vases Inventés, et Dessinés Par Mr de Fontanieu…* 82

Fragonard, Jean-Honoré (1732–1806), artist 71

Freudenberger, Sigmund (1745–1801), artist: *Le Petit Jour* 93

fruit dishes *see* table wares

Gaillard, René (1719–90), engraver: *Le Berger Récompensé* 71 *L'agréable Leçon* 45 *L'Amour à l'Ecole* 74

garnitures of vases 8, 41, 59, 66, 71, 74, 78, 93, 97, 107

vase à batons rompus; vases ferrés 36, *36–7*, 38

vase Duplessis à bandeau; vase Duplessis à monter 98–9, 100

vases à trois gorges; vase jardin 88, *88–9*, 90

vases chinois 104, 105

George IV (1762–1830), Prince Regent (1811–20), King of England (1820–30) 6, *7–8*, 10, 105, 178, *180*

Gérard, Benoist, *père*, clock-maker 17

Gérin, Claude-Humbert (1705–50) 12

gilded decoration *caillouté* 23, 35, 157 circles of dots 80 leaf trails 47, 71, 73 leaf-and-berry garlands 71 *mouches d'or* 52 pastilles 52 platinum, use of 118 *pois d'or* 52 trelliswork 47

Girardon, François (1628–1715), sculptor: *Rape of Proserpine* 189

goats' head handles 62, *63*, *64*

gobelet litron see tea wares, cups and saucers

Gresset, Jean-Baptiste-Louis (1709–77), poet: *Ver-Vert* 145

Gwydir, Lord: sale (21 May 1829) 10, 69

Halbou, Louis (1730–1809), engraver: *Le Sultan Galant* 88

Hébert, Thomas-Joachim, *marchand-mercier* 167

Hébert, *secrétaire du roi* 167

Helman, Isidore-Stanislas-Henri (1743–1806/9), engraver: *L'accord parfait* 93

herm heads/handles *92*, 93, *96*, 97

Huquier, Gabriel (1695–1772), engraver 105

jatte ovale 174, 175

Jeaurat, Etienne (1699–1789), artist: *Le Sultan Galant* 88

jewelled decoration 153

Lagrenée, Jean-Jacques, *le jeune* (1739–1821), painter, designer and engraver, co-director at Sèvres manufactory 123

Lajoue, Jacques de (1687–1761), painter 155

Launay, Nicolas de (1739–92), engraver 41 *Le Petit Jour* 93

Lawrence, Sir Thomas (1769–1830), artist: *George IV in Coronation Robes* 10, *180*

Le Bas, Philippe (1707–83), engraver: *La Quatrième Fête Flamande* 28

Leda 41

Le Guay, Jean-Pascal (active at Sèvres 1780–85) 153

Leloy, Jean-Charles-François (active 1816–44), artist 140

Le Riche, Josse-François-Joseph (1775–1801), *chef de sculpteurs*, sculptor and modeller 186

Liancé, Auguste-Marie (active 1782–92, 1795–1820), sculptor 189

Louis XV (1710–74), King of France (1715–74) 15, 88, 133 portrait *60*, 61

Louis XVI (1754–93), King of France (1774–92) 10, 97, 110, 133, 134, 139 bust 10, 66, 184, *185*, 186

Louis XVIII (1755–1824), King of France (1814–24) 178

Louis Philippe (1773–1850), King of France (1830–48) 140

Manchester, Duke and Duchess of *see* table wares, Manchester service

Marie-Antoinette (1755–93), Queen of France 100 bust 10, 66, 184, 186, *187*

marks 12–15

Marsy, Gaspard (1624–81), sculptor: *Rape of Orithyia* 191

Martinet, François-Nicolas (active c.1760–1800), engraver *L'Honoré de Cayenne* 100 *Sarcelle Mâle de la Chine* 157

Masonic emblems 160, *161*
medallions 61, 66, 87
Medici shape vase *72, 73*
mermaid figures *114*, 115, *115*
Missier, S. (clock-spring manufacturer) 17
Molière (1622–73), playwright and actor 130
 L'Avare 82
monster-head handles *106*, 107, *107*
Moreau, Jean-Michel, *le jeune* (1741–1814), illustrator and engraver 123
 L'accord parfait 93
 C'est un Fils, Monsieur! 57
 Déclaration de la Grossesse 93, 97
 N'ayez pas peur ma bonne Amie 93, 97

Napoleon Bonaparte, Emperor 10, 178
neo-classical style 23, 87, 113, 116

Orry de Fulvy, Jean-Henri-Louis, marquis de (1703–51), co-founder of the Vincennes manufactory 12
Oudry, Jean-Baptiste (1686–1755), painter 170
Ovid: *Métamorphoses* 123, 135, 191

painted decoration/scenes
 animals 62, *63, 64*, 74, *75–77, 108–9, 138*, 139, *139*, 146, *146, 147*
 arabesque *108–9*, 110, *111, 122–3, 158*, 159
 bacchanalian theme 73, *73*
 birds 74, *75, 76*, 100, *101*, 146, *146, 154*, 155, *155*, 157, *157*, 170, *171*, 175, *175*
 cats 74, *75, 77*
 chinoiserie scenes *98–9*, 100, *101, 104*, 105, 116, *116–17*, 118, *119–20*, 145, *154*, 155, *155*, 168, *168, 169*, 183
 comedy 82, 130
 Cupid 74, 151
 dogs 74, *77, 139*, 170
 garlands 71, *71*, 80, *81*

genre scenes 20, *21, 24*, 25, 28, *29*
grisaille 87
hunting scenes 26, 149, *149*, 164, *165*
marine scenes 18, *19, 34*, 35, *46, 47, 47, 48*, 49, 50, *51*, 52, *53*, 59, *60, 172*, 173
military encampment scenes 36, *36–7*, 38, *38*
military trophies 62, *65*
monochrome painting 87, 175
mythological themes *40*, 41, *42–3*, 74, *75*, 81, *122*, 123, 135, *136–7*
panoramic views (*paysages circulaires*) *172*, 173
pastoral scenes *44, 45*, 66, *67–8, 70*, 71, 78, *79*
putti 62, *63, 72, 73*, 86, 87, *87*, 130, *130–31*, 164, *165*
quayside scenes 50, *51*, 58, 59
tragedy 82
Turkish 88, *88–9, 142*, 143, *143*
wreaths, intertwined 50, *50*
Parpette, Philippe (active 1755–7, 1773–1806), painter 153
Perregaux, Alphonse-Claude-Charles-Bernard, banker and dealer 127, 129
Peyrotte, Aléxis (1699–1769), artist 105
Phillips, Harry (*d.*1840), auctioneer 10, 20, 133
Pierre, Jean-Baptiste-Marie (*c.*1713–89), painter 41
Pillement, Jean-Baptiste (1728–1808), painter and engraver 105, 116, 118
Pompadour, Jeanne Antoinette Poisson, marquise (Madame) de (1721–64) 10, 15, 17, 20, 25, 124, 151, 167
porcupine 146, *146–47*
pot à l'eau 174, 175
Provence, comte de, future Louis XVIII (1755–1824) 78 (*see also* Louis XVIII)

Rape of Orithyia 189, *190*, 191, *191*
Rape of Proserpine 188, 189, *189*, 191
Regnard, Jean-François (1655–1709), dramatist: *Le Joueur* 82
Republican emblems 160, *161*

rococo style 28, 124, 127
Rossini, Gioachino (1792–1868), composer 140
Salembier, Henri (1753–1820), painter and engraver: *Cahier de Frises* 159
seau à demi-bouteille see table wares, wine-bottle coolers
sphinx-head handles 73
Stuart, Charles Edward (1720–88) 170
'The Sunflower Clock' *16*, 17

Table of the Grand Commanders 10, 178, *179*, 180, *181*
table wares
 fruit dishes (shell-shaped) (*compotier coquille*) 126, 127
 Louis XVI service 134, *134*, 135, *136–7*
 Manchester service 10, *132*, 133
 plates (*assiette à palmes*) 128, 129
 plates (*assiette unie*) 130, *130–1, 137, 138*, 139
 Rossini service 140–41, *140–41*
 wine-bottle coolers (*seau à demi-bouteille*) 124–5, *124–5*
Tardieu, Pierre-François (1711–71), engraver 38
tea wares
 chocolate cup and saucer (*tasse à chocolat AB*) 164, *165*
 cups and saucers (*gobelet litron*) 10, *142*, 143, *144*, 145, 146, *146, 147, 148*, 149, *150*, 151, *152*, 153, *154*, 155, *156*, 157, *158*, 159–60, *161–3*
 déjeuner Bolvry 168, 169
 déjeuner grand plateau carré 166, 167
Teniers, David, the Younger (1610–90), artist 20, 25
 La Quatrième Fête Flamande 28
Thomire, Pierre-Philippe (1751–1833) 110, 115, 178
trompe l'oeil effect 71

Van Loo, Jean-Baptiste (1684–1745), artist 74

vases (*see also garnitures*)
 cuvette à masques 26, *26*, *27*
 cuvette à tombeau 20, *21*
 cuvette Courteille 18, *19*
 cuvette Mahon 20, 28, *29–31*
 'Etruscan' vases 116
 pot-pourri vases *22*, 23, 118, *119–21*
 vase à bandes 8, *70*, 71
 vase à bâtons rompus 40, 41, *42–3*
 vase à médallion du roi 10, *60*, 61,
 61
 vase à monter 112, 113, *114*, 115,
 116, *116–17*, 118, *119–21*
 vase à panneaux 50, *51*, 52, *53–5*,
 56, 57, *58*, 59
 vase à perles see *vases à panneaux*
 vase à têtes de bouc 62, *63–5*, 87
 vase Angora 41, 74, *75–7*, 78, 79
 vase Bachelier à anses tortillées 44,
 45
 vase Boileau rectifié 34, 35
 vase chinois de côté 106, 107
 vase cygne à roseau en buire 102,
 103, 107
 *vase de milieu de Duplessis fils
 108–9*, 110, *111*
 vase des âges 57, *92*, 93, *94–6*, 97
 vase Du Barry à guirlandes 80, *81*
 vase fontanieux 82, *83–5*
 vase hollandois 32, 33
 vase japon 122, 123, *123*
 vase jardin 88, *89*, *91*
 vase momie 73
 vase momie rectifié 72, 73
 vase royal 10, 66, *67–8*, 69, *69*
 vase solaire 86, 87
 with covers *24*, 25, *34*, 35
Venus and Cupid 74, *75*, *150*, 151
Voltaire (1694–1778), author and
 philosopher
 Alzire 82
 Brutus 82

Wagner, Joseph (1706–80), engraver 78
water jug (*pot à l'eau ordinaire*) *174*,
 175
Watier, Jean-Baptiste, *maître d'hôtel* to
 George IV 8, 123

Weisbrod, Carl Wilhelm (1743–1806),
 artist: *Le Chasseur prenant des Forces*
 149
Weltje, Louis, Clerk of the Kitchen to
 George IV 8
wine-bottle coolers *see* table wares

Yarmouth, Lord, Francis Charles
 Seymour-Ingram (1777–1842),
 3rd Marquis of Hertford
 (acceded 1822) 8, 36

Zuccarelli, Francesco (1702–88), artist
 78